Praise for *The Lost Painting*

"Harr's lean, observant prose provides sensory intimacy without sensory overload. . . . The result is a revealing portrait of a world seldom seen by ordinary folks. . . . At its best, Harr's magnetic storytelling recalls Cappelletti's first encounter with the work of Caravaggio. To her, his paintings seemed 'to pulse with heat and life, capturing a moment in time like a scene glimpsed through a window.'"

— *The Washington Post Book World*

"[*The Lost Painting*] reads like a whodunit, romantic thriller and scholarly monograph rolled into one. . . . A colorful cast of real-life charmers, dreamers and oddballs worthy of a novelist's vivid imagination."

— Baltimore *Sun*

"With *The Lost Painting* . . . [Harr] bestows on it all of his narrative gifts. . . . Cappelletti . . . notes that 'nowadays almost every art historian with an interest in the seicento [17th century] had a Caravaggio article in the works, and museums everywhere wanted to put on a Caravaggio exhibition. . . .' She called it 'the Caravaggio disease.' . . . Readers of *The Lost Painting* may well find themselves similarly afflicted."

— *Newsday*

"Riveting . . . Harr [is] a consummate storyteller. . . . An effortlessly educational and marvelously entertaining mix of art history and scholarly sleuthing."

— *Booklist*

"Part detective story, part treasure hunt, this book takes us from dusty basement archives to the ornate galleries of Europe's finest art museums. . . . Harr provides a fascinating glimpse into the insular world of art history and restoration. . . . Art lovers and mystery fans should find plenty to ponder and enjoy."

— *Kirkus Reviews*

ALSO BY JONATHAN HARR

A Civil Action

THE

LOST

PAINTING

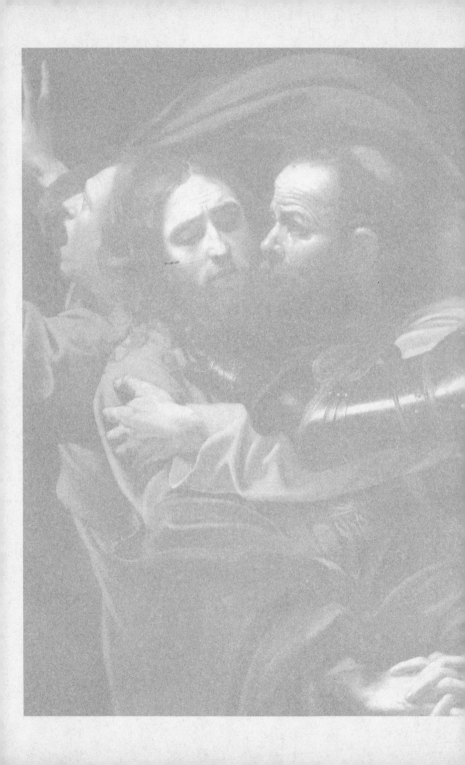

THE
LOST
PAINTING

JONATHAN
HARR

RANDOM HOUSE TRADE PAPERBACKS

NEW YORK

2006 Random House Trade Paperback Edition

Published in the United States by Random House Trade
Paperbacks, an imprint of The Random House Publishing
Group, a division of Random House, Inc., New York.

RANDOM HOUSE TRADE PAPERBACKS and colophon are
trademarks of Random House, Inc.
READER'S CIRCLE and colophon are trademarks
of Random House, Inc.

Originally published in hardcover in the United States
by Random House, an imprint of The Random House
Publishing Group, a division of Random House, Inc., in 2005.

Title-page art and part-title art: Caravaggio
(Michelangelo da Merisi), *The Taking of Christ*, 1602,
courtesy of the National Gallery of Ireland
and the Jesuit Community, who acknowledge
the generosity of the late Dr. Marie Lea-Wilson

LIBRARY OF CONGRESS CATALOGING-IN-PUBLICATION DATA
Harr, Jonathan.
The lost painting / Jonathan Harr.—1st ed.
p. cm.
ISBN-10: 0-375-75986-7
ISBN-13: 978-0-375-75986-4
1. Caravaggio, Michelangelo Merisi da, 1573–1610—criticism
and interpretation. 2. John, the Baptist, Saint—Art.
3. Painting, Italian—Attribution. 4. Painting—Expertising.
I. Title.

Printed in the United States of America

www.thereaderscircle.com

2 4 6 8 9 7 5 3 1

For my father, Jack

CONTENTS

PART I

❧

THE
ENGLISHMAN

THE ENGLISHMAN MOVES IN A SLOW BUT DELIBERATE SHUFFLE, knees slightly bent and feet splayed, as he crosses the piazza, heading in the direction of a restaurant named Da Fortunato. The year is 2001. The Englishman is ninety-one years old. He carries a cane, the old-fashioned kind, wooden with a hooked handle, although he does not always use it. The dome of his head, smooth as an eggshell, gleams pale in the bright midday Roman sun. He is dressed in his customary manner—a dark blue double-breasted suit, hand tailored on Savile Row more than thirty years ago, and a freshly starched white shirt with gold cuff links and a gold collar pin. His hearing is still sharp, his eyes clear and unclouded. He wears glasses, but then he has worn glasses ever since he was a child. The current pair are tortoiseshell and sit cockeyed on his face, the left earpiece broken at the joint. He has fashioned a temporary repair with tape. The lenses are smudged with his fingerprints.

Da Fortunato is located on a small street, in the shadow of the Pantheon. There are tables outside, shaded by a canopy of

umbrellas, but the Englishman prefers to eat inside. The owner hurries to greet him and addresses him as Sir Denis, using his English honorific. The waiters all call him Signore Mahon. He speaks to them in Italian with easy fluency, although with a distinct Etonian accent.

Sir Denis takes a single glass of red wine with lunch. A waiter recommends that he try the grilled porcini mushrooms with Tuscan olive oil and sea salt, and he agrees, smiling and clapping his hands together. "It's the season!" he says in a high, bright voice to the others at his table, his guests. "They are ever so good now!"

When in Rome he always eats at Da Fortunato, if not constrained by invitations to dine elsewhere. He is a man of regular habits. On his many visits to the city, he has always stayed at the Albergo del Senato, in the same corner room on the third floor, with a window that looks out over the great smoke-grayed marble portico of the Pantheon. Back home in London, he lives in the house in which he was born, a large redbrick Victorian townhouse in the quiet, orderly confines of Cadogan Square, in Belgravia. He was an only child. He has never married, and he has no direct heirs. His lovers—on this subject he is forever discreet—have long since died.

Around the table, the topic of conversation is an artist who lived four hundred years ago, named Michelangelo Merisi da Caravaggio. Sir Denis has studied, nose to the canvas, magnifying glass in hand, every known work by the artist. Since the death of his rival and nemesis, the great Italian art scholar Roberto Longhi, Sir Denis has been regarded as the world's foremost authority on Caravaggio. Nowadays, younger scholars

who claim the painter as their domain will challenge him on this point or that, as he himself had challenged Longhi many years ago. Even so, he is still paid handsome sums by collectors to render his opinion on the authenticity of disputed works. His verdict can mean a gain or loss of a small fortune for his clients.

To his great regret, Sir Denis tells his luncheon companions, he's never had the chance to own a painting by Caravaggio. For one thing, fewer than eighty authentic Caravaggios—some would argue no more than sixty—are known to exist. Several were destroyed during World War II, and others have simply vanished over the centuries. A genuine Caravaggio rarely comes on the market.

Sir Denis began buying the works of Baroque artists in the 1930s, when the ornate frames commanded higher prices at auction than the paintings themselves. Over the years he has amassed a virtual museum of seicento art in his house at Cadogan Square, seventy-nine masterpieces, works by Guercino, Guido Reni, the Carracci brothers, and Domenichino. He bought his last painting in 1964. By then, prices had begun to rise dramatically. After two centuries of disdain and neglect, the great tide of style had shifted, and before Sir Denis's eyes, the Italian Baroque had come back into fashion.

And no artist of that era has become more fashionable than Caravaggio. Any painting by him, even a small one, would be worth today many times the price of Sir Denis's finest Guercino. "A Caravaggio? Perhaps now as much as forty, fifty million English pounds," he says with a small shrug. "No one can say for certain."

He orders a bowl of wild strawberries for dessert. One of

his guests asks about the day, many years ago, when he went in search of a missing Caravaggio. Sir Denis smiles. The episode began, he recalls, with a disagreement with Roberto Longhi, who in 1951 had mounted the first exhibition in Milan of all known works by Caravaggio. Sir Denis, then forty-one years old and already known for his eye, spent several days at the exhibition studying the paintings. Among them was a picture of St. John the Baptist as a young boy, from the Roman collection of the Doria Pamphili family. No one had ever questioned its authenticity. But the more Sir Denis looked at the painting, the more doubtful he became. Later, in the files of the Archivio di Stato in Rome, he came across the trail of another version, one he thought more likely to be the original.

He went looking for it one day in the winter of 1952. Most likely it was morning, although he does not recall this with certainty. He walked from his hotel at a brisk pace—he used to walk briskly, he says—through the narrow, cobbled streets still in morning shadow, past ancient buildings with their umber-colored walls, stained and mottled by centuries of smoke and city grime, the shuttered windows flung open to catch the early sun. He would have worn a woolen overcoat against the damp Roman chill, and a hat, a felt fedora, he believes. He dressed back then as he dresses now—a starched white shirt with a high, old-fashioned collar, a tie, a double-breasted suit—although in those days he carried an umbrella instead of the cane.

His path took him through a maze of streets, many of which, in the years just after the war, still lacked street signs. He had no trouble finding his way. Even then he knew the streets of central Rome as well as he knew London's.

At the Capitoline Hill, he climbed the long stairway up to the piazza designed by Michelangelo. A friend named Carlo Pietrangeli, the director of the Capitoline Gallery, was waiting for him. They greeted each other in the English way, with handshakes. Sir Denis does not like being embraced, and throughout his many sojourns in Italy he has largely managed to avoid the customary greeting of a clasp and a kiss on both cheeks.

Pietrangeli told Sir Denis that he had finally managed to locate the object of his search in, of all places, the office of the mayor of Rome. Before that, the painting had hung for many years in the office of the inspector general of belle arti, in a medieval building on the Via del Portico d'Ottavia, in the Ghetto district of the city. The inspector general had regarded the painting merely as a decorative piece with a nice frame, of no particular value. The original, after all, was at the Doria Pamphili. After the war—Pietrangeli did not know the precise details—someone had moved it to the Palazzo Senatorio, and finally to the mayor's office.

Pietrangeli and Sir Denis crossed the piazza to the Palazzo Senatorio. The mayor's office lay at the end of a series of dark hallways and antechambers, a spacious room with a high ceiling and a small balcony that looked out over the ancient ruins of the Imperial Forum. There was no one in the office. Sir Denis spotted the painting hanging high on a wall.

He remembers standing beneath it, his head canted back, gazing intently up and comparing it in his mind with the one he had seen at Longhi's exhibition, the Doria Pamphili version. From his vantage point, several feet below the painting, it appeared almost identical in size and composition. It depicted a

naked boy, perhaps twelve years old, partly reclined, his body in profile, but his face turned to the viewer, a coy smile crossing his mouth. Most art historians thought Caravaggio had stolen the pose from Michelangelo, from a nude in the Sistine Chapel, and had made a ribald, irreverent parody of it.

From where he stood, Sir Denis could not make out the finer details. The surface of the canvas was dark, the image of the boy obscured by layers of dust and grime and yellowed varnish. But he could tell that the quality was superb. Then again, so was the quality of the Doria Pamphili painting.

He turned to Pietrangeli and exclaimed, "For goodness' sake, Carlo, we must get a closer look! We must get a ladder."

Waiting for the ladder to arrive, he paced impatiently in front of the painting, never taking his eyes off it. He thought he could discern some subtle differences between it and the Doria version. Here the boy's gaze caught the viewer directly, mockingly, whereas the eyes of the Doria boy seemed slightly averted, the smile distinctly less open. When a workman finally arrived with a ladder, Sir Denis clambered up and studied the canvas with his magnifying glass. The paint surface had the characteristic craquelure, the web of fine capillary-like cracks produced by the drying of the oil that contained the paint pigments. He saw some abrasion in the paint surface, particularly along the borders, where the canvas and the wooden stretcher behind it came into contact. In some areas, the ground, or preparatory layer, had become visible. He noted that the ground was dark reddish brown in color and roughly textured, as if sand had been mixed into it. This was precisely the type of ground that Caravaggio had often used.

He studied the face of the boy again, the eyes and mouth, areas difficult even for a great painter. This face, he concluded, was much livelier than the Doria version. Indeed, the entire work felt fresher and lighter in both color and execution. He detected the spark of invention and creativity in this painting, something a copyist could never achieve. By the time he climbed down the ladder he felt convinced that Caravaggio's hand had created this painting. As for the Doria version, it was possible, as some maintained, that Caravaggio himself had copied his own work, perhaps at the insistence of a wealthy patron. But Sir Denis was skeptical. He doubted that Caravaggio had ever known about the Doria painting.

At Da Fortunato, Sir Denis pauses after telling this story, and then he smiles. Longhi died years ago, and he'd never accepted the Capitoline version as the original. Longhi was not one to admit a mistake, says Sir Denis. That was the beginning—Sir Denis chuckles—of many disagreements and a long, contentious, and very satisfying feud.

The Englishman has had a hand in the search for several other lost paintings by Caravaggio. He mentions one in particular—it was called *The Taking of Christ*—that had been the object of both his and Longhi's desire. It had vanished without a trace more than two centuries ago. Like the *St. John,* many copies had turned up, all suggesting a masterpiece, but none worthy of attribution to Caravaggio. Longhi, near the end of his life, had come up with an important clue in the mystery of the painting's disappearance.

It had been a clever deduction on Longhi's part, Sir Denis tells his guests. But, poor fellow, he hadn't lived to solve the mystery.

The past held many secrets, and gave them up grudgingly. Sir Denis believed that a painting was like a window back into time, that with meticulous study he could peer into a work by Caravaggio and observe that moment, four hundred years ago, when the artist was in his studio, studying the model before him, mixing colors on his palette, putting brush to canvas. Sir Denis believed that by studying the work of an artist he could penetrate the depths of that man's mind. In the case of Caravaggio, it was the mind of a genius. A murderer and a madman, perhaps, but certainly a genius. And no copy, however good, could possibly reveal those depths. That would be like glimpsing a man's shadow and thinking you could know the man.

PART II

THE ROMAN GIRL

❧ I ❧

A LATE AFTERNOON IN FEBRUARY, THE SUN SLANTING LOW ACROSS the rooftops of Rome. The year was 1989. From the door of the Bibliotheca Hertziana on Via Gregoriana came Francesca Cappelletti, carrying a canvas bag full of books, files, and notebooks in one hand, and a large purse in the other. She was a graduate student at the University of Rome, twenty-four years old, five feet six inches tall, eyes dark brown, cheekbones high and prominent. Her hair, thick and dark, fell to her shoulders. It had a strange hue, the result of a recent visit to a beauty salon near the Piazza Navona, where a hairdresser convinced her that red highlights would make it look warmer. In fact, the highlights made it look metallic, like brass. She wore no makeup, no earrings, and only a single pearl ring on her left hand. Her chin had a slight cleft, most noticeable in repose, although at the moment she was decidedly not in repose.

She was late for an appointment. She had a long, rueful history of being late. As a consequence she'd perfected the art of theatrical apology. The traffic of Rome was her most common

excuse, but she'd also invented stuck elevators, missing keys, broken heels, emotional crises, and illnesses in her family. Her apologies had a breathless, stricken sincerity, wide-eyed and imploring, which had rendered them acceptable time and again to friends and lovers.

This appointment was with a man named Giampaolo Correale. He had hired Francesca and several other art history students, friends of hers, to do research on some paintings at the Capitoline Gallery. Every few weeks, he would convene a meeting at his apartment to discuss their progress. Francesca wasn't always late for these meetings. And on those occasions when she had been, Correale had usually forgiven her with a wave of his hand. She had proven herself to be one of his more productive workers. All the same, he had a temperament that alarmed Francesca, capable of expansive good humor one moment and sudden fits of anger the next.

She rode her motorino, an old rust-stained blue Piaggio model, past the church of Trinità dei Monte and the Villa Medici, down the winding road to the Piazza del Popolo. She was a cautious but inexpert driver, despite eight years of experience. Her destination, Correale's apartment, was on Via Fracassini, a residential area of nineteenth-century buildings, small shops, and restaurants, a mile or so north of the city center. She calculated she would be about fifteen minutes late and began considering possible excuses. The truth—that she simply lost track of time while reading an essay on iconography—seemed somehow insufficient.

By the time she reached Correale's apartment, on the top

floor, breathless and hair in disarray, she presented the aspect of someone suitably distraught.

Correale opened the door. He was in his mid-forties, although he looked older, moderately overweight, mostly bald, with a closely trimmed beard going to gray. He had a stubby black cigar in hand. He peered at Francesca from over a pair of reading glasses. His eyes protruded slightly, like the eyes of a fish.

"Ah, Francesca has decided to join us after all!" Correale said for the benefit of the others in the room. His tone was ironic, but he was smiling.

No excuses were necessary. Francesca entered, murmuring only apologies.

The apartment was small, just two rooms, the air thickly wreathed with yellowish smoke from Correale's cigar. He smoked cigars incessantly. Francesca always left the meetings with a headache. Several unpacked cardboard boxes stood in a corner, stacked atop one another. A large bookcase was half filled with volumes, as if they had been hastily shoved into place. A sofa, a few chairs, several small paintings on the wall, and little else. It appeared as if Correale had just moved in, although he'd been living there for almost a year now, ever since his wife had left him. For the moment, at least, domesticity seemed to have little relevance for him.

There were three other women in the room. One, Francesca's age, was a fellow student from the university named Laura Testa. The other two were older, in their late thirties. One was an art historian who taught at the Istituto Centrale per il Restauro.

The other worked as a restorer of paintings and frescoes. She was plump and good-natured, with a quick, infectious laugh. She and Correale had just begun having an affair, which they sought to conceal but was obvious to everyone.

This small group had been working part-time for Correale for the past three months. His project was simple in concept but grand in ambition. He proposed to create a computer database for Italy's vast trove of art. He imagined an entry with scientific, technical, and historical information—"a complete medical record," he liked to call it—on every artifact from Roman antiquity to the modern era. He had persuaded a technology company named Italsiel to finance a pilot project as a test of this idea's commercial viability. The pilot phase had consisted of recording and cataloguing every known fact on some two hundred paintings at the Capitoline Gallery—a fraction of the gallery's collection but, as Correale pointed out, one had to begin somewhere.

Francesca and Laura had gotten detailed forms from Correale, thirty pages in length, to fill out on each of the two hundred paintings. The forms had looked complicated at first, but completing them had turned out to be merely tedious—"a fake complexity," Francesca once remarked. But Correale had paid well for each finished form, and Francesca and Laura had become adept at filling them in swiftly.

Now Correale had a new idea. The forms had their purpose, he said, puffing on his cigar, smoke rising in a nimbus over his head. But it was time to demonstrate just how this scientific approach to art would work. A case study, he called it. They would examine the two nearly identical St. John paintings attributed to

Caravaggio: the Doria Pamphili version and the one that Denis Mahon had found years ago in the mayor's office, now cleaned and hanging prominently in the Capitoline Gallery. Most art historians had come to accept the Capitoline as Caravaggio's original, but the one in the Doria still had its adherents. Not only Roberto Longhi but also Lionello Venturi, the other great Caravaggio scholar of the previous era, had steadfastly insisted on the Doria's authenticity. Venturi had once dismissed the Capitoline as a "weak copy."

Correale laid out his plan. They would investigate every possible aspect of the two paintings, a forensic investigation of the sort usually conducted at the scene of a murder. They would put the paintings under a microscope, both literally and figuratively, using X rays, infrared reflectography, and chemical and gas chromatograph analysis of the paints and the canvases. And they would also plot the history, the provenance, of the two paintings, collecting every reference they could find from the moment each had been created to the present day.

Correale assigned this task to Francesca and Laura. Other art historians had already done some of this work, but, Correale pointed out, there remained gaps in the early history of both paintings. Caravaggio scholars still argued, for example, about precisely when Caravaggio had painted the *St. John*. Not even Denis Mahon had managed to track down that information. Who knows? Correale said with a shrug. Maybe you'll discover something new.

To Francesca, it seemed that Correale regarded the provenance research as largely perfunctory. His real enthusiasm lay in the scientific and technical aspects of the work. But Francesca

liked her assignment. No more tedious forms to fill out. Just two paintings to concentrate on. A perfect job, in her imagination, was one in which she could spend her life in libraries studying art history, the eternal student.

Along the way, she would discover that, sometimes, when you go looking for one thing, you find another. And every now and then, your reward for persisting is that the other is better.

⚔ 2 ⚖

FRANCESCA SAW THE WORK OF CARAVAGGIO FOR THE FIRST TIME
when she was eleven years old. It was in the church of San Luigi
dei Francesi, just a short distance from the Piazza Navona. Her
father, an accountant who worked in a law office, used to take
her and her two sisters in hand on Sunday afternoons, the girls
dressed in churchgoing finery, for excursions around Rome.
They would set out to see the ancient ruins in the Forum or the
paintings and sculptures in one of the city's great galleries or
churches. Francesca, the oldest of the three, made a game of
these excursions, trying to match the paintings with the artists
before looking at the attributions. In time she came to know the
names of the masters of the Italian Renaissance and Baroque in
the way that schoolboys know the names and statistics of pro-
fessional soccer players.

Her first encounter with Caravaggio remained vivid, a pin-
prick of brilliant light in her memory. The three paintings
known as the Matthew cycle hung in the dim, shadowed regions
of the church, at the far end of the nave, in a recess known as the

Contarelli Chapel. It smelled of candle smoke and incense. A pale light filtered into the chapel through a small lunette window made nearly opaque by dust and grime. In Caravaggio's day, the flickering light of candles would have illuminated the chapel. When Francesca was a girl, illumination required a coin in a box. When the light came on, Francesca felt suddenly as if she were no longer in the church but in a theater. The three paintings seemed to breathe, to pulse with heat and life, capturing a moment in time like a scene glimpsed through a window. She stood with her hands on the smooth, cool marble railing of the chapel, transfixed by the depictions of Matthew's life. The most captivating to her was the one known as *The Calling of St. Matthew*— a scene in a Roman tavern of the sort that Caravaggio would have gone to, with wooden stools and a scarred wooden table, the sunlight from an opened door raking across an old stucco wall and settling on the tax collector who would become a saint.

Later, when she began to study art history seriously, Francesca learned that Caravaggio had painted his self-portrait among the figures in the background of *The Martyrdom of St. Matthew.* He had been twenty-nine then, but in the painting he looked older than that, bearded, brow furrowed, his mouth contorted in a grimace of dismay, his dark eyes filled with anguish. The Matthew paintings, his first public commission, brought him fame and wealth. Ten years later he would die alone, an outcast, in strange circumstances.

3

THE INVESTIGATION INTO THE ORIGINS OF THE TWO ST. JOHN paintings occupied Francesca and Laura all that winter and into the spring. They worked well together, even though they worked in different ways. Correale, comparing the two, once said of Francesca, "She is intelligent and intuitive, but like a nervous racehorse." As for Laura, "She is methodical and scientific, more like the mule that pulls the plow."

Laura was the first in her family to go to the university. She was short and compactly built, and spoke with a heavy Roman accent, a working-class accent that she made no effort to attenuate. Her manner was blunt and direct. The small gestures, the feigned pleasantries that oil most social interactions, were foreign to her. "I try to be polite," she said of herself, "but even if I don't say what I think, I cannot hide it."

They had both completed their undergraduate work at the University of Rome with the highest honors. Each had her senior thesis published in the prestigious scholarly art journal *Storia*

dell'Arte. They entered the graduate program, the specialization, as it is called, on the same day and took the same classes. They developed a friendship, but of the sort mostly limited to school and work.

They began their research at the national art library in the Piazza Venezia. They started with a book known informally as the bible of Caravaggio studies, compiled by an art historian named Mia Cinotti. It carried the subtitle *Tutte le Opere*—"All of the Works"—and its bibliography listed three thousand journal articles, monographs, and books on Caravaggio. In the section on the *St. John,* they read that most scholars believed Caravaggio had painted it between 1598 and 1601, although a few put the date as early as 1596. There were eleven known copies. Cinotti considered the Capitoline version discovered by Denis Mahon to be the authentic one, although she conceded that the Doria picture—the only important copy, by her lights—could possibly be a replica made by Caravaggio himself.

The earliest mention of the painting came from another artist, Giovanni Baglione, who had lived and worked in Rome at the same time as Caravaggio. The two men had been rivals and bitter enemies. Neither had anything good to say about the other. Thirty years after Caravaggio's death, Baglione published a series of short biographies of artists and sculptors in Rome. He recorded that Caravaggio—"a quarrelsome individual," whose "paintings were excessively praised by evil people"—had painted the *St. John* and two other pictures for a wealthy Roman collector named Ciriaco Mattei. One of those, as it happened, was the lost *Taking of Christ.* After Mattei's death, according to Cinotti, the *St. John* had a complicated history, passing through several

hands over the centuries before finally ending up at the Capitoline Gallery.

The history of the Doria *St. John* was at once much simpler and yet more mysterious. There was only a single known owner, the Doria Pamphili family. The picture had been in their possession since at least 1666, when it showed up for the first time in a family inventory, more than fifty years after Caravaggio's death. The painting's history before that date was unknown. Several scholars had attempted to track it back further, but nothing had come of their efforts.

Francesca and Laura talked it over. They decided to start with the Doria painting. Since less was known about its early history, it seemed to offer the greatest possibility to make a real discovery. And besides, the Doria Pamphili palazzo was just around the corner on Via del Corso, a five-minute walk from the library.

THE PALAZZO OCCUPIED AN ENTIRE CITY BLOCK. IT WAS A MASSIVE edifice of rusticated travertine and brick, soot-streaked and blackened by the incessant traffic on the Corso. At the center of the palazzo, visible through an entryway, the two young students saw a courtyard of orange and lemon trees and towering palms, a garden where barely a whisper of the city outside was audible. The Doria Pamphili family and its descendants had occupied this palazzo for almost four centuries. Their art gallery, with its collection of hundreds of paintings and sculptures, was open to the public.

The family's archive lay deep inside the palazzo. At the rear of the building, just off a narrow lane called Via della Gatta, Francesca and Laura entered a battered wooden door, climbed a flight of dimly lit marble stairs, and went past a warren of small, drab offices, the bureaucratic center of the family's once great holdings. A man behind a desk directed them down the hall to a pair of tall wooden doors.

The doors opened into a spacious room with a high, coffered ceiling, a terra-cotta floor, and windows overlooking another courtyard. In the center of the room there was a stout wooden table surrounded by bookshelves filled with hundreds of old leather-bound volumes and neatly labeled boxes. Through a partially opened door, Francesca could see into the heart of the archive, a long, narrow chamber lined with gray metal bookshelves that contained thousands more volumes.

The archivist who greeted them was a young Englishwoman, only a few years older than they, with long red hair gathered loosely behind her neck and a complexion as white as a porcelain doll. Her voice was soft, no more than a whisper. At first Francesca thought that this was how one should speak in the Doria Pamphili archive, even though there was no one else in the room. Later, when she happened to encounter the archivist on the street, Francesca realized that this was how the woman always spoke. "Like a ghost from another time," Francesca remarked.

The archivist explained in her whispery voice the organization of the documents. The earliest dated back to the eleventh century. The shelves contained aspects large and small of a

prominent family's passage through time—wills, contracts, and inventories; documents concerning banking, lawsuits, the arrangements of marriages, the purchase and sale of properties and goods.

Francesca and Laura asked to see the inventory of 1666 that contained the first mention of the Doria *St. John*. The archivist went on silent foot to retrieve it from the back room. She returned some moments later carrying a thick volume bound in worn, faded leather.

Seated at the table, they opened the book and leaned over it, their heads almost touching. The inventory had been drawn up at the death of the head of the household, one Camillo Pamphili, age forty-four, taken ill one day in July and dead the next from a fever of unknown origin. The notary had recorded Camillo's possessions on heavy paper of good quality. The edges had turned brown with age, and the tome gave off a stale, musty odor, but the pages were still cream-colored and unblemished.

They found the entry for the *St. John* on page 325, among a list of more than four hundred other paintings owned by Camillo Pamphili. There was no mistaking its description: "A painting of a young nude boy who caresses a sheep with white fleece, and with red below, with plants at his feet." The entry also described a frame decorated with a crosshatch pattern and small carved leaves, and recorded the size of the painting in palmi, an old Italian measure equal to eight and a half inches.

The entry did not name the artist, but that was not unusual. Many inventories failed to note the names of painters and sculptors, in part because artists had almost never signed their

works. Up until the Renaissance, they had been regarded merely as skilled tradesmen, practitioners of a manual craft, like shoemakers or potters. And even after they began to achieve individual recognition and ascend the social ladder—after Michelangelo, Leonardo, and Raphael—the idea of signing one's name to a work of art remained foreign, a practice that wouldn't fully take hold until the end of the nineteenth century.

Francesca and Laura began working their way back in time through earlier inventories and account books, hoping to find a citation that might reveal the source of the painting. Their visits to the archive settled into a routine. They came once or twice a week, usually together, after classes at the university. They rarely saw other researchers there, just the archivist, who would appear and disappear so silently they never heard her footsteps.

It took them hours to check the pages of a single inventory. Some of the old volumes had held up well over the years, but in others the ink had turned feathery brown on the brittle pages. They bent over the documents, trying to decipher the handwriting of notaries and bookkeepers, which was, it seemed, invariably small and difficult to puzzle out, with some entries in Latin and others in old Italian, full of abbreviations and curious spellings.

They found no mention of the painting in any of the inventories before 1666. They broadened their search. Camillo Pamphili had been an enthusiastic collector of art. He'd bought dozens of paintings from the estates of aging cardinals, minor nobility, and other collectors. They combed through account books, receipts, and sales documents, looking for some indication of how Camillo might have obtained the *St. John*. The trails

they followed branched out in bewildering complexity, full of detours and false leads.

When they grew discouraged, they reminded themselves that this painting had not simply materialized out of thin air. It had a history, if only that history could be known.

4

CORREALE CALLED FRANCESCA AND LAURA SEVERAL TIMES A WEEK, usually during the evening. His calls always began with an announcement of some new development. "Una cosa tremenda!" he would exclaim, and then go on at length about some scientific detail that researchers had discovered in an X ray of one or another of Caravaggio's paintings.

To Francesca, it never seemed like a "cosa tremenda." Even worse, Correale seemed to call just as she was walking out the door, or late at night when she was about to fall asleep. She'd hear in his voice the tone of someone who was settling in for an hour-long chat. She thought of him living alone in his tiny apartment with unpacked boxes, thinking about his wife, who was living with another man. He had a precarious air about him, Francesca once remarked, as if the ground beneath his feet had shifted. In moments of good cheer, he addressed her and Laura as "tesoro" and "cara," while at other moments, when something small happened to upset him, he'd fly into a fury, eyes bulging and hand smacking the table. He scared Francesca at those mo-

ments. She started avoiding his phone calls. Laura tolerated him better. She didn't hesitate to yell back at him. Once, when he called after midnight, she said in an angry voice: "Giampaolo! Don't you know what time it is? Don't you think I sleep?" He apologized, Laura told Francesca, but then he kept talking anyway and Laura didn't have the heart to hang up on him.

<div align="center">❦</div>

ONE WINTER AFTERNOON, ALONE IN THE DORIA PAMPHILI archive, Francesca came across a large collection of letters bound with string, written by Girolamo Pamphili, a cardinal who had died in 1610. He had lived in Rome during Caravaggio's day and he would have known of the painter's celebrity. His circle of acquaintances included men such as Ciriaco Mattei, the owner of the other *St. John,* and Cardinal Del Monte and Vincenzo Giustiniani, all of whom had bought paintings directly from Caravaggio. Francesca thought it might be worthwhile to read these letters.

Laura dismissed this idea as a waste of time, but Francesca decided to try anyway. She began at random, picking a letter out of the thick batch. And she succumbed to the delirium of the researcher. Girolamo's letters contained a portrait of Rome, detailed and domestic, lost to time. He wrote at length about buying a fancy new carriage, about the oppressive heat of the Roman summer and his plans to escape to his country villa, about dinner parties, church politics, and also about his health and hygiene. He fell ill in his early fifties—a problem with his bronchi and lungs, he wrote to a friend. Confined to bed, with

time on his hands, he described in detail his treatment, his diet, the periodic bleedings, the leeches applied to his skin to draw poisons out. And then his letters ended abruptly. The ailment, whatever it was, had killed him.

Francesca was captivated by this account of a life, but she found nothing relating to the painting and no mention of Caravaggio. Of course, she'd read only a small sampling of the letters. She realized that she could spend months sitting in the Pamphili archive reading. Perhaps she would find something important, but the chances were against it. And she didn't have months. Laura had been right—if she was trying to find the origins of the Doria painting, Francesca was wasting her time.

<center>⊰✴⊱</center>

FRANCESCA, LIKE ALL STUDENTS OF ART HISTORY, KNEW THE broad outlines of Caravaggio's life. He had been resurrected from obscurity, in large part by Roberto Longhi, who had written in 1941 that Caravaggio was "one of the least known painters of Italian art." His eclipse occurred with astonishing rapidity. His realism had initially attracted many followers—the Caravaggisti, they were called—but the critics of his era found his paintings coarse and vulgar. They said that he did not understand the true essence of art and beauty, that he merely copied what he saw before him, that his work was no more than a "base imitation of nature." By the end of the seventeenth century, he was regarded as a minor painter of low repute. The years passed and few art connoisseurs bothered to take note of him. One who did, the nineteenth-century English critic John Ruskin, wrote in

disgust that Caravaggio fed "upon horror and ugliness, and filthiness of sin."

When Longhi put together his Caravaggio exhibition in Milan in 1951, many of the visitors, art historians among them, knew little or nothing about the artist. His paintings had long been consigned to the back rooms and storage bins of galleries and museums.

And then, in the years since that exhibition, Caravaggio scholarship suddenly, miraculously, blossomed into an industry. His rebirth into the world of art was swift, the mirror image of his disappearance three centuries earlier. Nowadays, it seemed to Francesca, almost every art historian with an interest in the seicento had a Caravaggio article in the works, and museums everywhere wanted to put on a Caravaggio exhibition, even if they had only one or two of his paintings. She called it "the Caravaggio disease." Sometimes she feared she would also be infected by it.

The accounts of much of his life remained sketchy. He arrived in Rome in 1592, in the late summer, or perhaps early autumn. He was twenty-one years old. He had come to Rome from Milan. Most likely he had walked, keeping company with wayfarers who banded together for protection against robbers. He entered the city's ancient walls through the Porta del Popolo, and from there he made his way to the Campo Marzio, the most densely populated district of the city. It was then, as it is now, a crowded district of narrow, winding lanes and shadowed passageways, opening every so often onto a sunlit piazza. The larger streets, the Via del Corso and the Via di Ripetta, were paved with cobbles, but most others were unpaved, dusty in summer, muddy

in winter. There were beggars and alms-seekers at every turn, fortune-tellers, jugglers, minstrels, prostitutes, street urchins, pilgrims, postulants, and, of course, priests in their black robes, and the endless cacophony of voices in dozens of dialects and languages. It was a city of odors, ripe and foul, chamber pots emptied every morning from windows overlooking the streets, in the marketplaces discarded vegetables and fruit rotting in piles on the ground, stray dogs scavenging around the butchers' stalls and the fishmongers' markets for offal amid the blood and flies.

It was said by the painter Giovanni Baglione that Caravaggio had found his first lodgings in Rome with another painter known as Lorenzo the Sicilian, who "had a shop full of crude works." Another account, by a doctor named Giulio Mancini, who also knew Caravaggio, said that he was given a room by one Pandolfo Pucci, master of the house for a relative of the former pope. He was ill-treated by Pucci, according to Mancini, made to do "unpleasant work" and given only greens to eat at every meal. To pay for his cramped attic room and miserable board, Caravaggio had to make copies of devotional figures, the sort of art that sold for a few scudi in stalls along the streets and in the Piazza Navona. At one point in those early years, an innkeeper named Tarquino gave Caravaggio a room. In payment Caravaggio painted the innkeeper's portrait, although that painting is now lost. During his first three years in Rome, he lived in as many as ten different places. He was exceedingly poor, reported Mancini, his clothing little more than rags. He lived on the bleak margins of the art world, selling his paintings in the street, along with hundreds of other young artists who had come to Rome to make their fortunes.

Francesca found herself enchanted by the brief moments, like scenes in a darkly lit play, that had emerged about Caravaggio's life. The most detailed and vivid of these came out of the voluminous records of old police reports.

There was, for example, an inquiry into an incident that occurred one Tuesday night in July 1597. It was notable for the fact that it constituted the first known physical description of Caravaggio.

Around sunset, shortly after eight o'clock, a dealer in paintings and secondhand goods named Constantino Spata was at work in his shop next to the church of San Luigi dei Francesi. He had already eaten dinner with his family—his wife and four children lived above the shop, in cramped quarters—when Caravaggio and another painter, Prospero Orsi, stopped by. Spata had sold a few paintings by Caravaggio for small sums of money. They were going out to eat, Caravaggio told Spata, and invited the shopkeeper to join them. Spata decided to accompany them to a nearby tavern, the Osteria della Lupa—the Tavern of the Wolf—just off Via della Scrofa. Some hours later, on returning to Spata's shop, the three men heard cries of alarm and saw a man racing in their direction. The streets were dark and Spata—or so he claimed in an interview before a magistrate—could not identify the man. A short distance farther on, they came across a black cloak lying on the ground, evidently the property of the fleeing man. Caravaggio bent down to pick it up. He had recognized the man and told the others he would return the cloak to him.

In the piazza of the church of Sant'Agostino, a two-minute walk from Spata's shop, Caravaggio banged on the door of a bar-

bershop. It was closed at that hour, but a light showed from within. Barbers of that era served as surgeons, and this barber, Luca by name, had once treated Caravaggio for a wound he'd gotten in a fight with a stablehand. Caravaggio knew the fleeing man as the barber's apprentice, and he handed over the cloak.

The barber Luca was summoned by the magistrate. In his testimony, Luca described Caravaggio in this way: a young man, around twenty or twenty-five, with a thin black beard, stocky in build, with black eyes, heavy brows, and thick unruly hair. He went about usually dressed in black, said Luca, his appearance disordered, with worn stockings and a threadbare cloak.

The precise nature of the incident—evidently it involved an assault or a vendetta—remains unknown, buried in the archives, or perhaps never pursued any further by the authorities. Caravaggio was apparently never called to testify. But to Francesca the police report captured a moment in time—a dark summer night on the streets of Rome—in the same way that Caravaggio's paintings seemed to arrest time. And to art historians, especially those afflicted with the Caravaggio disease, the details were precious. The testimony of Luca the barber, apart from his description of Caravaggio, also put a name to Constantino Spata, the dealer in paintings and secondhand goods who had sold at least two of Caravaggio's paintings in the days when he was living in poverty.

Spata, as it turned out, played a pivotal role in Caravaggio's fortunes. His shop was directly across the street from a great palazzo occupied by Cardinal Francesco Del Monte, then forty-four years old and a connoisseur of art. Passing by Spata's shop, the cardinal caught sight of a painting depicting a street scene in

Rome: two card hustlers cheating a naïve, well-dressed young man. It was a painting unlike any the cardinal had seen before— strikingly naturalistic, with a lucidity of color and light that stood out from the customary mannered scenes of saints and angels and billowing clouds. Del Monte bought that painting, which became known as *The Cardsharps,* for a few scudi. On another visit to Spata's shop, the cardinal bought a second painting, this one showing a young woman, a Gypsy fortune-teller, reading the palm of a smug, well-dressed Roman youth, smiling sweetly as she caresses his hand and steals his ring.

The details of the first meeting between Cardinal Del Monte and Caravaggio are lost to the past. Possibly the cardinal arranged the meeting through Spata; or perhaps Caravaggio, alerted to Del Monte's interest, arranged to be in Spata's shop when the cardinal came by. Caravaggio was then twenty-five years old, still living an itinerant existence, still near destitution. However the meeting occurred, it ended with Cardinal Del Monte offering Caravaggio room and board in his palazzo and freedom to paint.

And so it happened that Caravaggio, through his friend Spata, chanced upon the best of circumstances for an artist—he found a wealthy and appreciative patron who could advance his career by introducing him to other wealthy collectors. Caravaggio lived in Del Monte's palazzo for nearly four years. During that time he rose from obscurity to fame. Del Monte used his influence to get Caravaggio his first public commission, for the St. Matthew paintings in San Luigi dei Francesi, the paintings that Francesca had seen as a child.

⚔ 5 ⚔

IT WAS THE END OF MARCH AND THE MEETINGS AT CORREALE'S apartment began to grow more frequent. He would summon Francesca and Laura and the rest of his small staff every week or so. The group was growing in size. Correale was in the midst of arranging some scientific tests on the two *St. Johns,* and now he brought in for briefings the technicians who would conduct those tests. There was detailed talk of X-ray machines and infrared cameras, of chemical analysis of paint fragments, of microscopic examination of the fabrics of the two canvases. Correale, of course, planned to be in attendance throughout. Francesca had rarely seen him in such a good mood. He rubbed his hands together in delight at the prospect of these tests, as if he were about to sit down to a banquet table.

The technical talk bored Francesca. She and Laura had spent weeks in the archive, and they had finally come up with a tentative answer to the origins of the Doria *St. John.* They made their report to Correale at the end of the meeting, after the technicians had departed. They had tracked down a group of twenty-

seven unnamed paintings purchased by Camillo Pamphili from an elderly cardinal in financial difficulty. They'd gone to the Archivio di Stato to examine the cardinal's papers, and they found that he had sold a painting of St. John. Almost certainly Camillo had been the buyer. The painting was attributed to a talented Spaniard named Jusepe de Ribera, who had studied in Rome as a youth and had adopted Caravaggio's distinctive style. Ribera was a good painter, good enough to have made a faithful copy of the original St. John.

Correale listened, nodding from time to time, and filling the air in the small apartment with smoke from his cigar. "And what about the Capitoline painting?" he asked when they'd finished.

They had been working on that, they told him. The first owner, Ciriaco Mattei, had lived in a grand palazzo, one of four Mattei palazzi, on the edge of the Ghetto district, not far from the Capitoline Hill. Francesca and Laura had gone there—it was still known in Rome as the Isola Mattei, the Mattei Island—only to learn that there was no Mattei archive there. Nor were there any Mattei documents in the Archivio di Stato.

But they did have a lead, they told Correale. They'd come across an article by a German scholar, published more than twenty years earlier, about the construction of the last Mattei palazzo, built during Caravaggio's day. On the first page of the article, in a footnote, the German had thanked Her Excellency Principessa Donna Giulia Antici-Mattei for having "so generously made available" the family archive in the town of Recanati.

Recanati was a small and ancient hill town, little more than a village, located on the Adriatic coast, in the region known as Le Marche. Laura had called the Department of Culture for Le

Marche, but no one there knew about a Mattei archive. She'd also called the city hall in Recanati, and gotten the same answer. Then they had tried to find the German scholar, but they'd had no luck. They didn't even know if she was still alive.*

Correale pondered this. They could, of course, just go to Recanati and ask around, he suggested. It was small enough that they might find somebody who would know about an archive.

Francesca and Laura had considered doing that. But there was no guarantee that the archive was still there. The German had seen it, but that had been more than two decades ago. And getting to Recanati was not easy. There were no direct trains, and by car it was a trip of many hours across the Apennine Mountains.

<center>✳</center>

AT HOME ONE MORNING, FRANCESCA DID SOMETHING BOTH OBVI-ous and ingenious. She got out the Rome telephone book and looked up the name Mattei. The listings filled four pages. She ran her finger down the columns, looking for Giulia Antici-Mattei, and stopped at a listing for Guido Antici-Mattei.

A woman, elderly by the sound of her voice, answered the telephone.

Francesca asked if she could speak to the prince, Guido Mattei.

The woman gasped. Francesca imagined her hand fluttering to her chest. The prince had been dead for forty years, said the

*The German scholar Gerda Panofsky-Soergel was—and still is—alive and well, and working at the Institute for Advanced Study in Princeton, New Jersey.

woman. She was his daughter, the Marchesa, Annamaria Antici-Mattei.

Amazing, thought Francesca. After forty years the family had not changed the telephone listing. Francesca expressed her regrets, apologized for her intrusion, and then said she was looking for the Mattei archive. Did the Marchesa know by chance anything about it?

The old lady was immediately suspicious. "Who are you?" she asked.

Francesca explained that she and a colleague were doing research on a painting by Caravaggio, a painting that the Mattei family had once owned.

The Marchesa spoke dismissively. "A German woman visited the archives some years ago. She wrote an article that contains everything. And another German has also come there, doing some research. You won't find anything new. The Germans already did everything."

Yes, replied Francesca, she had read the article. But perhaps there was something more in the archive that the Germans had overlooked, especially concerning this one painting. Would it be possible to visit the archive, just briefly?

"No, no, no," said the Marchesa, her voice querulous and high-pitched. "Impossible, completely impossible. It is all in Recanati, too far away. And I would have to be present, you understand. I cannot let just anyone rummage around among those papers. And besides, the Germans have already seen everything."

And with that the Marchesa said a firm good-bye.

Francesca felt the sort of frustration a child might feel peering through a store window at a coveted doll. The Mattei

archive, unlike the Doria Pamphili, was virgin territory, explored only by a couple of scholars, and many years ago at that. It was precisely the sort of place where she and Laura might have a real chance of finding something original and important.

That evening Francesca called Laura and recounted her conversation with the old lady. Laura, of course, favored the direct, blunt approach. They should call the Marchesa back. They should implore her to let them see the archive.

"It's no use," said Francesca. "The woman has made up her mind. Calling her again won't change that. It will just annoy her."

They had no choice, it seemed, but to go back to the libraries and through the motions of research, citing documents by other historians, who had in turn cited earlier historians and all the familiar old travel guides and early biographers of Caravaggio.

THE NEXT MORNING, RIDING HER MOTORINO INTO THE CITY, Francesca found herself thinking about a friend from high school named Stefano Aluffi. He was himself descended from a family of minor nobility—he could claim the title of count, although he never used it—and he had a passion for Roman history and genealogy. He was tall and blond, and carried himself, on first acquaintance, with an Old World courtliness. He kept in contact with many of the old nobility, friends of his parents, and their descendants, who were his own contemporaries. He maintained, only half jokingly, that no household was complete without the *Albo d'Oro*—the "Gold Register" of Italian nobility.

Francesca recalled that Stefano had once introduced her, at some party or another, to a striking young woman whose name was Sabina. She and Sabina had talked, just briefly, in the way one does at parties, and Francesca had never seen her again. But she recalled now—why hadn't she thought of this earlier?—that Stefano had said Sabina was related to the Mattei family of the famous Isola Mattei.

Nowadays Francesca and Stefano might run into each other once a month or so, at the occasional dinners and parties of mutual friends. But a few years ago, when Stefano had arrived at the University of Rome to study art history, they'd spent a lot of time together. He had come to her for help. Like most new students, he'd gotten lost in the crowds and endless bureaucracy of the place. Francesca became his "spiritual adviser," as he later put it. They had taken many of the same classes, they had studied together at her house, and she tutored him well enough to enable him to graduate.

Francesca called Stefano and asked him about the Mattei family. Was Sabina in fact related to the same family that had owned the palazzi in the Ghetto? Stefano, who kept track of these things, said Sabina was the niece of the Marchesa, Annamaria Antici-Mattei.

Francesca explained that she wanted to see the Mattei archive and Annamaria had refused permission. Could Stefano ask Sabina to intercede on her behalf? Talk to her aunt and assure the old lady that she, Francesca, was not making a frivolous request, that she was a serious scholar?

A few days later Stefano called Francesca back. Sabina had

talked to her aunt. He thought that she had convinced the old lady to let Francesca into the archive. He suggested that Francesca try calling the Marchesa again.

This time the Marchesa sounded more welcoming. Her niece, of whom she was quite fond, had vouched for them. Why had Francesca not mentioned that she knew Sabina? But she warned Francesca again that the research would be a waste of time, and that they could stay only a day or two. The archive was kept in an old palazzo, the last of the family's once great holdings. The Marchesa used it as a summer house. It had no heating and was empty most of the year. The Marchesa said she would go to Recanati in late April, after Easter, to open up the palazzo. They could come then, if they liked.

<p style="text-align:center">❧</p>

"CHE BRAVA!" CORREALE SAID EXUBERANTLY WHEN LAURA TOLD him they had found the Mattei archive at last. He grew annoyed, though, when Laura said they couldn't get into the archive until the end of April. That was a month away. Couldn't they convince the Marchesa to let them see it sooner?

Francesca refused to ask the Marchesa again. She was afraid the old lady would grow irritated and withdraw her permission. Correale got upset, but in the end he could only resign himself to the wait.

⚡ 6 ⚡

THE BIBLIOTHECA HERTZIANA OCCUPIED THREE BUILDINGS ON Via Gregoriana, at the top of the Spanish Steps. The oldest of the buildings dated back four hundred years. Inside the library, the rooms were connected by a network of dark passageways and staircases that twisted and turned in labyrinthine complexity. The library, privately run by a German institution, was devoted solely to the study of art and architecture, particularly the Renaissance and Baroque. Entry was gained by permit only, and the grant of permits was strictly controlled. The Hertziana was the domain of scholars with credentials, not of students.

Francesca managed, after many applications and pleas, to get a temporary pass to the library, good for fifteen days. It was her second such pass, and her most valued possession.

She had a favorite place in the library, a long wooden table, scarred from years of use, on the third floor amid the shelves of books, in a pool of lamplight. At the far end of the table, the afternoon sun came in through tall French doors, which opened onto a balcony where a tangle of overgrown roses and vines grew

from cracked terra-cotta vases. From this spot, Francesca looked out the French doors to the sprawl of Rome below, the tiled rooftops and church domes, and in the distance, in the blue haze across the Tiber River, the great dome of St. Peter's. She could almost see the top of the building where she had been born, at the foot of the Spanish Steps, in a fifth-floor apartment overlooking the Via dei Condotti. In the days before that street had turned completely to glitter and commerce, before Gucci, Valentino, and Versace, Francesca's mother would go out to buy fruit and vegetables at the stalls on Via Bocca de Leone and come face-to-face with Sophia Loren and Alberto Moravia.

The Bibliotheca Hertziana stayed open until nine o'clock every night, and Francesca rarely left before then. At her table, she collected dozens of articles and monographs about Caravaggio and began reading through them. Many offered nothing particularly new or interesting, just the background noise of art scholars going about the business of advancing their opinions or disputing the opinions of their colleagues. Sometimes in an article, a real piece of information—an actual fact, a date, a contract—would emerge from the vast tangled swamps of archives. Then it would be scrutinized and interpreted by the confraternity of Caravaggio scholars, and if it withstood examination, it would assume its place in the assembled landscape of Caravaggio's life.

That landscape was a mere patchwork of moments. Only recently, for example, had scholars discovered that Caravaggio had been born in 1571 and not 1573, as they had long assumed. It was known from documents found in Milan, near his birthplace in the town of Caravaggio, that he had been apprenticed at the age

of thirteen to a painter of minor consequence named Simone Peterzano. No one knew whether he'd finished that apprenticeship, or why he'd left Milan to come to Rome. He could read and write—an inventory of his possessions taken at the time of his eviction from a house in the Campo Marzio listed a dozen books, although none of the titles—but not a single letter or document written by him had survived. Only the police records captured a few moments with the sort of immediacy and detail that Caravaggio himself had captured in his paintings. There was the afternoon of April 24, 1604, when he flung an earthen plate of cooked artichokes in the face of a waiter named Pietro de Fosaccia at the Osteria del Moro. Or the night of November 18, when he was stopped by the police near the Piazza del Popolo for carrying a sword and dagger and, after presenting a permit for the arms, told the police, "Ti ho in culo," "Shove it up your ass." On the evening of July 29, 1605, he struck a young lawyer named Mariano Pasqualone with his sword in the Piazza Navona. The lawyer, wounded in the head, told the police that he and Caravaggio had argued the day before over a girl named Lena who worked as a model for the painter—"She is Michelangelo's girl," the lawyer said.

From her table on the third floor of the Hertziana, Francesca could look out the French doors and see the places where these events and a dozen others in the police reports had occurred. The layout of the streets and piazzas of central Rome remained more or less the same today as four hundred years ago. Yet for all these details, pieced together like a mosaic to construct a narrative of his life, Caravaggio himself remained unknown, an enigma.

7

FRANCESCA BORROWED HER SISTER SILVIA'S CAR FOR THE TRIP TO Recanati. Silvia had just bought the car used, a type known as an A 112. It was tiny, with a forty-three-horsepower engine that coughed and shuddered when Francesca shifted gears. The bumper was loose and there were rust spots on the fenders, which had once been blue but had faded to gray. Through a hole in the floorboards, Francesca could see the pavement passing beneath her feet.

She left home on an April morning, a week after Easter. In Rome, the day was sparkling and the skies a deep blue, the temperature sweetly springlike. Francesca drove through crowded streets to the apartment where Laura lived with her mother and brother in the south of the city, near Via Marconi. Francesca was not, as she herself readily admitted, a skillful driver. She drove slowly, not out of caution but because of distraction: her mind was forever wandering to issues more interesting to her than driving. Motorists behind her would honk their horns and ges-

ticulate angrily as they passed her. She always looked mysti-
fied—large eyes opened wide—at their ire.

Laura put her overnight bag in the backseat and they set off,
their spirits high, laughing and looking forward to an adventure.
Within a few minutes, however, Laura began to get worried. It
seemed that Francesca had no idea where she was going. She
made one wrong turn, and then another. Laura began giving di-
rections. When Francesca reached into the backseat to retrieve
a book she wanted to show Laura, talking all the while, the car
veered toward the sidewalk. Laura gasped. She could endure it
no longer.

"Listen, Francesca," she said, "I think it would be better if I
drove."

Francesca happily agreed.

In Laura's capable hands, they left Rome without incident,
heading north on the Via Salaria, following the ancient Roman
route toward the Adriatic. The trip to Recanati would take
them over the Apennine Mountains, the spine of Italy, to the
Adriatic Sea. In little more than an hour they reached the
foothills. Ahead of them lay snowcapped peaks, shrouded in
mist. A chilly breeze came up through the holes in the floor-
boards. The car's tiny engine rattled, the gears made grinding
sounds. As the grades grew steeper, traffic on the two-lane road
began to back up behind them. Laura pulled over to the right, to
the edge of the pavement, and they climbed in slow motion.
Laura said they might have to get out and push the car to the top.
Francesca looked worried, but Laura laughed.

Cresting a long rise, they could see off to their right the great

peak of Gran Sasso—the Big Stone, the highest of the Apennines. On the descent, the car gathered momentum. Laura discovered that the brakes were not much better than the engine, but the road was wide and the curves gentle, and Laura liked speed. In the far distance, they saw the dark blue horizontal line of the Adriatic, dividing sky and earth. At the coast, at the small town of Giulanova, they turned left and drove north along the shoreline to Ancona. The day was so clear and bright that they could see the faint outlines of the Dalmatian coast across the Adriatic.

❧

THEY ARRIVED AT RECANATI SHORTLY AFTER TWO IN THE AFTERnoon. The town was eight miles inland from the coast, built a millennium ago on a hilltop. The little car struggled up the winding road, past groves of olives, in the shadow of an ancient defensive wall, crumbling in places, that still encircled the town. As they climbed, the countryside spread out before them like a storybook land—the Adriatic to the east, the Apennines to the west, and neighboring towns shimmering in the sunlight on their own hilltops, rising from the undulating plains below.

They entered the town through the remains of an old gate and drove down a narrow street paved in cobbles. They had made reservations at La Ginestra, a hotel named after a famous poem by the nineteenth-century writer Giacomo Leopardi. They went down Via Leopardi and past the central piazza of the town, Piazza Leopardi, which was of course dominated by a bronze statue of Leopardi. The poet, who had died young—he

was partially blind and suffered a spinal deformity that had bent him nearly double—had repeatedly tried to escape the place of his birth. He regarded it as a virtual prison. Now he was permanently entombed there. The town was small enough that they didn't bother to ask directions. It's the sort of place, remarked Laura, where everybody knows if you bought a new scarf, or how many lovers your mother had.

The hotel was run by a family, the same family that had run it for generations. From a door in the rear emerged a middle-aged woman, smiling and wiping her hands on an apron. All twenty-eight rooms had been occupied over Easter with tourists, said the woman. Now Francesca and Laura were the only guests. There was a small breakfast room, each table with a pink tablecloth and a vase of flowers, and windows looking out onto a garden. The sitting room had an upright piano and a TV. It looked as if it was used more by the family as their living room than by paying guests. Children's drawings and schoolbooks and homework papers were spread on the desk. Correale had agreed to pay the bill—forty-five dollars a night—for a single room with two beds.

The woman gave them directions to the Palazzo Antici-Mattei. "Just a short walk," she said. Everything in Recanati was just a short walk away. Turn right outside the hotel, go past the bar Il Diamante, past the church of San Vito, and then right again on Via Antici. They couldn't miss it.

They set off promptly, encountering only a few people, mostly elderly, on the street. A breeze from the sea made the air feel cooler in Recanati than in Rome, and they wore their jackets. In five minutes they reached the palazzo, at number 5 Via

Antici. It was three stories high, built of brick and covered by an old stucco finish that had fallen away in places, stained with streaks of rust and moss. The large wooden door had been painted green, but the paint was cracked and peeling now, as were the closed, sagging shutters along the row of windows on the upper floor.

Laura rang the bell. They stepped back and composed themselves, wanting to present a pleasing aspect to the old woman. A minute passed, and then another. Laura rang the bell again. They could hear it sounding distantly inside the building, but no one came to the door. Francesca peered through the heavy iron grating that covered the ground-floor windows, but she could see nothing. Once again they rang the bell, and this time Laura made a few heavy thuds of her fist on the door. Nothing.

"What should we do?" asked Francesca, gazing around.

Another, smaller door fifteen feet away seemed to be part of the building. They decided to knock there. They heard voices and movement inside, and at last an old woman, bent over a cane, hair gray and wispy, appeared. She was wrapped in several sweaters and wore two pairs of glasses, one atop the other, which had the effect of greatly magnifying her eyes. She was missing several teeth. She peered up at them suspiciously.

"We have an appointment to visit the Marchesa," Laura said. "But no one seems to be home next door."

"Yes, yes," said the old woman, "the Marchesa is there." She told them to wait and disappeared into the darkness of the room. A moment later she returned with a large key in her hand. When the Marchesa was away in Rome, she explained, she and her husband took care of the palazzo.

She led Francesca and Laura a few paces down the street to the green door, moving with surprising speed and agility on her cane. They followed her into the entryway. In front of them a large courtyard with a few small lemon and fig trees lay open to the sky. In another era, it would have been a gracious setting, but now it had a dilapidated, untended look, with a pile of dead leaves blown into a corner, weeds sprouting here and there from cracks in the tiled floor. They stood in the entryway while the old woman went in search of the Marchesa. They could hear her high, raspy call—"Maria! Maria!"—fading down one of the corridors, and then silence.

"One old lady in search of another," Laura whispered to Francesca.

A few minutes later they heard voices coming toward them and the stumping of the old custodian's cane on the tiled floor. Then two women appeared side by side. To Francesca, they seemed to be about the same age, but they were a study in contrasts. The Marchesa was tall and thin, her carriage erect, and she wore a colorful spring dress, a bit out of style perhaps, but still elegant. Her face was long and narrow, her eyes deep blue, blond hair turning to gray, cut short and neatly coiffed. There was something about her appearance that put Francesca in mind of British aristocracy, of the way, Francesca imagined, that Agatha Christie might have looked. Except, of course, the Marchesa's ancestry was Roman as far back as anyone could trace.

The Marchesa greeted them politely but with reserve. Francesca felt a momentary impulse to curtsy. She introduced herself and Laura, and the Marchesa held out a frail, trembling hand. On closer encounter, the Marchesa showed her age. Her face

was deeply lined, and her lipstick, thickly and inexpertly applied, had smudged at the corners of her mouth and the margins of her narrow lips.

"So," said the Marchesa, "you have come to see the archive? Now, what is it that you are searching for? What is the subject?"

They explained—the origins of Caravaggio's painting of St. John, once owned by the Marchesa's ancestor Ciriaco Mattei. Francesca had already explained this to the Marchesa some weeks ago on the telephone, but she did not seem to remember.

"Well, since you are here," the Marchesa said, "I will let you enter. But in my opinion, it will be a waste of time. This German woman has already gone through everything. We have become friends. She has seen everything and done everything."

The Marchesa led the way to the archive, down a flight of stone stairs to the cellar. They entered a large rectangular room, dimly illuminated by the daylight that filtered through two rectangular windows high on the opposite wall. There was no glass in the windows; they were covered only by a rusted iron grating and opened directly at street level. The Marchesa turned on a light—a single bare bulb suspended from the high ceiling. At the center of the room there was a long wooden table, squarely placed under the light of the bare bulb. Several opened cardboard boxes sat on the table, along with a few large leatherbound volumes and folders containing loose sheets of paper. Many more boxes sat on the brick floor. Along the walls, the Marchesa had installed—recently, by the looks of it—gray metal shelves to hold the archives.

Francesca thought of the Doria Pamphili archive, with its

high ceilings, shaded lamps, and tiled floors. This place felt damp and smelled musty, the odor of decay.

The Marchesa lit a cigarette. She was, Francesca and Laura would soon learn, an inveterate smoker. For the last few years, she told them, she had occupied herself with reorganizing the archives according to a new scheme she had discussed with the German woman. "Un grande impegno"—"a big undertaking"— the Marchesa remarked, gazing at the hundreds of volumes and folios on the gray metal shelves.

She opened a small notebook and asked them to sign their names. "Now, what is it you are looking for?" she asked again. And again Francesca explained. They would start with the inventories of the 1600s, and then try to find the account books.

The Marchesa donned a long white cotton shift that buttoned up the middle, the sort of coat a doctor might wear, and a pair of cotton gloves. "To protect myself from the dust," she explained. Indeed, the room was dusty. In the weak shafts of sunlight from the small windows, Francesca could see motes of dust, and the table was covered with a fine grit blown in from the street.

Francesca's eyes went to the leather-bound volumes on the steel shelves. Most were identified with labels on their spines, the legacy of an archival organization created in the early nineteenth century, when the documents were still housed in the family palazzo in Rome. But that organization had been turned topsy-turvy with the transport of everything to Recanati. Francesca ran her hand along the books. She felt as if she were touching history.

The Marchesa directed them to a collection of inventories

from the early 1600s. Most of these were contained in bound volumes, but a few were simply loose, in boxes that opened much like books. The first inventory, from 1603, concerned the possessions of Girolamo, the second of the three Mattei brothers. He had been a cardinal, an able administrator who had directed the city's Department of Streets and then the Department of Prisons. Some scholars believed that he had been Caravaggio's patron, and not Ciriaco. But his inventory recorded only eighteen paintings at the time of his death at age fifty-six, and these were devotional images of little consequence. It was clear to Francesca and Laura that Cardinal Girolamo Mattei had little interest in art.

The second and third inventories, dated 1604 and 1613, belonged to Asdrubale, Ciriaco's younger brother. Both had been compiled during his lifetime, at Asdrubale's request, by his maggiordomo, who oversaw the operations of the palazzo. They were bound in leather and much lengthier than Girolamo's. Asdrubale had built his own palazzo, a grand and imposing edifice, next to that of his two brothers, and had spent a fortune furnishing and decorating it. The German scholar had already examined Asdrubale's inventories at great length. Francesca and Laura leafed through them quickly and put them aside.

It was the inventory of the oldest brother, Ciriaco, that they most wanted to see. He had died in 1614, at the age of seventy-two, an advanced age in that day. He had left his entire estate to his son, Giovanni Battista. But it wasn't until two years later, on December 4, 1616, that the son ordered an inventory of his own possessions and those he'd inherited from his father. The volume that contained this inventory was also bound; it ran some

one hundred and fifty pages, on heavy paper. It had the name "Giovan Battista Mattei" on the cover, but it had somehow escaped the old filing system by which the archive had been organized. Francesca and Laura realized that they were the first to lay hands on it in decades.

They sat at the table, shoulder to shoulder under the solitary lightbulb, and opened the book. It was organized by category—furniture, statuary, books, jewelry, rugs and tapestries, silverware, carriages and horses, property of every conceivable sort. The list of paintings began on page twenty-one. The handwriting, by a notary named Ludovico Carletti, was bold and clear, the ink as fresh-looking as if it had been applied a week ago. Laura moved her finger down the list of paintings, reading each aloud in a soft voice. The Marchesa sat at the far end of the long wooden table, smoking a cigarette and casting an inquisitive eye at the two young women.

At the bottom of the page, Laura's finger stopped. They read the line together: "A painting of San Gio. Battista with his lamb by the hand of Caravaggio, with a frame decorated in gold."

Francesca let out a small cry of delight. They had found it, the earliest mention of the painting to come to light.

They began whispering excitedly together. At the end of the table, the Marchesa looked up sharply. "What is going on?" she demanded. "What have you found?"

Francesca felt compelled, for some reason she herself could not explain, to diminish the importance of their discovery. "Oh," she replied to the Marchesa, "it is just a word in the inventory that we didn't understand."

"Ah," said the Marchesa, nodding her head. She puffed on a

cigarette and went back to her work. She had three files opened in front of her and shifted papers with her white-gloved hands from one file into another. Occasionally she made a comment. "I found something concerning the building of the palazzo," she said. "Is that something you are looking for?"

"No, it isn't," Francesca replied.

And the Marchesa said, in consternation, "I really don't understand what it is you are looking for. What is the subject?" Every half hour, it seemed, the Marchesa asked them the same question, and they gave the same answer.

Francesca watched the Marchesa out of the corner of her eye. The old lady picked up a yellowed card, an index of the documents contained in one file, studied it for a moment, and then ripped it in half.

"Interesting, this work of yours," Francesca said. "May I ask what is it you are doing exactly?"

The Marchesa explained that she was changing the archive from its old chronological system. She was more interested in the people in her family than in a simple chronology. Consequently, she was organizing the documents so that those pertaining to a particular person—Ciriaco, for example—would all be gathered in one place. "After this, it will be much easier to find everything," she said.

"Ah, I see," said Francesca.

Francesca and Laura talked in low voices between themselves. Watching the Marchesa at work, Laura whispered, was like watching someone clean house by throwing things out the window—plates and silverware, pots and pans—as if that were completely normal.

They went back to the inventory. Ciriaco Mattei had owned, according to the earliest sources, at least three paintings by Caravaggio, and perhaps more. On the next page, midway down, they saw Caravaggio's name again, this time for the painting called *La Presa di Giesu Cristo*—*The Taking of Christ*—the painting that had been missing for hundreds of years. Francesca and Laura had both seen photographs of the many copies of the painting, and they'd read articles by Roberto Longhi, who had been obsessed with finding it. The inventory described the picture as having a black frame decorated with gold, and a red drapery with silk cords that had been used to cover it.

They had been in the archive only two hours and they had already found two important entries concerning Caravaggio. They had conclusive proof now that Ciriaco had owned both the *St. John* and *The Taking of Christ*. If they achieved nothing else, they could consider their trip a success. But they hoped to trace both paintings back even further. The Mattei brothers had kept careful account of their expenditures. The German scholar Gerda Panofsky-Soergel had found Asdrubale's *libri dei conti*, account books, and had published hundreds of items dealing with the cost of constructing his new palazzo. And yet no one, it seemed, had ever looked through Ciriaco's account books.

They found three of Ciriaco's leather-bound account books, each about two hundred pages long, on the same shelf as the inventories. Written on the cover of the first book were the words "Rincontro di Cevole dal 1594 al 1604"—"Account of Expenses from 1594 to 1604." The second one, similarly labeled, covered the next seven years, up to 1612. The last one contained only two years of expenditures, the last two years of Ciriaco's life.

They opened the first account book. Every page, front and back, was densely covered with entries in black ink. The writing was small, but the hand was neat and orderly, and it was consistently the same hand throughout. On the far right of each page they saw a column of numbers, and at the bottom, under a heavy line, a total of that page's expenditures.

Ciriaco would have had a bookkeeper, a computista, to keep a record of daily expenses for running the palazzo, for the purchase of food and wine, for payments to merchants and employees. But this book did not contain these sorts of mundane entries. It appeared to record mostly works of art—statues, paintings, frescoes—as well as improvements Ciriaco had made to his palazzo and his garden.

It took Francesca and Laura time to decipher the handwriting. The entries were full of abbreviations, a sort of informal shorthand, and words spelled in the old manner, the English equivalent of reading Shakespeare. They noticed a distinctly personal phrasing in some of the entries—"thirty scudi paid on my behalf to Franco the sculptor for the price of a statue bought for my garden." It dawned on them that a bookkeeper hadn't kept this account, that Ciriaco himself must have written out these entries. To Francesca, they acquired a sudden and beguiling intimacy. She ran her finger across the handwriting, touching the ink on the page.

Ciriaco had been a diligent accountant. He had noted payments as small as eight scudi and as large as two thousand. In an era when it cost forty-five scudi to rent a house for a year in the Campo Marzio, he had spent astonishing sums—thousands of scudi every year—on his passion for art.

He could afford it. The Mattei fortune was built on vast agricultural holdings in the Roman countryside, on vineyards, olive groves, wheat fields, and especially cattle, and these had made the family fabulously rich. Ciriaco's ancestors had a talent for prospering even when times were bad. After the Spanish sacked Rome in 1527, when all was chaos and uncertainty and thousands of people fled the city, the Mattei clan bought up property at a fraction of its value. By the time of Ciriaco's birth, in 1542, the family was perhaps the richest in Rome, with a household staff to manage its affairs that numbered more than three hundred, second in size only to that of the papal court.

Francesca and Laura scanned quickly through the entries for the first years. The light coming in the small windows overhead faded to dusk, and their eyes burned with the effort of reading the tiny handwriting by the light of the single overhead bulb. The Marchesa, meanwhile, had grown more loquacious as the afternoon passed. Francesca, trying to be polite, turned her attention to the old woman while Laura continued to read. The Marchesa was smoking a cigarette and reminiscing, talking about her childhood in the palazzo in Rome, the elegant dinner parties and concerts, the tables set with the finest crystal and silver, the beautiful rooms with gilded ceilings and frescoes on the walls, the staff of twenty servants. It had all ended, the Marchesa recalled, her voice turning brittle, on a day in 1933, when she was twelve years old. Her mother told her one evening, just before her bedtime, that they would leave the palazzo the next day and move to an apartment on Via del Plebiscito, into a building owned by their friends the Doria Pamphili family.

A strange coincidence, thought Francesca, that the two fam-

ilies should be linked by friendship as well as the twin St. John paintings.

"Imagine," the Marchesa said to Francesca, "from one day to the next, without any warning, my life had changed completely."

Her family had brought with them only their clothes and a few personal items. All of the paintings, the statues, the furniture, the tapestries and rugs—everything that had belonged to the Mattei family for generations—all of that they left behind. Of course, at the age of twelve, she had not understood how this could have happened. Her parents spoke only vaguely of debts. It was only later that the Marchesa learned the details of how her father, Prince Guido, had gambled away everything in card games. He'd lost what remained of the family's patrimony in a final game with a count named Pierluigi Donini Ferretti.

The ruin of the family's fortune was not the fault of the Marchesa's father alone. The decline had begun much earlier, in the generations after Ciriaco's death, a common story of folly and indolence, of great wealth sapping the ambition and industry of those born into it. But it was also the consequence of events beyond the control of Ciriaco's descendants. Napoleon's army had swept through northern Italy in 1798 and occupied Rome. To pay for the army's keep, Napoleon's administrators had levied punitive taxes on the Roman nobility. The Mattei family had been forced to sell many of their possessions, among them the paintings by Caravaggio, Guido Reni, Antiveduto Grammatica, Lorenzo Lotto, Valentin de Boulogne, and Francesco Bassano. They'd had to borrow money at usurious rates, and then sell even more of their patrimony to pay the moneylenders. They had survived

that period, much diminished, up until the Marchesa's father started losing at the card table.

By the time the Marchesa had told her story, it was dark outside and the cellar had grown chilly. The Marchesa seemed dispirited. Francesca and Laura decided it was time to leave for the night. The Marchesa accompanied them up the stone steps to the front door. They asked her permission to return the next morning, and the Marchesa, looking sad and distracted, merely assented with a nod.

8

THAT EVENING, FRANCESCA AND LAURA ATE IN A RESTAURANT
next to the hotel, sitting before windows that looked out over
the countryside toward the Adriatic. They knew Correale would
be pleased with the citation of the *St. John* in Ciriaco's inventory.
Laura had a feeling that tomorrow they might find something
even better in the account books: the actual date and record of
payment. It was just a matter of time and persistence. It was a
good thing they had gotten to the archive now, Laura said. The
Marchesa was turning it upside down. No one would be able to
find a thing after she finished her work. And, besides, there was
always the risk that she might set the entire palazzo aflame. She
was so absentminded she might leave a smoldering cigarette in a
cellar full of old paper.

The Marchesa greeted them at the door the next morning, in
distinctly better spirits. She offered them coffee; she seemed to
want to chat, especially with Francesca, as if this were a social call.
Francesca felt inclined to humor her, but Laura said they really
should get to work on Ciriaco's account books. The Marchesa,

suddenly looking a bit out of sorts, accompanied them down to the cellar.

She fixed them with a stern look as she donned her white gloves. "Now, tell me," she said, "what is it exactly that you are looking for? What is the subject?"

They opened the account book to the place where Laura had left off the previous night, on the page that marked the start of the year 1600. It was at the end of that year, or perhaps in the spring of 1601—no one knew for certain—that Caravaggio left Del Monte's palazzo and took up residence with Ciriaco Mattei. The parting with Del Monte had been amicable. Caravaggio saw him again several times and relied on him when he got into trouble with the law.

In Ciriaco's household, as in Del Monte's, Caravaggio would have lived on the third floor of the palazzo. He would have had a room to himself, one large enough to use as a studio, rather than sharing cramped quarters with other servants. His circumstances had vastly improved. He lived under the protection of a powerful and wealthy patron, he received free room and board, and Ciriaco would have paid him the going rate for his paintings. Furthermore, Caravaggio was free to paint for others, not just for Ciriaco. By then, his fee was the highest of any painter in Rome. After the success of two public commissions, in the churches of Santa Maria del Popolo and San Luigi dei Francesi, his work was in great demand. He was twenty-eight years old, and the talk of Rome.

Francesca and Laura worked their way through the entries for 1600, but found nothing concerning Caravaggio. Laura grew momentarily excited when she found a reference to a "Mich'

Angelo pittore." But it was for work in the garden, and for only ten scudi. Caravaggio commanded much higher sums.

They went slowly and carefully through the year 1601, but again found nothing. By then, Caravaggio certainly was living in Ciriaco's palazzo. They each began to feel a sense of resignation, although they said nothing of it to each other, as the possibility grew that they might not come across anything more significant than they'd already found.

Francesca had gotten up from her chair when she heard Laura softly exclaim, "Ecco!"

The date was January 7, 1602, and Ciriaco had written in a clear, unmistakable hand the name "Michel Angelo da Caravaggio pittore." The payment was one hundred fifty scudi for the painting of—and here they had difficulty deciphering Ciriaco's handwriting. It seemed to say, "for the painting of N.S. in," and then two words that were unclear. One of them looked as if it began with a "p"—could it be "padrone," meaning master or owner? The "N.S." probably meant "Nostro Signore," a common reference to Christ.

The Marchesa, her attention attracted by their excitement, looked on with curiosity. "You've found something interesting?" she asked.

"Possibly," replied Francesca, "but there are some words we don't quite understand."

They each copied out the entry in their notebooks as precisely as they could, mimicking Ciriaco's handwriting for the words they couldn't decipher. The entry was four lines long, a record of payment to Caravaggio that no one had seen since the moment Ciriaco wrote it almost four centuries ago. Almost cer-

tainly it referred to the painting known as *The Supper at Emmaus,* which Baglione had seen in Ciriaco's palazzo. It now hung in London, in the National Gallery.

Two pages later—it took Francesca and Laura half an hour of reading to get there—they found another payment to Caravaggio. The date was June 26, 1602, and the sum was sixty scudi, but this time Ciriaco did not specify the reason for the payment. Could it have been for the *St. John?* Sixty scudi seemed a rather small sum for Caravaggio, but the *St. John,* after all, depicted just a single figure.

They worked quickly, skimming through the entries, occasionally sharing a glance with each other. Now they knew for certain that Ciriaco had been a diligent bookkeeper and that they would find the other payments to Caravaggio. Such a find was the grail for all art historians, the closest one could come to the past creation of a work of art.

The next payment came at the beginning of the year 1603, on January 2. And this time they understood immediately which painting Ciriaco had bought. One hundred and twenty-five scudi "for a painting with its frame of Christ taken in the garden."

"*La Presa di Cristo,*" murmured Francesca.

The Marchesa looked over with inquiring eyes.

"Another painting by Caravaggio," explained Francesca.

"Now, is that the one you're looking for?" asked the Marchesa.

"Not exactly," replied Francesca. "It's been lost for many years."

"Ah," said the Marchesa, narrowing her eyes. "What happened to it?"

"No one knows for certain. Several people have looked for it, but they haven't found it."

"Such a pity that we have lost everything," said the Marchesa in a dolorous voice.

Francesca and Laura had found three payments, and Baglione had written that Ciriaco had owned three paintings by Caravaggio. And perhaps Ciriaco had bought even more. Baglione said that Ciriaco had owned *The Incredulity of St. Thomas*—a painting now in the Bildergalerie in Potsdam, Germany—but they'd found no reference to it in any of the inventories. They pressed on. Several pages later they saw Caravaggio's name again, a payment of twenty-five scudi. A small sum, given the other payments, and a little mystifying. Ciriaco once again did not specify what he had paid Caravaggio for.

By now it was early afternoon. They had not taken a break for coffee or for lunch, but neither of them felt hungry. They read through another year of payments—1604—hoping to find more, but not expecting it. By that year, Caravaggio had left Ciriaco Mattei's palazzo. They went back to the first payment and slowly checked through the entries again to make sure they had overlooked nothing about the *St. John*.

Laura was not completely satisfied. She felt troubled at not having found a specific mention of the painting. Correale will not be happy, she told Francesca.

Francesca was not much concerned about Correale. They had found enough to set the world of Caravaggio scholars— those with the Caravaggio disease—into a frenzy. And the payment of sixty scudi without mention of a painting was, in all probability, for the *St. John*.

The archive was almost too good to leave, a trove of discoveries waiting to be made. But it was almost four o'clock in the afternoon and they decided to return to Rome with what they'd already discovered. They would have to come back, and that meant convincing the Marchesa, but Francesca sensed that the old woman liked her. And the Marchesa's trust in them seemed to have grown. She'd spent part of that day upstairs, apparently feeling it wasn't necessary to monitor them.

They were just about to leave when Francesca, holding Ciriaco's account book, paused for a moment. "I think we should hide it," she whispered to Laura. "There are three hundred other books the same size. If the Marchesa changes the number, it will take us hours to find it again."

The Marchesa had several piles of books on the table and on top of boxes on the floor, work that she'd already completed. Francesca slid the book into the bottom of one of those piles. The Marchesa had been working in the archive for years, and she'd made slow progress. Francesca figured there was a good chance those piles would remain untouched until she and Laura returned.

❧ 9 ❧

THEY ARRIVED BACK IN ROME AROUND MIDNIGHT. ON THE RIDE
home, they discussed what they should do with their findings.
They would, of course, call Correale tomorrow morning. Fran-
cesca suggested they also talk to Maurizio Calvesi, their pro-
fessor at the university. He had been head of the art history
department for many years and was just then finishing a book
on Caravaggio. Francesca thought he would want to have these
dates and records of payment.

Francesca's mind kept returning to the payment for *The Taking
of Christ*. She recalled sitting in the Bibliotheca Hertziana just be-
fore the trip to Recanati and reading in the art journal *Paragone* a
brief article by Roberto Longhi, only three pages long. It had at-
tracted her attention because Longhi had commented on Gerda
Panofsky-Soergel's research at the Mattei archive.

Francesca remembered the article clearly, partly because of
the disdain with which Longhi had treated the German scholar.
Age had not mellowed his acid temperament. It had irritated
him that Panofsky-Soergel had gotten access to an archive

which had been, he wrote, "long precluded to Italian scholars." It apparently further irritated him that she was a woman. He kept referring to her as the "kind lady," and the "illustrious woman," although he clearly meant neither. Worst of all, Longhi implied, Panofsky-Soergel had no idea what she was looking at, and she had compounded her ignorance by making no attempt to understand what she had uncovered.

Francesca recalled that Longhi had made a particularly interesting deduction from one of the documents that Panofsky-Soergel had found in the Mattei archive. The document was dated February 1, 1802, and it concerned the sale of six Mattei paintings to a rich Scotsman named William Hamilton Nisbet. The first painting on the list was called *The Imprisonment of Christ,* and it was attributed to one "Gherardo della Notte"—Gerard of the Night. Longhi recognized this as the Roman nickname of Gerard van Honthorst, a Dutch artist who had come to Rome in 1612, two years after Caravaggio's death. Honthorst had stayed in Rome for eight years, earning a living by imitating the style— a shadowy scene illuminated by a single light—that Caravaggio had made famous.

The attribution of this painting to Honthorst had struck Longhi as curious. For one thing, he knew of no Honthorst painting of that subject, and he had a vast and encyclopedic memory for art. But Caravaggio, wrote Longhi, had painted just such a work for Ciriaco Mattei. Longhi had never seen the original—the painting, he pointed out, had been lost long ago. But he knew it almost as well as if he had seen it. He'd read a detailed description of the painting written in 1672 by an art critic named Giovan Pietro Bellori. A description so lucid, so precise,

Longhi wrote, "that it would enable me to recognize the painting at first sight, were fortune to allow me to encounter it."

Pietro Bellori had seen Caravaggio's original more than three centuries earlier, in the Mattei palazzo. "Judas lays his hand on the shoulder of the Lord after the kiss," Bellori had written, "and a soldier in full armor extends his arm and his ironclad hand to the chest of the Lord who stands patiently and humbly with his arms crossed before him; behind, St. John is seen fleeing with outstretched arms." Bellori had criticized Caravaggio for his "excessive naturalism," yet he had admired the realistic touches in this painting: "Caravaggio even imitated the rust on the armor of the soldier whose head is covered by a helmet so that only his profile can be seen; behind him, a lantern is raised and one can distinguish two more heads of armed men."

Longhi had read that description while just a boy and it had stayed vividly in his mind ever since. He had recognized a copy of the painting—"weak and lifeless," he called it—at the shop of a dealer in antiques named Tass in London, on Brompton Road. That was in the 1930s, when Longhi had been forty years old. Since then he had come across several other copies, but even the best of them did not possess the spark, the vitality, that he knew he would see when he finally came across the original. Back then, he expected it would turn up in his lifetime.

Francesca imagined Longhi reading Gerda Panofsky-Soergel's article. He had written his critique of her in 1969, when he was seventy-nine years old, and he had died the next year. From everything Francesca had heard about him, he had been a thoroughly unpleasant man, given to grudges and malicious comments about colleagues. But he was a brilliant scholar. In his

later years, thought Francesca, he'd probably given up hope of finding Caravaggio's original picture. And then, by chance, he had come across that single line about the sale of a painting by Honthorst to a Scotsman. His pulse must have quickened. Was it not possible, Longhi speculated in his critique of Panofsky-Soergel, that the painting had been mislabeled? And that the Scotsman, Hamilton Nisbet, had actually purchased the lost painting by Caravaggio? In which case, Longhi surmised, the original *Taking of Christ* was likely somewhere in the British Isles, possibly still in the unwitting possession of Hamilton Nisbet's descendants, or perhaps hanging in obscurity in some small parish church.

To Francesca, this inspired deduction was a perfect illustration of Longhi's genius as an art historian. From the smallest of clues—one line in a two-hundred-year-old document—he had started to unravel, without moving from his chair, the mystery of a missing Caravaggio.

Or so it seemed. Twenty years had passed since Longhi had written that brief article, and no one had found the painting yet. It was possible, thought Francesca, that Longhi had been wrong, that Hamilton Nisbet had bought some other painting, not the one by Caravaggio. But Longhi clearly hadn't thought so. And, of course, he'd found fault with Panofsky-Soergel for not having made the same deduction.

IN ROME THE NEXT MORNING, LAURA CALLED CORREALE AND TOLD him they'd had some success in Recanati.

"Lauretta cara!" he exclaimed over the telephone. "Tell me all about it."

Laura gave him a report of the payments to Caravaggio. Correale wanted to arrange a meeting at his apartment that evening so they could inform Rosalia Varoli-Piazza, the art historian working on the project, of their findings.

At home, Francesca prepared herself to call Professor Calvesi at his office at the University of Rome. She felt shy about calling him. He was a renowned and widely published scholar, regarded in his world with respect and, as with all people who wield influence and power, with fear. Among students, he comported himself with an icy detachment that warned against intrusion. He was Francesca's thesis adviser—in name, at least. She'd met him face-to-face only a few times, always briefly, and always in the company of others. On one of those occasions she'd had to seek his approval for the subject of her undergraduate thesis. A younger professor had escorted her into Calvesi's office, where Francesca had stammered out a few words, heart beating in her throat. Calvesi had approved her project with a perfunctory nod. Later, when they passed each other in the hall and she smiled at him, his look told her that he could not quite place her.

Francesca rehearsed a brief account of the Recanati payments, took a few deep breaths, and dialed the number. The telephone rang in his office for two minutes, but no one responded. She looked up his home number, dialed again, and this time got an answering machine. But as she began to leave a message, a series of beeps cut her off. Either the machine was full or it was broken. That afternoon, she tried again, with the same result.

Later that day she met Laura at the library in the Piazza

Venezia. Laura suggested they check on the prices Caravaggio had been paid for other paintings, to see how they corresponded to Ciriaco's payments. They looked up a contract Caravaggio had signed on September 24, 1600—a contract found by Denis Mahon in the Archivio di Stato—in which Caravaggio agreed to paint two pictures for a wealthy Vatican official in a chapel in the church of Santa Maria del Popolo. The patron, one Tiberio Cerasi, had stipulated a painting depicting the martyrdom of St. Peter and another of the conversion of Paul. The contract called for Caravaggio to deliver the paintings within eight months for a payment of four hundred scudi for both pictures. Each measured about ten palmi by six, or seven feet by five and a half.

This seemed to accord with the one hundred twenty-five scudi that Ciriaco had paid for *The Taking of Christ,* and the one hundred fifty scudi for *The Supper at Emmaus.* The price of a painting was often based on its size, and both Mattei paintings, measuring around eight palmi by six, were smaller than the ones in Santa Maria del Popolo.

The *St. John* owned by Ciriaco was the smallest of the three, and it depicted just a single figure. To Francesca and Laura, it seemed reasonable to infer that Ciriaco's payment of sixty scudi for an unspecified work might have been for the *St. John.* Perhaps even the second payment of twenty-five scudi was also for that painting.

⊰ IO ⊱

CORREALE GREETED FRANCESCA AND LAURA AT THE DOOR OF HIS apartment on Via Fracassini with open arms and a big smile.

"My dear girls!" he exclaimed. "You've found something important for me! I want to hear all about it."

The living room of Correale's apartment had now become a library dedicated to Caravaggio. Books and articles on the painter covered every surface. The smoke from Correale's cigars already hung thickly in the air. Both the art historian Rosalia Varoli and Paola Sannucci, the restorer, awaited the report from Recanati.

Correale wanted to know all the details about the archive and the Marchesa. Francesca and Laura took turns telling him, and he laughed and clapped his hands and swore delightedly. Rosalia Varoli understood immediately the importance of the payments and the dates. These findings, she said, would create a huge stir in the art world. For years scholars had been debating and disagreeing about the precise dates of Caravaggio's early paintings, and now they had indisputable evidence for at least two of them, *The Taking of Christ* and *The Supper at Emmaus*.

Correale, however, grew a little perturbed. "So, then," he said, "there was no specific payment for the *St. John?*"

"We couldn't find anything in Ciriaco's account book," said Laura.

"Are you certain?" asked Correale. "Could you have missed it?"

"Well, it's possible, but I don't think we did. We looked carefully."

"But in this basement with such terrible lighting! And you were there for such a short time!"

"We need to go back. There are many other things to look at, but we wanted to show you what we'd found as soon as possible."

"Of course, of course!" exclaimed Correale. "You did an excellent job, but we have to check again to make certain."

They discussed the two payments of sixty and twenty-five scudi that Ciriaco had made to Caravaggio without specifying the reason. Rosalia Varoli speculated that one of the sums—the twenty-five scudi—might have been for the *St. John,* and the sixty scudi for another unknown painting, perhaps *The Incredulity of St. Thomas,* which Baglione claimed that Ciriaco had owned. Correale acknowledged this possibility. A pity that history could not be more precise. He would have preferred to have an explicit citation for the *St. John.*

But he was only mildly disappointed, and he quickly got over it. The discoveries in the Recanati archive, he understood, had become the most important aspect of his *St. John* project. "Che colpo tremendo!" he exclaimed at the end of the evening, beaming at the two young women. "I didn't expect that you would find something this important."

And then Correale said, "Of course, we must keep this ab-

solutely secret. No one else must know about it until the exhibition. It will come as a revelation!"

Both Francesca and Laura thought at that instant about Professor Calvesi. They hadn't yet spoken to Calvesi, and neither was about to mention just then their efforts to contact the professor.

After they left Correale's apartment that night, they discussed the dilemma.

"I still think we ought to tell Calvesi," said Francesca.

"Correale will be furious if he finds out," replied Laura.

"But Calvesi is our professor; we owe it to him. And he's writing his book about Caravaggio—he should have this information. Correale will see that we had an obligation." Francesca paused for a moment, and then added: "I don't think Correale will be that angry."

"I think he will."

II

FRANCESCA MADE ANOTHER ATTEMPT TO GET IN TOUCH WITH
Calvesi. She called his house, and this time the message machine
worked. She spoke to the machine, trying to keep her message
brief. The moment she uttered Caravaggio's name in connec-
tion with the Recanati payments, she heard the phone at the
other end being picked up and Calvesi's voice.

"Payments to Caravaggio?" Calvesi said.

"Yes," replied Francesca. "I thought you'd want to know."

"Who is this, please?" Calvesi asked her.

Francesca explained: one of his graduate students.

"Ah, yes, Francesca! Of course," said Calvesi. "Certainly I
want to know about this. You must come over as soon as possi-
ble. This afternoon?"

Francesca and Laura met in the Campo dei Fiori half an
hour before their appointment with Calvesi. He lived nearby, on
the Via dei Pettinari, an ancient narrow street that dated back to
the days of the Roman empire. They both felt nervous about

seeing the professor. They calmed themselves by eating gelato and rehearsing their presentation.

At the door, Calvesi greeted them with a brief smile and re-membered both of their names. He was in his early sixties, white hair neatly trimmed, dressed in a cardigan and corduroy pants. At the university he always wore professorial tweeds and carried himself with an air of stern preoccupation. But now, at the door to his house, he seemed to Francesca much less forbidding, per-haps even a little self-conscious.

He led them into his apartment. They would talk in his li-brary, he told them. They followed him through a series of rooms, spacious and well-appointed, with subdued lighting, Oriental rugs, and an abundance of art, almost all of it contem-porary paintings and sculptures. He and his wife had lived in this apartment for more than thirty years, he told them. The library was large, two stories in height, with a modern wooden staircase that went up to a mezzanine. The shelves extended from floor to ceiling, all neatly ordered, a collection of tens of thousands of books and journals that the professor had amassed in his long career as an art historian.

Calvesi was not given to small talk, and this made him seem aloof. In her anxiety, Francesca tended to talk, making com-ments about his collection of art, about the library—stupidly, she thought later, as if she were chattering at a cocktail party, as if she were playing the role, as a boyfriend had once accused her, of the dumb blonde, although she was neither blond nor dumb. For her part, Laura adopted a strategy of respectful silence.

In the library, Calvesi sat in a large leather chair and di-rected the two young women to the couch. He crossed his arms

and cleared his throat. At that moment, Francesca realized—
she couldn't say exactly what it was that brought her to this
realization—that Calvesi was not deliberately aloof, but rather
shy. Perhaps it was the way he'd cleared his throat, or the move-
ment of his eyes, which never quite met hers. It shocked her mo-
mentarily to think that a man of his stature, of his achievements,
could actually be shy.

They told him briefly about Correale's *St. John* project and
how that had led them to the Recanati archive. Calvesi listened
attentively, nodding now and then, and when they described the
account books of Ciriaco, Francesca could see his interest
sharpen. He made no interruption, but leaned forward in his
chair. They brought out their notes to show him the entries they
had copied, and he took them in hand and studied them carefully.

"This," he said slowly, "is a very important discovery. It puts
everything about these years of Caravaggio into focus. Now we
have a chronology that is indisputable."

As he talked about the significance of the entries and the
dates, he stood and began pacing, growing flushed and more ex-
cited than Francesca had ever seen him. He was in the grip,
thought Francesca, of the Caravaggio disease. She and Laura
were smiling broadly, happy that they had made their professor so
happy.

Calvesi told them he was in the final stages of correcting the
page proofs of his book about Caravaggio, called *Le realtà del Ca-
ravaggio*. It was too late, he said, to insert this information in the
body of the text, but he wanted to mention it in the introduc-
tion. Of course, he would give them full credit for the discovery.

And then he said they must publish these findings, the pay-

ments and the dates, in a responsible journal such as *Storia dell'Arte* as soon as possible.

Laura said, "Well, Correale has asked us to keep it secret until the *St. John* exhibition."

Calvesi shook his head. "If other people know about this, there will be talk, rumors. It's inevitable. Once you find something like this, it is impossible to keep quiet. Someone else might publish it first and take the credit. It has happened to me before."

They resisted, but not for long. Calvesi convinced them it was not just in their own interests, but in the interest of art history. "Correale should not ask such a thing of you. It is too important for him to keep for his own purposes."

By the end of the meeting, Calvesi had helped them decide on a strategy. They would publish first in a monthly art journal, *Art e Dossier,* a brief article dealing only with the two named paintings, *The Taking of Christ* and *The Supper at Emmaus.* They wouldn't mention the *St. John,* which was Correale's primary interest. After the exhibition, they would work on a longer, more thorough essay for *Storia dell'Arte,* which came out only four times a year.

Calvesi walked them to the door and congratulated them warmly. They promised to keep in touch with him and to inform him of any new discoveries when they returned to the Recanati archive.

They left Calvesi's apartment and walked together down Via dei Pettinari to the Tiber River, to the Ponte Sisto. It was dusk in Rome. Overhead the swallows of spring circled and pirouetted high in the sky and the last rays of the sun bathed the church

domes of the city in a golden light. They both felt excited by Calvesi's reaction. In the small and insular world that mattered to art historians, they really had achieved something. Neither of them felt like telling Correale that they had talked to Professor Calvesi. They would delay that moment of reckoning until it was absolutely unavoidable.

⚔ 12 ⚔

Francesca arrived at the Doria Pamphili palazzo on a Monday morning in late April, a day when the picture gallery was closed to the public. Correale had arranged for the technical examination of the Doria *St. John* on that day, and he wanted all of his staff present. Two weeks earlier he had subjected the Capitoline painting, the presumed original by Caravaggio, to its examination. Francesca and Laura had been in Recanati and had missed that event. Francesca hadn't minded. She didn't find the scientific side of art history—paint analysis and X rays—very interesting.

By the time she walked in, the Doria painting had already been taken down from its customary place and moved to a table in a large room just off the main gallery. The windows in the room were shuttered, the corners in shadow. A weak light came from the chandelier overhead. Technicians wearing white lab coats brought in various pieces of equipment, including a portable X-ray machine and a device the size of a handheld video camera that would scan the painting with infrared light.

They set up powerful lamps on portable metal stands around the table. All in all, the scene looked like a makeshift operating room.

Correale, dressed for the occasion in coat and tie, moved about briskly and with an air of authority, smoking his small cigars and issuing a steady stream of commentary and observations as he watched the technicians prepare their equipment. Paola Sannucci, the restorer working for Correale, was examining the painting through a large magnifying lens on a metal stand. Correale would pause now and then in his officiating to peer through the magnifying lens. After watching the examination of the Capitoline painting, he had acquired enough knowledge of the scientific jargon to sound like an expert even though without the real experts, the technicians, he would have been lost.

The Doria painting had been shorn of its frame. It lay on a soft white cloth draped over a table. To Francesca, it had the aspect of a creature of advanced age and in grave health. At this angle, the paint surface seemed lusterless and appeared worn. The tacking edges of the painting, where the raw, unpainted canvas was nailed to the stout wooden stretcher, were concealed by strips of dark wood, apparently applied long ago to ensure a tight fit within the frame. The original canvas, whether by Caravaggio or not, was almost four hundred years old, and the fabric itself was not readily visible, even from the back of the painting. Age and the effects of gravity would have caused it to sag on the stretcher, distorting the surface of the picture. To remedy this, a second, newer canvas had been glued to the back of the original—a process called relining—during a restoration performed thirty years ago.

Close up, Francesca could see the damage caused by time. Over its entire surface the picture had lost many tiny particles of paint, mere pinpricks—puntinature, Paola Sannucci called them—not discernible from a normal viewing distance. These particles had fallen at nearly regular intervals, at the intersections where the threads of the canvas, the warp and the weft, crossed each other and formed small nodules. The canvas had been cheap, made of poor-quality hemp and carelessly woven. Still, Caravaggio might have used just such a canvas. He had once painted a picture on a bedsheet. Another time, after he'd left the Mattei palazzo and was living alone in a small house off the Via della Scrofa, he had spread a half-finished canvas on a kitchen table and dined off the back of it.

The earlier examination of the Capitoline *St. John* had revealed it to be in much better shape than the Doria, in large part because the Capitoline canvas was of higher quality, more tightly woven with linen threads of uniform diameter.

The technical examination lasted the entire day, and for long periods Francesca and Laura had nothing to do but observe. The portable X-ray machine could capture only a small portion of the painting, and the technicians had to keep repositioning the machine, sixteen times in all, to get a composite of the entire picture. Francesca wandered in and out of the room and tried to dream up an excuse for leaving early.

Correale had a particular interest—an obsession, one could call it—with finding incised lines in Caravaggio's paintings. Few other Baroque painters had made these types of lines, scored with the butt end of a brush into the wet undercoat, and no one had made them in quite the same way as Caravaggio. He painted

from life, from models sitting before him, and most art historians believed that he didn't make preliminary drawings. In this, he had departed from a long-established tradition by which painters made detailed studies before applying brush to canvas. The scored lines, it was surmised, had served as a guide for positioning his models. In the finished paintings, the lines were sometimes visible to the naked eye, usually at a certain angle, in a raking light. Not every one of his paintings revealed signs of these marks. But to Caravaggio experts, their presence was almost as good as the artist's signature.

Two weeks earlier, during the examination of the Capitoline *St. John,* Correale had hoped to find incised lines, and thus add to the proof that it was Caravaggio's original. He and Paola Sannucci and the technicians had scrutinized every inch of the painting, but in the end they had not found a scoring mark. True, there were a few faint ridges on the borders of the boy's figure, and for a while Correale maintained that these *could* be scoring marks, but everyone else interpreted them merely as brushstrokes in wet paint, places where Caravaggio had defined the boy's flesh against the dark background.

But evidence of a different kind had emerged from beneath the surface of the Capitoline version, and it seemed to confirm the painting's authenticity. The X rays and the infrared images had revealed a ghostly image—a pentimento—at the precise point where the boy's arm and the curved horn of the ram intersected. The artist had painted the arm first, and then had painted the ram's horn over the finished arm. This constituted a clear sign that the painting was the authentic one. A copyist, following the outlines of an original painting, would not have

bothered to paint the arm and then paint the horn over it. The infrared images also revealed other pentimenti, in the folds and drapery of the red and white cloths, and in the foliage in the dark background. These were false starts and adjustments that no copyist would have needed to make.

So Correale had come to accept the Capitoline as the original even before the technical examination of the Doria version. All the same, the paintings were so strikingly similar—the outline of one placed atop the other matched in almost every contour—that it seemed necessary to examine the Doria picture as fully as the Capitoline. But how, Correale wondered, could anyone make such a near perfect copy?

This question interested Francesca, too. She thought of all the copies Roberto Longhi had found of the lost *Taking of Christ*. None of them had been good enough for Longhi to mistake for the original. Yet the Doria *St. John* had fooled him completely.

Paola Sannucci offered an answer, based on a technique described in a seventeenth-century manual on painting. A copyist, she explained, would take a piece of paper large enough to cover the original painting, and grease it well with walnut oil, which would make it translucent. The copyist would lay the greased paper on top of the original and trace the outlines with charcoal or a soft pencil. Once he had a complete tracing, he would lightly sprinkle the reverse side of the greased paper with charcoal or some other black powder, and place the paper on a fresh canvas already primed with the ground. He would then go over the traced outlines with a stylus and transfer them precisely to the new canvas. Then, of course, he had to possess the talent to replicate Caravaggio's colors, the sense of volume and the play of

light, a task more difficult than the mechanical act of tracing contours.

Obviously the Doria copyist would have needed both skill and unfettered access to the original painting, and this would have meant seeking the approval of Ciriaco Mattei. Francesca wondered whether the Recanati archives might contain some document, or perhaps just a notation buried among the thousands of entries, authorizing the making of a copy. It was possible that Ciriaco had commissioned the copy himself, as a gift to a powerful friend such as Cardinal Savelli's father, who might have admired the original. One more thing, thought Francesca, to search for when she and Laura returned to Recanati.

It was mid-afternoon when Francesca finally invented an appointment and got away from the Doria Pamphili. By then, the technical work was drawing to a close. Some items, such as a chemical analysis of the paint, would require laboratory work and specialized equipment. Whether Caravaggio himself had copied his own painting remained unresolved, a matter still left to speculation. If the paint proved to be the same used by Caravaggio in the Capitoline *St. John,* it would support that hypothesis. But by now, none of the investigators still believed that Caravaggio had touched this canvas, or even seen it. He had only made two known copies of his own paintings, and neither was a literal and precise copy, as this one was. It seemed unlikely that an artist of his skills and temperament, who had plenty of commissions, would spend time laboriously making an exact copy of his own work.

13

FRANCESCA AND LAURA BEGAN MAKING PLANS FOR ANOTHER TRIP to Recanati. They had a long list of items to look for, and they expected to spend several more days in the basement archive. That depended, of course, on the Marchesa's good graces. It fell to Francesca to make the telephone call and ask permission for another visit.

The Marchesa seemed pleased to hear from her. Francesca spent the first twenty minutes asking after the Marchesa's health, the state of her garden, her nieces and nephews. Finally she brought up the subject of the archive. Had the Marchesa made progress in her new system of ordering the past? Ah, not much, the old lady replied, family matters had occupied her. Would the Marchesa mind terribly if Francesca came for another visit to the archive?

"Oh, you may come and look around," replied the Marchesa. "Now, tell me," she added, "what is it you're looking for?"

They started the trip on a Monday morning in June. Laura drove her own car this time, an old Fiat Uno, which climbed the Apennines only slightly faster than the one Francesca had borrowed from her sister. By late afternoon, they had checked in to the Hotel La Ginestra, the same room as before, with two small beds. Notebooks in hand, they set out for the Mattei palazzo.

A young woman in her thirties answered the door. In the background Francesca and Laura could hear the voices of children. A moment later the Marchesa appeared, in a long summer dress, red lipstick still smudged at the corners of her mouth. She held out a fluttering hand in greeting and introduced Francesca and Laura to her daughter-in-law. The family had come from Rome for a stay in the country, and the Marchesa, smiling and in good humor, was clearly delighted to have her relations around her.

She led Francesca and Laura down the stone steps to the archive. It appeared unchanged from the time they'd last seen it a month before. The same bare bulb and stale, damp fungal odor of stone and earth, the same opened boxes of documents and stacks of volumes on the floor, the same piles of folders and books on the table. An ashtray full of the Marchesa's cigarette butts, each with the crimson mark of her lipstick, lay on the table where Francesca last remembered it.

The Marchesa donned her white coat and cotton gloves and took her customary seat at the head of the table. While she opened folders and held up old documents to scrutinize them, Francesca went over to the stack of volumes piled on top of a box on the floor, in the corner of the archive, where she'd hidden Ciriaco's account book. It was still there, untouched.

They began where they'd left off, going through Ciriaco's account book to see whether they had missed an entry concerning the *St. John*. By the end of the day, they concluded that they had overlooked nothing. Correale would have to content himself with the record of two smaller payments that Ciriaco had made to Caravaggio for unspecified works. Clearly at least one of those payments must have been for the Capitoline *St. John*.

Their research for Correale was nearly complete. The painting's voyage across nearly four centuries of time was documented thoroughly enough to satisfy almost any art historian. The *St. John* had remained in the Mattei family for only twenty-two years, until 1624, before passing on to other hands. The rest of the archive would contain nothing more about the painting.

Even so, Francesca and Laura had no thought of leaving Recanati. They knew that they were at the doorstep of an even more intriguing narrative—the story of the lost painting by Caravaggio. Had the Scotsman Hamilton Nisbet really bought the original *Taking of Christ,* as Longhi had speculated? And if so, how had the painting come to be attributed to a minor Dutch painter named Honthorst? The archive might reveal the answer to that.

They spent the end of the day gathering together all the family's inventories and account books from among the hundreds of volumes. They cleared a place on the table and arranged them chronologically, always under the curious eye of the Marchesa. That night they ate dinner at the same small restaurant near the hotel, this time on a terrace looking out toward the Adriatic, a soft summer breeze coming from the sea. Afterward they walked around the town, joining residents and the few tourists in the

evening passeggiata—the promenade—traditional in small cities all over Italy.

<center>⚜</center>

THE NEXT MORNING, DOWN IN THE CELLAR WITH THE MARCHESA, they started going through more inventories. They knew the earliest ones quite well now, up to the death of Ciriaco's son, Giovanni Battista, in 1624.

Of the paintings Caravaggio had made for Ciriaco Mattei, *The Taking of Christ* had remained longest with the family. Ciriaco had given *The Supper at Emmaus,* probably in exchange for a favor, to his powerful friend Scipione Borghese, an avid art collector and also nephew to the Pope. And in his will, Giovanni Battista had left the *St. John* to Caravaggio's first patron, Cardinal Del Monte. But Giovanni Battista had specified that his cousin Paolo, the son of Asdrubale, should receive *The Taking of Christ.*

Francesca and Laura came across their first surprise late that morning, in an inventory of 1676. Along with *The Taking of Christ,* duly noted as by the hand of Caravaggio, they saw, several pages further on, an entry that read "Copia della presa di Giesu nell'orto del Caravaggio": "Copy of *The Taking of Christ in the Garden* by Caravaggio." The entry supplied no other details about the copy, no measurements, no description of the frame.

The next inventory, some fifty years later, cited the original by Caravaggio, and also the copy, this time as "by a disciple" of Caravaggio.

A day later they stumbled across more information about the copy, in the account books of Asdrubale, Ciriaco's younger

brother: a payment of twelve scudi made in September 1626 to one Giovanni di Attili, a painter. The entry explicitly stated that Attili was being paid to make a copy of Caravaggio's *Taking of Christ*. Asdrubale must have greatly admired the painting. He'd had the copy made soon after the death of his nephew Giovanni Battista. Perhaps he had been disappointed not to have the original, to see it go to his son instead of himself.

Neither Francesca nor Laura had ever heard of Giovanni di Attili. He was a painter unknown to history, his life and death a mystery. But as a copyist he must have had the necessary skill to get the commission from Asdrubale. Perhaps he had also been commissioned to make the Doria Pamphili copy of the *St. John.* It would please Correale to find such a citation and clear up the murky origins of that painting.

Caravaggio was one of the most copied of all painters, and *The Taking of Christ* was, as Roberto Longhi had discovered, one of the most frequently copied works. Most were of low quality, like the one Longhi had found in London in the 1930s. But one very good version had surfaced in Odessa, in the Ukraine. A Soviet art historian had published photographs of that painting more than thirty years earlier, back in 1956, advancing it as the original. A Russian count had acquired it in Paris sometime before 1870, but its earlier history was largely unknown. Longhi and other Caravaggio experts had studied the photographs. All had agreed that it was a very good painting. A few had even embraced it as the original. But without inspecting it "nose to the canvas," as Denis Mahon would say, most Caravaggio scholars were not willing to make a definitive judgment one way or the other. And it was difficult to inspect close up. The trip was long

and complicated, requiring visa negotiations with the Soviet authorities and then several connecting flights to Odessa.

Longhi, for one, had remained unconvinced by the Odessa version. He believed until his death that the original was probably somewhere in Scotland, masquerading as a Honthorst. If that was true, and the Odessa version really was just a very good copy, good enough to give some experts pause, then it might be the work of Giovanni di Attili. Like the copyist of the Doria *St. John,* Di Attili had enjoyed unfettered access to the original.

※

LAURA AND FRANCESCA WORKED IN THE DARK ARCHIVE FOR three days, glimpsing the summer sun from the small grated windows above their heads. The Marchesa kept them company, and when she grew weary, she would summon the elderly housekeeper who always wore two heavy sweaters even on the warmest days. Sometimes the Marchesa would send down her daughter-in-law, who would chat with them and leaf in desultory fashion through one of the volumes.

By the third day Francesca began to yearn for the sun. She felt she had grown pale and sickly-looking after so much time in the clammy cellar. She had plans to attend the wedding of a friend in Rome the following week and she knew that a young man she'd met the previous fall would also be there. She'd had a brief fling with him. She didn't want to have another, but all the same, for reasons of vanity, she thought a few hours at the beach, under the Adriatic sun, would make her look better.

She tried to convince Laura to go with her. Laura wasn't in-

terested in the beach. Francesca explained her ulterior motive and the young man.

Laura said, "I thought you and Luciano were together."

Luciano was a boy Francesca had known since her first year in high school, when they were both fourteen years old. Laura had never met Luciano, but she'd heard Francesca talk about him. He was in England, studying philosophy at Oxford. The previous year, Francesca had spent time with him in London, when she'd had a two-month grant to study at the Warburg Institute. They'd had a romance, which had grown complicated because Francesca didn't take it seriously, but Luciano did.

"Everyone seems to think we're together," replied Francesca. "But it's not really so. He's more of a really good friend."

"Oh," said Laura. "I thought it was more than that."

Laura still wouldn't go to the beach. But they did agree to take some time off and visit the town of Loreto, a few miles away, to see the famous basilica. It was said that Caravaggio had gone there once. He had later painted a picture of the Madonna of Loreto for a chapel in the church of Sant'Agostino near the Piazza Navona. Baglione and others had criticized it as lacking in decorum because it depicted the dirty feet of the pilgrims kneeling in front of Mary.

⚮

THEY FOLLOWED *THE TAKING OF CHRIST* THROUGH ONE INVENtory after another. The language varied slightly—in some places the painting was called *The Taking of Christ in the Garden,* in others *The Capture of Christ,* and in yet another *Christ Betrayed by Judas*—

but it was always attributed to Caravaggio. Most entries also mentioned its size—eight palmi by six—and its black frame decorated with gold filigree.

The first alteration in this description came in 1753, when the painting was recorded as measuring only six palmi by seven. By then, the *Taking* had been moved twice to new locations in the palazzo. Possibly the inventorist had made a mistake in the measurement. Or perhaps the picture had been cut down slightly to fit its new quarters.

Near the end of the 1753 inventory, they found an entry for a "large painting" called *The Betrayal by Judas*. It hung upstairs, in a room in the family's private apartments. Was this the copy by Giovanni di Attili? It seemed so, but there was no way for Francesca and Laura to know for certain, since the entry contained no other details and no measurements, merely a valuation of less than two scudi.

It is in the nature of such inventories, performed over two centuries and by different hands, to vary in style and detail. For the most part, however, each new Mattei inventorist appeared to have consulted the work of his predecessors. But when Francesca and Laura began examining the inventory of 1793, they found themselves confronted with a new and completely strange landscape, a collection that bore only a faint resemblance to the Mattei galleries. It was here that they saw the attribution for *The Taking of Christ* suddenly change, after almost two hundred years, from Caravaggio to Gherardo della Notte. Moreover, the painting was said to measure "6 palmi riquad.ti"—it was now recorded as square instead of rectangular.

The particulars of the Caravaggio painting—if, indeed, it

was still the same painting by Caravaggio—were not the only details scrambled in this inventory. Many other works had new attributions, new measurements, different titles. It was a tossed salad of an inventory, jumbled and confused, and utterly untrustworthy.

Before long, Francesca and Laura discovered how this had happened. In the archive, they came across a guidebook called *An Instructive Itinerary of Rome,* published seven years before the 1793 inventory. Written by one Giuseppe Vasi, it was replete with errors, the same sorts of errors that later infected the inventory, among them the attribution of *The Taking of Christ* to Honthorst. The family was in decline. The inventorist they hired was either incompetent or lazy. He had clearly relied on Vasi's guidebook alone, perpetuating one confusion after another.

Another guidebook of that era, by a German named Von Ramdohr, took note of the mistaken attribution to Honthorst. Von Ramdohr had no doubts about who had painted the picture. "Judas betrays Christ with his kiss, by Caravaggio," wrote Von Ramdohr, adding, "Others say it is by Honthorst, which is less likely."

So Longhi's intuition appeared to have been correct. The Scotsman Hamilton Nisbet had bought Caravaggio's *Taking of Christ,* believing it was by Honthorst. But what had happened to the copy, which had disappeared from the records? In an inventory so confused, could the original have been mistaken for the copy? There was simply no way to tell.

Francesca and Laura spent another full day in the archives, wading through more inventories and account books. Each no-

ticed that the other had dark circles under her eyes from the poor light and eyestrain. Their hands felt cramped from hours of copying entries into their notebooks, their backs ached from bending over the old volumes.

They left Recanati on the afternoon of the fourth day, their notebooks full. In Rome the next evening, they went together to see Correale. He had a new task for them. The exhibition catalogue would contain several essays on the history, iconography, and technical investigations of the two *St. John* paintings. Correale had planned at first to incorporate their findings into the essay by Rosalia Varoli-Piazza on the paintings' histories. But now, with the smile of someone bestowing an award, he told them that they should write a separate essay on the archive and their findings.

This pleased Francesca and Laura. They had made the discoveries, and they deserved the credit for them, not just a footnote in someone else's article. But they had already made a commitment to write a short article for *Art e Dossier*. They had not yet told Correale about that.

❧ 14 ❧

THE REST OF THE SUMMER PASSED QUICKLY. FRANCESCA ATTENDED her friend's wedding and saw the young man she knew at the reception. They smiled and flirted, which was all she had wanted. She and Laura divided up the task of writing the essay for Correale. Each worked on her own. They saw each other infrequently, meeting only a few times at the library to coordinate their efforts and review what each other had written. It was a good time to work, the season of tourists, the time of year when most Romans made plans to leave the city, when shops and restaurants shuttered their doors in the August heat.

Francesca was also busy planning for another trip to London in September. She had won a second research grant, this time for a year, to the Warburg Institute, part of the University of London's School of Advanced Study.

The Warburg was familiar ground to her. Luciano had convinced her to come the previous year. He'd described the libraries at the universities in England, open until late at night and on weekends, where you could wander from floor to floor

and take down whatever books interested you. He told her about how he'd spent the entire night in a library at Oxford, eating in the cafeteria and studying and writing until the sun rose. They were both accustomed to the national library in Rome, always crowded, closed on weekends, where you could request only two books at a time and then had to wait, sometimes for hours, for a bored civil servant to fetch them. Compared with that, Luciano told Francesca, "England is like arriving in paradise."

⟡

ON THAT FIRST TRIP A YEAR EARLIER, FRANCESCA HAD ARRANGED to rent a room in London with another student. But those plans had fallen through at the last minute, and she'd arrived having no place to stay. Luciano was in Oxford, an hour away by train. She called him, and he gave her the name of a friend in London. One friend led to another, until finally Francesca had the address of a large house on Sloane Square, in Chelsea. She'd been told that the owner, a young Italian named Roberto Pesenti, often took in boarders.

Bags in hand, Francesca rang at the door of the house on Sloane Square, but no one answered. A sign tacked to the door informed her that there was a key under the mat. She opened the door and wandered in. In the dining room, she encountered a small, irate-looking woman wearing an apron and vigorously vacuuming a rug littered with crumbs. On the table was a tub containing the remains of a sangria—wine dregs and rotting fruit. The woman, evidently the maid, looked up at Francesca. Smiling politely, Francesca asked in English if Roberto Pesenti

was present. The woman's eyes narrowed at Roberto's name, she brought up a wagging finger and spoke rapidly and with obvious disapproval in a language that Francesca recognized as Portuguese. Francesca tried Italian, to no avail. The maid went back to vacuuming. Francesca looked around the house—three floors, wide hallways, impressive staircase, many bedrooms, and a plethora of nooks and crannies. Francesca found a small room, no bigger than a closet, with a narrow bed. It was the only bedroom that seemed unoccupied.

The house, it turned out, had an ever-changing cast of residents. Many were Italians, but at any given time there might also be Spaniards, Swiss, French, Swedes, Germans, and Americans. People came and went. The cooking was communal, big dinner parties routine. In the course of her first day there, Francesca met several of the residents, all young, mostly graduate students. Roberto, she learned, was himself studying finance and working at Goldman Sachs. No one seemed to know precisely where he had gone. Spain, someone thought. He often took business trips, she was told.

The room with the narrow bed was too small for Francesca to work in, so she installed her books and files on a credenza in the now spotless dining room. She used the dining room table as her desk.

The next morning she found her way to the Warburg Institute. She was greeted by a member of the staff and given a tour of the facilities, something that would never have happened in the milling, chaotic halls of the University of Rome. In the library, order and quiet reigned, the study areas seemed vast, and everything was available to her for the asking. She looked

around in amazement. For someone who loved libraries, it was, as Luciano had promised her, a type of paradise.

Late that afternoon, back at the house on Sloane Square, Francesca was at the dining room table working when she heard someone come in the front door. Behind her she heard a voice ask in English, "Excuse me, but do we know each other?"

Francesca turned and saw a man a few years older than she, small in stature, sparrow-like with a narrow face and thin, dun-colored hair. He was dressed in a dark blue business suit. She replied in English, heavily accented, saying her name and that she had just recently arrived. Immediately the man spoke to her in fluent Italian, with a Milanese accent. It was Roberto Pesenti. He looked a bit perplexed, perhaps even exasperated, as she explained her circumstances, that she just needed a place to stay briefly until she found other lodgings.

He asked what she was studying.

Art history, she replied, at the Warburg Institute.

His eyes lit up. He had just taken an art history course at Christie's, the auction house. He'd wanted to study art, but his family thought he should get a background in finance. Most of his friends worked in investment banks or were studying to become lawyers.

Francesca went out to dinner that night with Roberto and another resident of the house, a young man from Naples. Roberto explained that he was on a campaign to curb the chaos in the house. The Portuguese maid had given him a lecture. But he told Francesca she could stay until she found another place. They talked about art and the Warburg Institute and nightlife in London, a subject the man from Naples seemed to know a lot

about. Roberto spoke English with near fluency and could mimic the refined diction of the upper class. He told Francesca that he'd known immediately she was from Rome because of her strong accent. She frowned, a little offended. Most Italians considered Roman accents coarse and uncultured, the equivalent of a Cockney accent in Britain. The man from Naples said, with genuine surprise in his voice, "Oh, really? I thought she was from Tuscany." Tuscan accents are viewed as elegant, the purest form of Italian. Francesca clapped her hands with delight and laughed at Roberto, who laughed along with her. She realized he had been teasing her.

<div align="center">⁂</div>

ON WEEKENDS LUCIANO TOOK THE TRAIN IN FROM OXFORD TO see Francesca. During the week, they talked often on the telephone, long conversations about life, art, and philosophy. She found it easy to talk with him, "about anything and everything," she once said. When he came to London, they went out to dinners, to movies, to parties, often in the company of other Italians and foreigners.

Luciano had once told Francesca that he'd fallen in love with her when they were in high school, the moment he'd laid eyes on her, on their first day at the Liceo Lucrezio Caro. She'd dismissed that with a roll of her eyes as romantic exaggeration, but he insisted that it was true. He had been too shy ever to ask her out, too shy that first year to say anything to her. He came from a rural district north of Rome where his father had a medical practice, an area of agricultural fields alternating with large,

bleak concrete apartment blocks known as dormitorios. As a teenager, he'd been tall and skinny, with elbows and knees that sometimes felt as if they didn't belong to his body. He wore glasses and he dressed differently from his classmates, in clothes that looked, Francesca would later say, as if they had been bought by his mother.

Francesca had been the best student at the liceo, winning one academic prize after another. She had been invited to compete for a position in the Scuola Normale Superiore in Pisa, the most prestigious university in Italy. But her scholastic achievements embarrassed her and she did her best to conceal them. Her boyfriend back then rode a motorcycle, wore the right clothes, was handsome, outgoing, athletic, and in constant danger of failing at school. Luciano said that Francesca was the smartest person he'd ever met, but his classmates had widely regarded him as the school genius for the way he challenged the received wisdom of their textbooks and their professors.

They'd gone their separate ways at the University of Rome. They found their own paths through the chaos of the university, through the milling crowds of students and the interminable lines, the lecture halls and libraries so packed that every chair, windowsill, and bit of floor space was occupied by a warm body. The university, the second largest in the world after Cairo's, offered no orientation, no advisers, counselors, or tutors to guide students. It was, Luciano once remarked, "a true Darwinian context—only the fittest survive."

And then one day, after three years, Luciano called Francesca. Would she mind giving his younger brother some advice on courses and professors? At the end of the conversation,

they agreed to meet for dinner with some of their old acquaintances.

They began seeing each other more often, always in the company of other friends. Their relationship was chaste, involving nothing more than the customary kiss on the cheek in greeting. They were friends, not lovers.

That changed during Francesca's first stay in London. One night, she and Luciano went to a dinner party at the apartment of another Italian studying in England. They both knew everyone there. It was a night like any other. Luciano tended to be quiet at such gatherings, Francesca talkative. Luciano, by his own admission, had little talent for the idle, good-humored chatter of dinner parties. Francesca, on the other hand, moved with ease from one person to another, full of gaiety and laughter, able to make each conversation seem personal. At the end of the evening, they walked out together. On the street, they fell into a deep discussion and walked for several blocks. Finally they arrived at the house on Sloane Square. Francesca paused and turned to face Luciano. It was late, and the street was silent and dark. She looked intently at him, eyes serious, as he talked. He noticed a change in her demeanor and saw that her gaze had grown soft and expectant. He looked down at his shoes, and mumbled that it was late, he should be on his way. She blinked and looked at him quizzically. "Yes, of course. I'll see you soon," she said, and turned to go up the steps.

Luciano told himself that he was a fool. She had expected him to kiss her. Or at least, he thought that was what she expected. He had wanted to kiss her; he should have kissed her.

But what if he'd read the situation wrong? If he had kissed her and she had not expected it, it might ruin a friendship.

The following night they again met with a group of friends. After dinner at a restaurant, they again walked together to the house on Sloane Square. They did not get far before Francesca stopped abruptly and turned to Luciano. She leaned forward and kissed him full on the mouth. She pulled back and smiled at him. "I had to kiss you," she said with a laugh, "because last night you should have kissed me."

"Yes," he said, "but it seems that I never do the obvious thing."

They spent that night together. To Francesca it was not an event of great consequence. She still considered Luciano her friend, not her lover. "I've just never thought of him in that way, as a possible boyfriend," she'd said to Laura and others.

For Luciano, it was different. Not long after, he told Francesca that he had been in love with her since high school. Francesca claimed she didn't really believe him, even when she heard him say this to others. She made light of it. "You only think you love me," she told him. "You just don't want to take the time away from your books to find anyone else."

But in time she came to understand that he was serious. "I was not being honest with him," she said later. "I knew that for him it was different. But I pretended that I didn't know. I pretended that it was just friendship when I knew that it was something more for him."

He'd say to her, "Okay, you're not in love with me now, but you will be. I'm persistent."

For her second trip to London, Francesca found a basement apartment near King's and Fulham roads. The Sloane Square house had been too distracting for serious study. And this time Francesca was coming with a Roman friend, Caterina, who also had a research grant in London. They had known each other since their first years as undergraduates at La Sapienza, the University of Rome. Apart from an interest in art history, they shared the same sense of humor and, being roughly the same size, they also shared their clothes. Neither had a propensity for neatness. They were, in short, ideal roommates.

The apartment was small and dark, but efficiently organized, far enough from the noise and tumult of central London and yet convenient to the Warburg. It was, Francesca told Luciano, ideal for her purposes.

She made a second home of the Warburg's vast library. She usually arrived late morning—she was a late riser, eyes soft and occluded with sleep and dreams until almost noon—and stayed among the books at her favorite table until long after nightfall. She was working on several projects at once, fulfilling her obligations for the Warburg grant, still writing the unfinished essay for Correale, and pursuing the fate of the Mattei paintings.

Between projects, she looked for information on William Hamilton Nisbet and his art collection. Her first efforts, searching under the family name, yielded no interesting results. She changed tactics and began searching for catalogues of Scottish exhibitions in which Hamilton Nisbet's collection might have appeared. The earliest listing was for a catalogue entitled *Old*

Masters and Scottish National Portraits, published in 1884 in Edinburgh. She went into the stacks to retrieve the catalogue. Standing there, book in hand, she flipped through the pages. It contained an introductory essay about the exhibition and lists of paintings and their attributions, but no reproductions. She scanned the long list of paintings and her eye lit on the name Honthorst. The painting, now called *The Betrayal of Christ,* had been lent to the exhibition by one Miss Constance Nisbet Hamilton. Curious, she thought, that the name had been inverted, but it could only be the same painting that William Hamilton Nisbet—Constance's great-grandfather—had bought in Rome from the Mattei family.

Francesca went back to the library index and made a list of other catalogues. She collected the books from the stacks and brought them back to her reading table. One was called *Pictures for Scotland: The National Gallery of Scotland and Its Collection.* This was not an exhibition catalogue, but rather a history of the National Gallery of Scotland's collection. She turned to the index and looked under Honthorst. Nothing. Nor anything by Caravaggio. Then the name Serodine caught her attention, the painting called *Tribute Money.* Hamilton Nisbet had bought just such a painting from the Matteis, although, like the one by Caravaggio, it had also been misattributed, in this case to Rubens. Francesca flipped to the indicated page and saw the Serodine painting reproduced, the size of a postcard, in black and white. The legend above it read: "Bought as by Rubens from the Palazzo Mattei by William Hamilton Nisbet in 1802."

In the accompanying text, Francesca read that the painting had come to the National Gallery of Scotland in 1921 as part of

a bequest of twenty-eight paintings from Mary Georgina Constance Nisbet Hamilton Ogilvy, the last of William Hamilton Nisbet's direct heirs. The gallery also had another picture from the Mattei family, a small painting from Francesco Bassano's studio called *The Adoration of the Shepherds.* But the National Gallery had rejected, for whatever reason, the other three Mattei paintings—including *The Taking of Christ*—that Hamilton Nisbet had bought in Rome. They had gone up for auction at a place called Dowell's, in Edinburgh, in 1921. One of them, *Christ Disputing with the Doctors,* by Antiveduto Grammatica, had been found in 1956, hanging in a Scottish presbytery in Cowdenheath.

The only Mattei painting still unaccounted for was *The Taking of Christ.* The National Gallery had let what would become the single most valuable painting of the group slip through its hands. Francesca thought that the writer of the essay—his name was Hugh Brigstocke, and he was the assistant keeper of the gallery—had done his homework well. He had read Longhi's 1969 article in *Paragone* and he knew that the *Taking,* sold as a Honthorst, was most likely the missing Caravaggio. In footnotes, Brigstocke had listed his sources and included the portfolio numbers of the Hamilton Nisbet papers in the Scottish Record Office.

So what had happened at the auction at Dowell's on April 16, 1921? Surely an auction house kept records of its sales, thought Francesca. Who had bought *The Taking of Christ*?

Francesca presumed that Brigstocke had checked the records at the auction house, although he made no mention of them. Most likely he'd arrived at a dead end. She looked up the publication date of the book—1972, eighteen years earlier. She wondered whether

Brigstocke still worked at the National Gallery of Scotland. Was he even alive? She wanted to speak to him. She also wanted to go to Edinburgh, to Dowell's auction house, and follow the document trail herself. Perhaps, she thought, she could entice Luciano into coming with her.

⚜

LUCIANO SHOWED FRANCESCA AROUND OXFORD AND TRIED TO convince her that she should move to England. The Italian educational system, he told her, was a type of Mafia, a national scandal. He knew at first hand. He had applied to doctoral programs in philosophy in Rome, Florence, Bologna, Venice, Milan, and Turin. Each admitted only three students a year. He'd taken the oral and written exams, traveling by train and staying in cheap hotel rooms with other applicants, people in their thirties and forties who had applied time and again and never gotten a place. Admission depended on knowing someone, on having a rich father who could pull strings, or on being the protégé—or the sycophant—of an important professor. Luciano had no connections. Time and again he'd been rejected.

It was a different story in England, where he applied to Oxford, Cambridge, St. Andrews, and the University of Warwick. All accepted him. "You shouldn't be wasting your time in Italy," he told Francesca. "You should come to England."

She knew he was right about Italy. But she had a talent for making connections. She actually liked going to the openings of new exhibits and academic conferences, where she was learning to make her presence gently known, to use charm and flattery on

important art historians and powerful professors, nodding seriously at their observations and laughing at their witticisms, often putting a hand softly on their arms. Luciano called it "fare marchette"—using feminine wiles instead of her native intelligence to get ahead.

He devoted himself to her while she was in London, always ready to help, always caring and attentive. There were moments when she thought that maybe this was love after all, even if she didn't feel the sort of passion she'd experienced in other romances. It is a rare thing, she thought, to have a friendship like this, so maybe it is love. And then she'd catch herself and think, No, I think it's a mistake. It's because I am in London, far from my family and other friends. It's like being in vitro.

Perhaps the trouble was just the dreary skies of London, but the crispness and precision of the Warburg also began to weigh on her. She was one of only a few fellows, and the staff was cheerful and helpful. Too helpful, it sometimes felt to her. "I couldn't go look at a picture without someone asking—always very nicely—why I wanted to see it. And I might not even know why I wanted to see it, just an idea that I had that I was too shy to express."

Luciano didn't seem to miss Rome at all. Francesca told him that he must have been switched at birth, that he really was an Englishman who by accident had grown up in Italy.

She, on the other hand, found herself hungering for Rome, for the colors of the old buildings and the narrow, crowded streets, the small noisy cafés where Romans would stand shoulder to shoulder at the bar drinking espresso and talking, a tight nest of bodies, the warmth and humidity of humanity. Coming

down a narrow, winding street in the Campo Marzio, Via dei Portoghesi, in the dark shadows and dampness from the buildings on either side, she would round a corner and suddenly see a burst of sunlight illuminating the façade of a building, the ocher walls turned to gold by the sun. She realized that she could not imagine living anywhere else in the world.

⊰ 15 ⊱

In Rome, meanwhile, Laura began investigating what had happened to the six Mattei paintings after Hamilton Nisbet had bought them. The Scotsman would have needed authorization from the papal authorities to take the paintings out of Rome. The export license, usually granted as a matter of course, should contain a list of the paintings and their attributions along with the sum Hamilton Nisbet had paid for each.

Laura went one morning to the Archivio di Stato on Corso del Rinascimento. In the catalogue she found the section called Esportazioni, Exportations, of art and antiquities. The records were contained in filing case number 14. The individual export licenses were not listed. Laura expected that the file would be vast, containing hundreds, perhaps thousands of export requests made by rich travelers on the Grand Tour.

At the desk, she submitted a request for the case and then began a long wait for the clerk to retrieve it. When it finally arrived, late in the afternoon, Laura saw that it was indeed immense, almost too thick for her to put her arms around. But

inside the case were individual files with dates. She thumbed through them, a century of export licenses, until she found file number 300, with individual pieces of paper dated between 1801 and 1802. She took that file to a table in the reading room and began leafing through the pages. There was no standard form for requesting an export license, so each request was unique.

She went through dozens of pages, quickly scanning each for the name Mattei or Hamilton Nisbet. Near the end, with only a few documents remaining, she began to think that perhaps the license didn't exist. It was possible that Hamilton Nisbet had smuggled the paintings out of Rome, perhaps because he had anticipated problems, or perhaps simply to avoid taxes.

She went back to the beginning of 1802 and studied each document more carefully. Her eye stopped on one that began with the name of Patrizio Moir—Patrick Moir, certainly an Englishman. It was a single page, dated February 8, 1802, and it contained a short list of paintings that Moir said he wanted to send to England. The third in that list was described as "Jesus betrayed by Judas, in the Flemish style," with a size of seven palmi by five and a price of one hundred fifty scudi. It corresponded in subject and size to *The Taking of Christ*. The descriptions of the other paintings—among them *Christ Disputing with the Doctors* and *Christ with the Samaritan*—matched the five additional paintings that Hamilton Nisbet had purchased from Giuseppe Mattei.

Laura knew that she had found the correct export license, even though the document mentioned neither Hamilton Nisbet nor Mattei. But who was Patrizio Moir? Most likely an agent for Hamilton Nisbet, Laura surmised, one of many Englishmen

who lived in Rome and offered their services as cicerones to their wealthy countrymen on the Grand Tour.

The sales document from the Recanati archive had not listed the prices that Hamilton Nisbet had paid for the six paintings. But Moir, in order to obtain the export license, had to give a monetary value for each painting. He described each painting as being "in the style of," or "in the school of," making it seem as if they were copies, or works by unknown, unimportant painters. The total price for all six came to only five hundred twenty-five scudi. Laura suspected that Moir had understated what Hamilton Nisbet had actually paid. Moir was probably experienced at this sort of transaction. The less consequential the paintings, the easier it was to get them out of the country, and the lower the export duties. Moir had probably saved his client a substantial sum in taxes.

The bottom of the export license had a seal of authorization stamped into red wax, just above the signature of the assessor of fine arts and antiquities. Interesting, thought Laura, how expeditiously this license had been granted. It had taken Moir only a week from the time of Hamilton Nisbet's purchase to secure the license. Perhaps the bureaucracy had worked with greater efficiency back then. More likely, she thought, Moir had bribed the officials in the export office.

❧ 16 ❧

Francesca returned to Rome in December for the Christmas holidays. Within a few days, she and Laura completed the article for *Art e Dossier* that Professor Calvesi had urged them to write. It was scheduled for publication in February. They would have to tell Correale soon.

As it happened, the timing of the publication could not have been worse. The article would come out just as Correale planned to present the results of the *St. John* project at a symposium of experts at the Capitoline Gallery.

Now that the moment was near, Francesca wasn't so confident that Correale would take the news well.

"Do you think he'll be angry?" she asked Laura again.

"You know what he's like," replied Laura. "But we have to tell him. If we don't, he'll find out anyway."

They kept putting off the chore. They had plenty to do. They had to finish the essay for Correale and check all the footnotes, which numbered more than a hundred. Francesca had the additional burden of writing the brief biography of Caravaggio

that Correale had requested. She had started it but had not gotten very far. She knew that it would not take her long to write, a few evenings of hard work, and for that reason she never seemed to get around to it.

Meanwhile, Correale was busy organizing the details for the *St. John* symposium. He oversaw the editing of all the essays for the catalogue and occupied himself with writing invitations to the most highly regarded Caravaggio experts. He planned the event meticulously, down to the order in which the scholars would speak and the seating arrangements for the lunch that would follow. These were delicate matters. Several of the scholars were touchy and easily offended, and others had ongoing feuds. Correale hoped to avoid any unpleasantness.

In mid-January Francesca and Laura finally concluded that they could wait no longer, they had to tell Correale about Professor Calvesi and the *Art e Dossier* article. Correale had scheduled a meeting at his apartment. Francesca and Laura decided that they should wait until the end of the meeting, when the others had gone and they were alone with Correale.

That evening several people crowded into Correale's apartment. He was in fine form, orchestrating the discussion, delighting in the plans for the symposium. Francesca and Laura sat silent most of the time, listening to the others talk. As usual, Correale's interest lay with the technical people. The meeting dragged on. Francesca kept looking at her watch. One or two people had already left. Just after eight o'clock she whispered to Laura that she also had to leave, she had a dinner engagement, she hadn't thought the meeting would go on so long.

Laura looked at her with astonishment. "What about telling Correale?" she whispered back to Francesca.

"We can tell him another time," Francesca said. She clasped Laura's hand. "Sorry, but I really must go."

With that, Francesca stood up, made her apologies, and said she had another appointment. Going out the door, she cast a last glance at Laura, a look of regret.

Laura knew that Correale's temper frightened Francesca. They'd both seen him grow red in the face, throw papers and swear vilely. His angry moments were unpredictable and usually short-lived, but Francesca had always looked terrorized afterward. Laura understood that she had left tonight because her courage had deserted her.

Laura decided to tell Correale herself. If she waited for Francesca, they would never get around to telling him. When everyone else had finally gone, Laura rose from the sofa as if to depart, but paused and said to Correale, as if it were an afterthought, "Listen, Giampaolo, there's something you should know about."

"Tell me, Lauretta cara," said Correale.

Laura explained that they had gone to see Calvesi and told him about the Caravaggio payments. She could see Correale start to get angry, eyes narrow, puffing rapidly on one of his small cigars. He seemed about to say something, but Laura continued talking. Calvesi had told them they should publish this information, that they had an obligation as art historians to publish, and of course they had felt obliged to listen to their professor, head of the art history department. And so, Laura concluded, they had written an article for *Art e Dossier*.

CORREALE REMEMBERED THE EVENT DIFFERENTLY. IN HIS RECOL-
lection, Laura told him about discussing the Recanati findings
with Calvesi, but not about the article in *Art e Dossier*. Correale
found out about that only after it had been published, from a
friend who called to say he had just seen the article in the latest
edition at a newsstand. Correale at first did not believe his
friend. Impossible, he said. Then he ran out to the newsstand
and bought a copy for himself. He stood on the street, staring at
it in disbelief. The cover of the magazine had a close-up repro-
duction of a Caravaggio painting, *Martha and Mary Magdalene,* and
the words "New Dates for the Mattei Paintings." He flipped
through the magazine, came to the photos of two of the Mattei
Caravaggios, *The Supper at Emmaus* and *The Taking of Christ,* the
Odessa version. The article was short, barely two pages long.
Scanning it with furious eyes, Correale saw that it did not men-
tion him or his project. "The insult of the insult," said Correale
later. At the very least, he should have gotten credit for initiating
the research. The article referred only in passing to the *St. John.*
But it contained the essential facts about the Recanati discover-
ies, discoveries that Correale had wanted to reveal to the world.

Whatever the truth of the matter, there is no dispute con-
cerning his call to Francesca. The moment she picked up the re-
ceiver, she heard Correale's voice swearing without pause, an
incessant stream of epithets, each more inventive than the last.
Francesca held the phone away from her ear, but she couldn't
mistake the words. Once, twice, she tried to explain—they'd had
to tell Calvesi, she began—but she never got any further than

that. After what felt like a long while to Francesca, Correale's energy seemed to flag. She made another effort to explain, but he interrupted her. Because they had betrayed him in such a way, he said, he would never again speak to her or Laura. They were beneath contempt. And then he hung up.

Later, in calmer moments, Correale would say that he understood why they had gone to Calvesi. He was their professor; they looked to him for approval, the way, thought Correale, a child would look to his mother. He was angry that they had spoken to Calvesi, but if they had asked his permission, he would have given it to them. But he could never forgive the article in *Art e Dossier*. "A knife in the back," as he put it.

✤ 17 ✤

CORREALE KEPT HIS WORD. HE DID NOT SPEAK TO EITHER Francesca or Laura again. A few last editing questions about their article in the symposium catalogue were communicated to them by someone else on the project. They received their invitations to the symposium in the mail. It was scheduled for February 27 at the Capitoline Gallery.

Correale had set up an impressive panel of Caravaggio scholars to make presentations. Francesca recognized all the names, luminaries in the world of art history such as Denis Mahon, Mina Gregori, Keith Christiansen from the Metropolitan in New York, Luigi Spezzaferro, Christoph Frommel, and of course Calvesi. Except for Calvesi, she had not met any of them.

Neither she nor Laura intended to miss the symposium, despite Correale's wrath. It was, after all, their discoveries in the Recanati archive that made the event truly noteworthy for other Caravaggio scholars. Francesca wanted to make a good appearance. She tried a different hairdresser and bought her-

self a new outfit—a lavender skirt and matching jacket, a flowery silk foulard, and a pair of magenta heels.

She rode her old Piaggio motorino to the Capitoline Gallery, skirt hiked to her thighs, hair blowing in the wind. She arrived half an hour late for the opening of the symposium, but this time her tardiness was deliberate. She felt apprehensive at the prospect of encountering Correale. She had decided to avoid the mingling and casual chatting among acquaintances that always occurred at the beginning of such affairs. And then there would be the formalities, the welcome by the director of the Capitoline and by Correale and the introductory speeches by two executives from Italsiel, the software company that had financed the *St. John* project. She didn't mind missing those, either.

Nearing the grand hall of the Capitoline Gallery, she saw that the symposium had attracted a large audience. People stood near the entry, holding their winter coats in their arms. She wended her way through the crowd. All of the folding chairs, some two hundred of them, were occupied. She found a place among others standing in the back along the gallery walls. At the other end of the hall, the two *St. Johns*, bathed in light, were displayed side by side behind velvet ropes, like identical twins with only slight variations in their features. The Doria version looked darker, the colors less vibrant, next to the luminous Capitoline painting.

Correale was at the podium, looking plump and formal in a dark suit and tie, his reading glasses low on his nose. She heard him speaking about Italsiel's new system of gathering scientific and technical information on works of art. Francesca scanned

the crowd for familiar faces. Laura, ever punctual, had arrived in time to get a seat in the middle of the hall. Here and there among the crowd she spotted others she knew, professors and fellow students at the university. In the front row she noticed Calvesi, and she recognized nearby the fat, bejowled form of another Caravaggio scholar, Luigi Spezzaferro.

Correale had finished his speech and the director of the Capitoline had risen to introduce Denis Mahon. Francesca watched the elderly Englishman rise from the front row and move cautiously to the podium, cane in one hand and a sheaf of papers in the other. He adjusted his glasses, fussed with his papers, and peered out at the crowd. The hall grew quiet. Francesca did not know precisely how old Sir Denis was—in his early eighties, she'd heard. Everyone remarked on his age, and in the same breath on his astuteness of mind. He looked elfin to Francesca, his eyes bright and a small smile, almost mischievous, playing across his face.

His voice surprised her—its high, almost feminine register, without the watery quaver of old age. He spoke in Italian, flawlessly, with a British accent that Francesca found delightful. He noted that everyone was gathered here on this day because of his discovery, almost forty years ago, of the *St. John* hanging high on the wall of the mayor's office, at a time when everyone else thought the original painting was at the Doria Pamphili. He said this without seeming to brag, even though his age and accomplishments would have allowed him that indulgence. He had a few barbs for what he called the "old barons" of the art world— Longhi and Lionello Venturi, both long dead—who had never openly acknowledged the authenticity of the Capitoline *St. John.*

Francesca had imagined Mahon would give a short, unremarkable speech, the sort one often heard at such events. But he spoke at length, and midway through she saw how clear and sharp his mind had remained. The problem, he said, lay in the two payments of sixty and twenty-five scudi by Ciriaco Mattei for unspecified work to Caravaggio. The payments for *The Supper at Emmaus* and *The Taking of Christ,* said Mahon, seemed to accord well enough with Caravaggio's other known fees, although perhaps one hundred twenty-five scudi for the *Taking* was a trifle low. But to assume that Ciriaco had paid only sixty scudi for *The Incredulity of St. Thomas*—of which the Mattei archive contained no mention—and a mere twenty-five scudi for the *St. John* made no sense at all. Both payments were, said Mahon, "by a wide margin, too little."

Mahon proposed a different schedule of payments. He thought the Mattei family had probably never owned *The Incredulity of St. Thomas,* and that Baglione had erred in saying they had. He himself had never seen Baglione's original handwritten manuscript in the Vatican library. Some young scholar might want to check the manuscript against the published versions. Perhaps there had been a transcription error, repeated through the centuries, in the printing of the book.

And then he suggested that it made more sense to regard the first payment of sixty scudi as being for the *St. John,* not *The Incredulity of St. Thomas.* The second, smaller sum of twenty-five scudi might represent an additional payment for the *St. John,* or perhaps an advance for *The Taking of Christ.*

Mahon had challenged, in the same way Longhi might have, the conclusions in Correale's symposium catalogue. He had ad-

vanced a new set of conclusions that, once articulated, seemed far more likely to be accurate.

Standing among the tightly packed listeners at the back of the hall, Francesca listened with half an ear as one after another of the scholars spoke, displaying their erudition. Some argued that Caravaggio had made preparatory drawings for his paintings; others disagreed. Some speculated that he'd had a bottega of sorts, a commercial workshop, which had produced authorized copies of his works, such as the Doria *St. John,* although no evidence for a workshop had ever turned up. The meeting went on for three hours. It grew warm in the hall. People shifted in their seats.

During a break in the proceedings, Francesca made her way up through the crowd to the front, where the eminent art historians were gathered, surrounded by others. She saw Laura standing near Calvesi and went up to them. Correale stood nearby, talking to someone she didn't know. Their eyes met for a moment, and he looked away.

Luigi Spezzaferro, bespectacled, face flushed, wearing a billowing suit coat that bore traces of recent meals, bellied his way up to her. "Francesca Cappelletti?" he said, voice loud and heavy with a Roman accent. "Congratulations on your work. You should have come to me first, of course. I could have helped you with the bibliography: it would have been much better. You did pretty well, but you don't know enough yet."

A few minutes later, Francesca and Laura found themselves introduced to Denis Mahon. "Marvelous work," he said to them with a warm smile. "I really must compliment you both. It is so important to have these dates."

Francesca could feel herself blush, at once shy and proud.

Then Sir Denis said to them, "I wonder if you might have time tomorrow to lunch with me? There are some other matters I would like to ask you about."

Francesca was taken aback by this invitation. She wondered if she'd understood correctly.

Laura said, "Yes, of course, it would be our pleasure."

Francesca, nodding vigorously, stammered a simple assent.

"Tomorrow at one, let us say? I will meet you at the Hotel Senato."

✕ 18 ✕

THE INVITATION BOTH EXCITED AND UNNERVED FRANCESCA. IT was as if a grandmaster in chess had taken note of her talent and invited her to play a game. She was afraid of making a foolish mistake.

She met Laura the next day in front of the Albergo del Senato, in the Piazza della Rotunda. They had both arrived early; this was one appointment for which even Francesca would never have been late. Denis Mahon was himself early. In the hotel lobby they saw him sitting in an armchair, hands resting on his cane. He wore a heavy coat against the February chill. He seemed lost in thought, staring straight ahead.

They went over to him. He looked up, as if startled, and then smiled and said, "Ah, che piacere!" and rose slowly from the chair. He addressed them in the formal manner, shaking each woman's hand in turn. They walked out of the hotel, Francesca on one side of the old man, Laura on the other, and went across the piazza toward Da Fortunato.

Inside the door, the manager greeted Sir Denis with a beam-

ing smile and helped take the heavy coat off his shoulders. Photographs of Da Fortunato's more famous clientele—actors, politicians, writers—hung in the entryway. Francesca saw a black-and-white photo of Mahon in a pin-striped suit, looking up at the camera with a grin, seated at a table with another man. Sir Denis paused briefly to cast an eye at the display of fresh fish on ice—sea bass, oysters, squid, shrimp with their carapaces intact. He seemed to lift his nose to catch the aromas in the air and rubbed his hands together. A man who liked to eat.

The manager escorted them to a table in the front room, near a window facing the street. Francesca had a tendency to chatter when she felt nervous, but that habit deserted her now. Both she and Laura sat solemnly, awkwardly, hands in their laps, too shy even to open the napkins until Mahon made a move. He seemed to realize their discomfort. He congratulated them again on their research. He asked about the Recanati archive, how they had tracked it down, how long they had spent there. He drew them out with ease and deftness, asking their opinions on various matters concerning the Mattei family and Caravaggio. Did it seem possible to them that Ciriaco had actually owned *The Incredulity of St. Thomas* by Caravaggio, as Baglione had written? It might be worthwhile, he suggested, for one of them to perform the research he'd suggested and check Baglione's original manuscript. It might contain some clues, a note in the margin perhaps.

The dishes arrived as they talked—for the Englishman, an antipasto of mixed seafood marinated in olive oil and lemon juice, followed by medallion of veal with lemon and capers and a plate of spinach repassato, cooked with garlic and oil. He ate

slowly, but with obvious pleasure, commenting on the excellence of the seafood, the tenderness of the veal. Laura ordered a simple plate of pasta and Francesca just a salad with ruchetta and Parmigiano. She took only a few bites and moved the rest around on her plate, listening intently to Mahon's every word. It seemed surreal to her, this lunch with Denis Mahon asking them questions, wanting to hear their opinions, as if he regarded them as his peers.

It was apparent that he had read their essay with great care. Not even the smallest item in the footnotes had escaped his notice. In addition to the dates, he told them, they had verified Longhi's suspicion that Hamilton Nisbet had bought the original *Taking of Christ* in 1802. And that meant that the Odessa version had to be a copy. It had turned up in Paris in the 1870s, while Hamilton Nisbet's heirs still had possession of the original.

Francesca mentioned that she had come across the essay by Hugh Brigstocke concerning the Hamilton Nisbet collection.

"Hugh Brigstocke?" said Mahon. "Yes, I know him. He has left the Scottish National Gallery. He's at Sotheby's now, in charge of cataloguing Old Masters."

"Brigstocke had written that *The Taking of Christ* went up for auction in 1921," continued Francesca. "What happened to it after that?"

Mahon said he was certain that Brigstocke had checked the records of the auction house, but had come up empty-handed. He gave Francesca an appraising look. He asked how she had happened to come across the essay.

"At the Warburg Institute," she replied. She had a scholar-

ship to study there for a year. She was, in fact, returning to London the next day.

"You know," said Mahon, "I think you ought to talk to Brigstocke when you get back to London."

"I'd like to talk to him," said Francesca. "But I felt reluctant to call him without an introduction. I thought he might be offended by a student asking him questions."

Mahon smiled. "You can tell him that I told you to call. By the way, where are you staying in London?"

"Radcliffe Road, near King's Road and Fulham," Francesca said.

"How lovely!" said Mahon. "We are neighbors! I live in Belgravia, in Cadogan Square. You must stop by for a visit and see my paintings. Here, let me give you my telephone number." He called to the waiter to bring him a pen and a piece of paper and jotted down his number. He gave her the pen and asked that she write down hers.

Francesca couldn't imagine actually summoning the courage to call Mahon. He's just being kind, she told herself, he doesn't really expect me to call.

Only later did it occur to her that she'd probably misunderstood. He hadn't given her his number out of kindness, and he wasn't taking a personal interest in her and her career. Sir Denis's true interest in life was art. That was his chessboard, Francesca realized, and all his moves had significance. He'd given her his number because he thought that perhaps she might come across something else of interest to him. And if she did, he wanted to be the first one to hear about it.

❧ 19 ❧

FRANCESCA RETURNED TO LONDON AND TOOK UP HER STUDIES AT the Warburg. In a spare moment, she looked up an address for the Ogilvy family in Scotland, the descendants of Constance Nisbet Hamilton, the last of the direct line of William Hamilton Nisbet. She wrote a letter asking for information about their collection of paintings, and inquiring whether, by chance, they could shed any light on the fate of *The Taking of Christ* by Honthorst. Luciano, in London for a weekend, corrected her English grammar. She tried calling Hugh Brigstocke at Sotheby's. She got as far as a secretary and left a message. Several days passed without a response.

One evening, after a day at the Warburg library, she was washing her hair in the bathroom when she heard the telephone ring. Her roommate, Caterina, answered. A moment later Caterina appeared at the door and said, "It's Denis Mahon; he wants to speak with you."

Francesca stared at her. "Are you joking?" she said.

Caterina shook her head.

Francesca wrapped a towel around herself and went to the telephone.

The Englishman said brightly in his high voice, "I hope I am not disturbing you."

"Oh no," said Francesca, hair dripping on her shoulders. "Not at all."

Mahon asked whether she had spoken to Brigstocke yet.

Francesca said that she had called Sotheby's and left a message, but she had not heard back.

Mahon said he would give her Brigstocke's home number. He would call Brigstocke himself, he added, and tell him to expect a call from Francesca. Mahon seemed in the mood to chat for a while. A seventeenth-century painting, a battle scene, had just come up for auction. Mahon felt certain it was by Poussin, a Baroque artist about whom he had written more than a dozen monographs. Others had raised questions about this attribution. Would Francesca, when she returned to Rome, mind checking a few documents in the Vatican library concerning this painting?

Francesca, clutching the towel around her, damp strands of hair on her shoulders, said she would be delighted to help.

Mahon spoke on for a while about Poussin. Francesca tried to call to mind paintings and dates, tried to think of intelligent comments to make on the subject of Poussin, on the old theoretical debate concerning line and color that had divided him and Rubens. For almost an hour she stood half naked and cold, trying to find a way to end the conversation without giving offense.

It was Mahon who finally brought the talk to a close, expressing his pleasure at chatting with her and making her promise to let him know if she happened to find anything interesting.

The next evening Francesca called Hugh Brigstocke at his home. Their conversation was brief. He was polite, but Francesca had the impression that he didn't like receiving phone calls about business at home, even if they had originated from Denis Mahon. She explained that she was interested in paintings Hamilton Nisbet had acquired in Rome. Brigstocke said he didn't think he would be much help to her on that subject. Francesca told him briefly about her work in the Recanati archive. Might she come to see him at Sotheby's? With some reluctance, it seemed to Francesca, he gave her an appointment for the following week.

❧

ON A WET, GRAY AFTERNOON, FRANCESCA CAUGHT THE BUS ON King's Road and rode in to Piccadilly. Caterina came with her to keep her company. At the door of Sotheby's on New Bond Street, Caterina wished her luck and they parted.

The receptionist directed Francesca to the third floor. A young woman met her at the elevator and escorted her down several long corridors to Brigstocke's office. The place seemed busy, people walking here and there with sheaves of papers in their hands, all apparently on urgent business. Brigstocke rose from behind his desk to greet her. He was a handsome man in his late forties, with a heavy, craggy face. Francesca took a seat in

front of the desk. She wondered whether he spoke Italian—her English was still imperfect—but she was reluctant to ask.

He spoke to her in English. "So you know Denis Mahon?" he said.

"Not well," she replied honestly, explaining that she had just met him a few weeks ago in Rome.

"He latches on to young scholars," said Brigstocke. "He likes to have them in tow. He'll come in and out of your life when you're doing something that interests him."

Brigstocke said this in a way that Francesca interpreted as dismissive. She was just another young scholar to Mahon, and to Brigstocke as well.

"He'll call you at all hours to talk," continued Brigstocke. "It's an obsession with him."

A woman poked her head in the door and asked Brigstocke a question that Francesca didn't understand. Brigstocke said he would be free in a minute. And at that moment the phone on his desk rang. Francesca looked around the office as he spoke. His desk was piled with catalogues and files. Several paintings, old but not recognizable to Francesca, leaned against the wall.

Brigstocke hung up the phone and apologized to Francesca. "Now, what can I do for you?"

"The Mattei paintings that Hamilton Nisbet had bought in 1802," began Francesca.

"Ah, yes," said Brigstocke. "Denis mentioned that you're interested in them."

"Only one of them is still missing, *The Taking of Christ*," said Francesca. The research she and Laura had done in Recanati had

shown to a near certainty that it was the lost painting by Caravaggio. Brigstocke seemed to grow more interested when she talked about finding the inventory in which the attribution had changed to Honthorst.

"Well," said Brigstocke, "I looked into it. It was sold in 1921 at Dowell's auction house in Edinburgh. I found the Dowell's catalogue, but it had been put together by someone uneducated, someone who either didn't know or didn't care what he was doing." Brigstocke fished around among the files on his desk and drew forth several pages, which he handed to Francesca. "This is from the auction catalogue," he said. "Denis thought you'd want to see it."

It was dated Saturday, April 16, 1921, and contained a list of paintings. On the seventh page of the catalogue, midway down, Francesca saw the words "After Gerard Honthorst. The Betrayal of Christ." Just below it was another of the six Mattei paintings, *Christ and the Woman of Samaria,* with the attribution "After Lodovico Caracci." This was a painting actually by Alessandro Turchi that had been found in a collection in New York.

"There's no record of who bought any of these paintings," Brigstocke told Francesca. "And Dowell's doesn't exist anymore. It was bought in 1970 by another auctioneer, Charles Phillips & Sons."

"Perhaps the heirs of Constance Nisbet Hamilton would know something more?" asked Francesca.

Brigstocke said he had contacted the family. They knew nothing. "Maybe it'll turn up someday. I hope so, but many paintings have been destroyed."

Francesca said she planned to go to Edinburgh and see what she could find. Did he have any suggestions for her?

Brigstocke gave her a level gaze. "You look like the sort of person who won't be discouraged," he said. It didn't sound to Francesca as if he meant it as a compliment. But he smiled at her as he rose from his chair to signal the end of the interview.

✺ 20 ✺

IT WAS MAY IN ENGLAND, THE DAYS WARMER AND SUNNY, THE tulips in riotous bloom in Hyde Park. Francesca received a reply, formal and brief, from her letter to the Ogilvy family, the distant descendants of William Hamilton Nisbet. As Brigstocke had already told her, the family had no information about the paintings that had gone up for auction seventy years ago. The letter suggested that Francesca direct her efforts to the archives of the National Portrait Gallery in Edinburgh.

Francesca told Luciano about her plan to go to Edinburgh, and he offered to go with her. They were both busy with their studies, Francesca writing a paper on the iconography of Renaissance depictions of mythology and studying for an exam in medieval art. They decided to go at the end of the school term, in June. Francesca found a small, inexpensive hotel, family-run with only a dozen rooms but in the center of the city. With the help of a guidebook, she planned her itinerary, circling on a street map of Edinburgh the National Gallery, the National Portrait Gallery, the National Library, the Scottish Record Office,

and the location on George Street of what had once been Dowell's auction house.

On a Sunday in late June, they set off in Luciano's car. For Luciano, this was purely a vacation, an opportunity to be alone with Francesca for the next few days. And she also regarded it as a vacation, even if she had brought along a suitcase heavy with art history books for the exam she would have to take back in Rome. She told herself not to expect too much from this trip. She didn't really think that she would find the painting, but she did hope to find something, some clue, that would take her a step further.

They spent four days in Edinburgh, in the small hotel with bow windows and pink steps located just behind the National Portrait Gallery. The old center of the city reminded Francesca of an anglicized Rome—narrow cobbled streets, eighteenth-century buildings, the ruins of an ancient castle on a hill overlooking the city—but Edinburgh was well-ordered and clean, with traffic that actually obeyed the rules.

Luciano accompanied her on her rounds. First to the National Gallery, where a heavyset Scottish woman with thick spectacles narrowed her eyes in puzzlement at Francesca's accent. Finally the woman took in hand the photocopy of the page from the Dowell's catalogue that Francesca had gotten from Brigstocke. She held it close to her nose, scrutinized it, turned it this way and that, disappeared for twenty minutes, and came back empty-handed. She suggested that Francesca try the archives at the National Portrait Gallery or the Scottish Record Office.

At the Scottish Record Office, another bespectacled, middle-aged woman cocked her head at Francesca's accent. Francesca

finally made herself understood, and then spent an hour in fruitless search for documents from Dowell's. She did find a thick folder on Hamilton Nisbet, his forebears and his heirs. She leafed through the pages, taking notes on Hamilton Nisbet's life. He had been enormously wealthy, as rich as the Mattei family in Ciriaco's day. He'd owned three grand estates on vast tracts of land in East Lothian, east of Edinburgh. His primary residence had been Biel House, a sixty-six-room mansion where, according to an inventory, *The Taking of Christ* by Honthorst had hung in the dining room. All very interesting, thought Francesca, but nothing in the folder revealed what had happened to the painting after the auction.

Her last stop of the day was the archive at the National Portrait Gallery, and it was there, with Luciano patiently at her shoulder, that Francesca came across dozens of old catalogues from Dowell's. Her heart quickened when she saw the one dated Saturday, April 16, 1921, the date of the Hamilton Nisbet auction. The title page read: "Catalogue of a Collection of Valuable Pictures in Oil and Water-colour Removed from the Mansion-House of Biel, East Lothian." There were several copies of the catalogue, all identical except for one that had been annotated with a list of figures, handwritten in the margins next to each painting. The sum next to *The Betrayal of Christ,* by Gerard Honthorst, was noted as £8-8-0—eight guineas. Francesca did not know the precise value of eight guineas in 1921, but it seemed like a paltry sum. Luciano guessed it would be no more than fifty English pounds in current value.

Francesca searched the entire Dowell's folder, looking for records of sale, some accounting of the disposition of the paint-

ings, of who had bought them. Nothing. She felt a sudden sadness, like a wave of fatigue. She put her head in her hands.

"Eight guineas," she murmured to Luciano. Had the painting actually sold at that price? Or had the auctioneer merely noted in the margin the reserve prices for the paintings? One way or the other, the sum of eight guineas was a measure of how time had eclipsed Caravaggio's fame. She remembered the opening of Longhi's famous essay "Ultimi Studi sul Caravaggio e la Sua Cerchia," written some fifty years earlier: Longhi said that by 1900 Caravaggio had become one of the least-known painters in Italian art.

The next morning Francesca and Luciano walked over to 18 George Street, the former site of Dowell's, now owned by Charles Phillips & Sons. The building, several stories tall and constructed of stone with a pinkish hue, dated from the turn of the century and had spacious windows on the ground floor through which one could see a display of paintings and antique vases.

Francesca approached a young woman seated behind a desk. Using her best English diction, she asked whether, by chance, Charles Phillips & Sons had kept any old records from Dowell's.

The girl tilted her head in perplexity, either at the substance of the question or, more likely, thought Francesca, at her accent. She told Francesca to wait a minute and went to summon help. A moment later, she returned with an older woman. More frowning and tilting heads. Finally they understood the words "Dowell's" and "documents."

The older woman shook her head and smiled merrily. "Dear me, those old records, we wouldn't keep them. Maybe some of

them went to the archive at the Record Office or the National Gallery, but I imagine they've been burned."

"Nothing at all?" said Francesca. "You are certain?"

"Oh yes, quite certain," said the woman, still amused.

On the sidewalk outside the building, Francesca turned to stare at the gallery. "No records," she said to Luciano, her voice tinged with bitterness. "You always tell me how precise and orderly this country is. In Italy, at least, they keep every piece of paper, every document, going back five hundred years!"

Francesca had tracked the painting over three hundred and twenty years. During that time empires had risen and fallen, wars had been fought, fortunes had been made and lost, plagues, famines, floods, and droughts had ravaged lands. A mere seventy years ago, on a Saturday afternoon in April, the painting had been here in this building, and then it had simply disappeared. It was not unreasonable to think that it might have perished. It was, after all, a mere piece of cloth, measuring four feet by five.

❧

It was the first day of July when Francesca and Luciano left Edinburgh. Just one month later, across the Irish Sea, the chronicle of the lost painting by Caravaggio was about to take a new turn.

PART III

❧

THE
RESTORER

❧ I ❧

THE NATIONAL GALLERY OF IRELAND STANDS NEAR THE CENTER of Dublin, directly across from the large green expanse of Merrion Square, with its paved walkways, flower beds, and copses of neatly pruned trees. From Merrion Square, the gallery presents a stolid, institutional aspect—it is a heavy gray stone edifice with a squat portico and four blocky columns. On the gallery's roof, barely visible from the street, there is a curious structure of wood and glass. It is clearly a late addition, boxy and utilitarian, bearing no architectural relationship to the gallery's nineteenth-century Georgian façade. Some gallery employees refer to it as the penthouse.

The penthouse has long been the domain of the gallery's two restorers, the studio where they cleaned and repaired old and damaged paintings. It was accessible by means of a freight elevator, but the restorers usually climbed up an old marble spiral staircase that led to a dark landing and a stout metal door. Its interior was luminous, even on cloudy days, with light filtering in through an expanse of large windows high up on three of the

walls. The concrete floor was stained by years of paint splatters. The room was spacious. In it stood a broad table, also paint-stained, three sturdy easels, a binocular microscope mounted on a wheeled tripod, and several powerful lamps. In one corner, a tall metal cabinet held jars and tins of solvents, varnishes, lacquers, and oils. A smaller wooden cabinet with wide, shallow drawers, the sort of cabinet one might have seen in a dentist's office years ago, contained dozens of small tubes of restorers' paint, fine-tipped brushes, and an assortment of stainless-steel implements. Paintings in various states of distress—flaking, torn, cracked, infected with the white bloom of fungus—stood propped against the walls. One, a portrait of an English noble-man, had a triangular rip in the center, two inches on either side, a wound produced when a security guard backed into a camera on a tripod. Another, a small sixteenth-century Italian panel of the Madonna, lay on the table, its surface mottled and blackened by an early, inept restoration.

It was August 1990. Sergio Benedetti had worked in the restoration studio at the National Gallery for the past thirteen years, along with Andrew O'Connor, the gallery's chief restorer. Benedetti was then forty-seven years old. He was married and had two children. He had a steady, if low-paying, job, but for some time now he'd found himself growing discontented with his professional lot in life. He had felt that he was destined to achieve something important, to make himself known in the art world, and yet the years had come and gone without presenting him any clear opportunities. At times he felt that life in Ireland was akin to exile, in a land on the far periphery of the art world. He missed Italy, often acutely. He had begun his career there,

restoring paintings and frescoes, but the bureaucracy, the endless delays in getting paid, and the constant need to seek out work had finally defeated him.

To supplement his salary at the National Gallery, Benedetti took in freelance work from time to time, by an understanding he had worked out with the gallery's director. The gallery also had a policy of opening its doors every Thursday morning to offer free assessments on the merits of sundry objects of art carted in by the public. Very little of value turned up, but Benedetti enjoyed these mornings and the diversion they provided from his routine.

On this particular Thursday morning in August, Benedetti had an appointment to look at some paintings outside the gallery. The appointment had been arranged by the gallery's new assistant director, Brian Kennedy. An acquaintance of Kennedy's, the rector at the St. Ignatius Residence, where fourteen Jesuit priests lived, had inquired several months ago about the possibility of having some paintings cleaned. At the time, Kennedy had been busy with the details of his new job. He'd put the matter off until just recently, when the rector called again to remind him.

The Jesuit residence was situated at 35 Lower Leeson Street, a ten-minute walk from the gallery. Benedetti and Kennedy set out in late morning, the day sunny and warm. Walking side by side, they presented a study in contrasts—Kennedy in a dark suit, tall and lanky, in his late twenties, with horn-rimmed glasses and a birdlike face, and Benedetti in corduroy pants and cotton shirt, shorter and much stouter, his features growing heavy with middle age. Kennedy had a youthful, energetic manner. He was

smart and ambitious, and yet affable, while Benedetti tended to brood. For all their differences, Benedetti liked the young man's company.

On their way to Leeson Street, Kennedy mentioned that he'd visited the Jesuit residence in the past. The rector, Father Noel Barber, edited a scholarly journal for which Kennedy had written several articles. He recalled that the residence had half a dozen paintings, works with religious themes. "Some dark copies of Old Masters," he told Benedetti, "the sort of thing you find in lots of Irish religious houses. They have one hanging in the parlor that I think might be quite good."

They walked past St. Stephen's Green and turned onto Lower Leeson Street, a quiet, well-kept thoroughfare lined with old Georgian row houses in brick and stone, each four stories tall. The door of 35 Lower Leeson Street was painted bright blue and lace curtains hung in the windows. Father Noel Barber greeted Benedetti and Kennedy and welcomed them in. He explained that they were in the midst of cleaning and refurbishing the house—pulling up old carpeting, polishing the floors, and painting the walls. They had taken down all the paintings and moved them to the library on the second floor. He led the way up the stairs.

The library was a large book-lined room overlooking the street. Benedetti saw seven or eight paintings of varying sizes propped up against the bookcases. His eyes were drawn immediately to the largest one, in an ornate gilt frame. He stared at it for a long moment, and then forced himself to look away to the other paintings. He knelt before each, his eyes registering the details, but his mind remained with the large painting in the gilt frame. He saw several early twentieth-century Irish paintings of

little consequence, and an Italian work, possibly sixteenth century but provincial and clumsily executed. All rubbish, he thought to himself. He made no comment. Behind him, he heard Kennedy and Father Barber talking.

Finally he turned his attention to the large painting. It was dark, the entire surface obscured by a film of dust, grease, and soot. The varnish had turned a yellowish brown, giving the flesh tones in the faces and hands a tobacco-like hue. The robe worn by Christ had turned the color of dead leaves, although Benedetti's eye told him that beneath the dirt and varnish it was probably a coral red. He could see that the canvas had gone a little slack in the frame. He judged that it had not been cleaned or relined in more than a century.

He came close to the painting, squatting on his haunches before it, his face inches from the surface. It was definitely a seventeenth-century work, he thought. The craquelure, the network of fine hairline cracks, was just what he would expect in a painting almost four centuries old. All in all, the picture appeared to be in rather good shape. He could see only a few areas where the paint surface had cupped slightly and flaked, the worst on the right edge of the canvas, on the back of the second soldier. But the most important areas, around the hands and faces, seemed free of damage.

He examined the features of Christ and of Judas, the eyes and ears, and the details of the hands. Could it possibly be? he asked himself. He reached out and touched the surface lightly with the pads of his fingers, feeling the texture of the paint, the slight give of the canvas. If it is not by him, Benedetti thought, it is the best possible copy.

Benedetti stood and turned to Kennedy and Father Barber, who had fallen silent and were observing him. "Of all the paintings," Benedetti said, keeping his voice neutral, "this one is definitely the best. To understand it better, we should take it back to the gallery for cleaning and restoration. If you care," he added with a shrug.

Father Barber responded with a smile. "Oh, yes," he said. "We've always thought it to be the best work in the house."

"A good second-division work," added Kennedy with a nod.

The painting, said Father Barber, had hung for many years in the dining room, which had a high ceiling, an old coal-burning fireplace, and large windows looking out on the back garden. More recently, the Jesuits had moved it to the front parlor.

Benedetti said he would make the arrangements to pick up the painting. The restoration process, he told Father Barber, would normally take around three to four months for a painting of this size. But he also had his regular obligations at the gallery, so it would no doubt take longer.

"How long do you estimate?" asked Father Barber.

"Possibly six months or eight months," said Benedetti. "I can't say for certain. I think it should be relined first, before I can start cleaning. I'll know better then."

Father Barber, a small, trim man in his mid-fifties with lively, intelligent eyes, seemed curious about the restoration process. He asked Benedetti several questions, to which Benedetti responded politely but briefly. None of the other paintings in the residence was mentioned, nor was there any discussion of a fee for Benedetti's work. A fee was the furthest thing from Benedetti's mind at that moment. His only thought was to get this

painting into the restoration studio so that he could examine it at length and in detail.

On the way back to the gallery, Brian Kennedy noticed a change in Benedetti's demeanor. The restorer hadn't uttered a word since they'd left the Jesuit residence, and he was walking at a fast and determined pace.

"Sergio, what's up?" Kennedy asked.

"The picture is possibly much more important than they think," replied Benedetti.

"Why? What do you think it is?"

"I think it might be by Caravaggio."

"You must be joking," said Kennedy, although he could see that Benedetti was in no joking mood. Kennedy had a doctorate in art history, but his areas of concentration were twentieth-century Irish art and arts policy. He had worked at the Ministry of Fine Arts before coming to the National Gallery. He understood the import of what Benedetti had just suggested. It seemed quite preposterous to him.

"Well," said Kennedy, "I guess we should talk to Raymond straightaway."

2

RAYMOND WAS RAYMOND KEAVENEY, THE DIRECTOR OF THE
National Gallery of Ireland. Benedetti had known him for eleven
years, ever since Keaveney had arrived at the gallery as an unpaid
trainee curator. Benedetti had been in Ireland for just two years,
and he barely spoke English. Keaveney had studied art history in
Rome, and to Benedetti's relief, he spoke Italian, so they could
converse in the restorer's native language.

Keaveney had risen through the gallery's small ranks to be-
come director a year and a half ago. Now he occupied a spacious
second-floor office furnished with dark, heavy antiques. He was
a wiry man with sharp features and a crest of wavy gray hair that
grew long over his ears and collar. He tended to get excited eas-
ily. He reminded some gallery employees of a rooster.

Keaveney was seated at his desk when Benedetti and Kennedy
appeared at the door. Kennedy told him about their visit that
morning to the Jesuit residence. He wasted no time getting to
the point. "Sergio thinks one of the paintings might be by
Caravaggio."

Keaveney looked startled. "Are you serious?" he asked Benedetti.

"It is either by him, or it is the best copy of his painting," replied Benedetti.

Keaveney was deeply skeptical. He had learned to respect Benedetti's professional judgment, and he could see that Benedetti was agitated, in a state of excitement that Keaveney had rarely seen before. But to stumble across a Caravaggio in your own backyard—in Dublin, of all places—seemed wildly improbable.

Benedetti described the painting to Keaveney. He said he had immediately recognized the subject—the betrayal of Christ by Judas. Such a painting was known to have been lost for many years, Benedetti explained, although many copies had turned up. There was one in Odessa that some art historians thought might be the original, although most regarded it as a very good copy. The quality of the one in the Jesuit residence appeared equally good. "I think it could be the original," he told Keaveney. "I want to get it into the studio as soon as possible, to study it more closely."

"Of course," said Keveaney, who was himself anxious to take a look at the painting. "But how in the world did the Jesuits get it?"

Kennedy replied that they hadn't asked the Jesuits that question yet. In fact, apart from the three of them, no one else knew of Benedetti's suspicion.

"We should keep it that way, for the time being," said Keaveney, now pacing back and forth, trying to order his thoughts. "Not even other gallery personnel should know. Let's go slow

and not get ahead of ourselves. We don't want to make fools of ourselves."

Benedetti hurried out to make arrangements to transport the painting from Lower Leeson Street to the gallery. The painting was too big to carry back, too big even to fit in the trunk of his car, and the gallery did not have a vehicle of its own. Benedetti would have to lease the van of an art dealer with whom the gallery regularly did business.

Keaveney shut the door to his office and conferred alone with Kennedy. "What's your honest opinion?" he asked Kennedy.

"It all seems so unlikely," said Kennedy. "I've seen the painting before—it was hanging in the parlor—and so have a lot of other people, some of them very knowledgeable about art. It's not as if it just came out of somebody's attic."

"But if Sergio is right," mused Keaveney, "the implications are staggering. There will be dealers from London and New York with their wallets wide open. It'll be a circus!" He drew a deep breath. "The most important thing is that we get this right and don't embarrass the gallery. We must keep it absolutely quiet until we are sure of ourselves."

That evening, Keaveney tried to keep calm by telling himself that surely Benedetti was mistaken. After all, the restorer had said that many copies of the same painting existed. No doubt this was just another copy. They would proceed on that assumption.

But Keaveney's mind kept racing back to the possibility that the picture was genuine. A stroke of incredible fortune, he thought, to find a painting like that! One that would put the National Gallery of Ireland on the map! And also an incredible

burden. The gallery was ill equipped to handle a discovery of such magnitude. The professional staff numbered fewer than a dozen, including the bookkeeper, the photographer, and a part-time public relations person. One entire section of the gallery had been closed down because of chronic leaks in the roof. A larger and richer museum could assign a team of scholars to conduct a thorough investigation into the painting's provenance, and another team of technicians to carry out the scientific tests. How could the National Gallery of Ireland possibly manage it all alone?

3

BENEDETTI LEARNED THAT THE VAN BELONGING TO THE ART dealer was in use, unavailable to the gallery until the following week. The restorer resigned himself to the wait. The weekend seemed interminable. His mood shifted feverishly from elation to doubt to anxiety. One moment he was certain he had found the lost original by Caravaggio; the next moment he thought he couldn't be that lucky, it was just another copy. In his mind, he played over and over again the image he'd retained of the painting, like a lottery winner obsessively examining his ticket. He longed to see it again, to take it into his possession, to study it alone and in peace.

His greatest anxiety, one that kept him turning restlessly in bed at night, was that the painting would disappear just at the moment it was in his grasp. He imagined Father Barber calling in another restorer, or an art historian, for a second opinion. Or some antiquarian visiting the Jesuit residence and offering to buy it. In the morning light, Benedetti told himself these

thoughts were irrational, the painting wouldn't vanish in a mere four days, but in his darkest hours his fears beset him anew.

When Benedetti had first arrived in Ireland, it had crossed his mind that he might, with luck and vigilance, happen upon a valuable discovery. He knew that an endless stream of antiquities, sculptures, and especially Renaissance and Baroque paintings had flowed into the British Isles during the eighteenth century, sent back by wealthy young aristocrats on the Grand Tour. Families and fortunes had risen and fallen over the past two centuries, and many of the collections had been dispersed. Some had gone to museums, others had gone up for auction, and a few worthy pieces of art had simply disappeared. The Italian Baroque, in particular, had fallen out of favor, denigrated by critics like John Ruskin, who had written that a work by Guercino was "partly despicable, partly disgusting, partly ridiculous," a fair summary of his entire view of the era.

By the time Benedetti arrived in Dublin, the Baroque had already begun coming back into fashion. The paintings had acquired a new luster and value. Museums were spending large sums of money, sometimes millions of dollars, to obtain them. Every year or so, it seemed to Benedetti, he would read in newspapers and art journals about another remarkable discovery.

Benedetti had not expected to enrich himself personally by discovering an important painting. But he had hoped he might advance his career by publishing such a find in a prestigious art journal. Yet the years had passed, and he had found nothing of note. Perhaps, he thought, if he had ended up in England or Scotland or Wales, he would have had a better chance. He hadn't

realized just how poor Ireland had been—almost like a third world country just a decade ago, he once remarked to an Italian friend.

For twenty-five years he had tended to torn canvases and cracked panels, to cupping, flaking, peeling, and alligatoring paint. He had learned his trade at the Istituto Centrale per il Restauro in Rome, which admitted only twelve students every year. In Italy, restorers were looked upon as skilled tradesmen. Art historians, on the other hand, were regarded as professionals, on the same social level as doctors and lawyers and university professors. Benedetti had aspired to study first archaeology, and then later art history, but he had become a restorer out of necessity. He couldn't afford the years of schooling and postgraduate studies, and then the uncertain job prospects that faced a newly graduated art historian.

He had lived in Rome but had traveled all over Italy, from Sicily to Genoa, restoring frescoes and oil paintings. He had spent months in Assisi, working with a team of other restorers on the Giotto frescoes on the ceiling of the cathedral of San Francesco. He had worked on hundreds of paintings, masterpieces from the sixteenth and seventeenth centuries, although he had never laid his hands on a Michelangelo, a Raphael, or a Caravaggio.

In Rome, he often ate at a trattoria called Mario's, in the Piazza Madonna dei Monti, a short distance from the Istituto Centrale. A liter carafe of red wine cost one hundred sixty lire, the equivalent of fifty cents, a plate of spaghetti one hundred twenty-five lire, a steak three hundred lire. Mario's wife did the cooking. The place was furnished simply, with large, sturdy

wooden tables and chairs, and white tablecloths washed only once a week, but covered with butcher paper to keep them clean. The décor consisted of a Peroni beer calendar on the white-washed wall. Mario kept the door open until three in the morning. The trattoria was always crowded, loud, and convivial, always with a card game of scopa going on. Mario's attracted students and professors from the institute, sitting eight to ten to a table, and then, as word spread about the late-night discussions and debates concerning art, a few famous art historians began dropping by. At Mario's on an evening in 1968, Benedetti met Denis Mahon, then in his late fifties, dressed in his usual dark double-breasted Savile Row suit and surrounded by acolytes. The topic was Caravaggio. Benedetti entered into the discourse. Mahon seemed to take note of the young restorer's scope of knowledge.

Benedetti had, in fact, read just about everything there was to read concerning Caravaggio. His hero back then was Roberto Longhi, the master of Caravaggio studies. Mahon came in a close second. Most art historians tend to adopt a particular artist and make a career of studying him. Benedetti, the amateur, had adopted Caravaggio.

Mario's trattoria was not the sort of place Denis Mahon visited regularly, but after meeting the Englishman there, Benedetti made an effort to keep in contact with him. When there was an exhibition opening in Rome or Bologna or Florence that he knew Mahon would attend, Benedetti would try to go. At conferences where Mahon spoke, he came to listen and stayed afterward to make his presence known. Mahon remembered his name and always seemed pleased to see him. Most important, Mahon always spoke to him as an equal.

THE MORNING DAWNED CLEAR AND BRIGHT ON THE DAY BENEDETTI had arranged to pick up the painting. He felt thankful for the sunny day. In Ireland, there was always the possibility of rain, and he had not wanted to transport this painting in a downpour.

He and two art handlers from the gallery, members of what was called the Working Party, rode in the art dealer's van to the Jesuit residence. Father Barber escorted them upstairs to the library. The Working Party had brought along a roll of heavy plastic bubble wrap to protect the painting during the move. Benedetti's nerves were on edge, but he wanted to betray no emotion. He and Father Barber chatted, Benedetti keeping his voice casual, as they watched the gallery men prepare the painting for its move.

The Working Party carried the wrapped painting downstairs and installed it in the van, strapping it into place so that it wouldn't shift during the short ride to the gallery. No mention was made by Father Barber or Benedetti of a receipt or a document attesting to the terms of the transaction. Normally Benedetti or one of the Working Party would have written out such a document, describing among other things the condition of the painting. But given Brian Kennedy's relationship with Father Barber, and the unspoken agreement that the cleaning and restoration would be carried out at no cost to the Jesuits, it seemed that trust and one's word were sufficient.

Up in the penthouse studio, Benedetti had begun removing the plastic wrapping from the painting when Raymond Keaveney appeared at the door. Like Benedetti, Keaveney had spent

a difficult weekend, weighing the advantages and problems of having a lost Caravaggio on his hands. His field of study had been sixteenth-century Roman frescoes: the high Renaissance and the Mannerists. He had seen many paintings by Caravaggio in the churches and galleries of Rome, but as he gazed at this one, he admitted to himself he would not have recognized it as a Caravaggio. He stared at it, chin cupped in the palm of his hand. He thought the face of Christ and the way in which Christ's hands were clasped looked somewhat awkward for a master-piece. The details, of course, were hard to make out through the yellow film of grime and old varnish. But Keaveney's first reac-tion was one of grave doubt. He compressed his lips and shook his head slightly. To Benedetti, he said, "Ahh, I'm not so sure about this one, Sergio."

Benedetti, looking upon the painting for the first time in good light, was experiencing precisely the opposite reaction. The painting was as good as he'd remembered. At least as good, he thought, as the photographs he'd seen of the Odessa version. He forced himself to be skeptical, but he couldn't help feeling that he was in the presence of the master.

He noticed just then, for the first time, the wooden plaque attached to the frame at the bottom of the painting. It was itself dirty, the words barely legible. He gently wiped away some of the grime. The plaque read, in neat precise lettering, "The Betrayal of Christ," and beneath that appeared the name Gerard Hont-horst. In smaller lettering, in parentheses, was written "Ghe-rardo della Notte."

4

THAT AFTERNOON BENEDETTI SET ABOUT PREPARING FOR THE OP-erations he would perform on the painting. He covered the large table in the center of the studio with a white cloth and laid the painting in its frame facedown on the cloth. The back of the canvas was stained here and there and had turned brown and brittle with age. The canvas was attached to an old, heavy wooden stretcher, which in turn had been fitted into the frame and secured by a series of thin, headless brads. The brads, now rusty, had been hammered into the soft wood of the frame and bent over the stretcher to keep the painting in place. It was an old framing method. Nowadays Benedetti would use stainless-steel spring clips to attach a painting to its frame.

He removed the brads with a pair of pliers and lifted the wooden stretcher out of the frame. He saw immediately that the picture had been relined at least once before. The previous re-storer had glued another canvas onto the back of the original one and, in the process, had trimmed the old tacking edges of the seventeenth-century canvas to within a quarter inch of the

painted surface. Benedetti judged that the relining canvas was itself now more than a hundred years old. It had held up remarkably well, but the effects of gravity and repeated expansions and contractions from humidity were causing it to sag, if only slightly, on the stretcher.

Benedetti had known from the outset that he would have to reline the picture with a fresh canvas. Relining served several functions. In the first place, it provided a strong new support for the old canvas; next, the glue used in relining would penetrate the back of the picture and aid in securing any minute fragments of paint that had cupped or lifted over the years. On this painting, that damage was limited, confined mostly to the far right side, the dark areas on the shoulder and back of the second soldier. Considering the picture's age, its state of health was, all in all, remarkably good.

Gallery procedure required that before anything was done to the painting, it be photographed in its original state. Benedetti called down to the basement lab of Michael Olohan, the gallery photographer, to notify him that the painting was ready. It was Olohan's job to make a detailed visual record of each step in the restoration process of all the gallery's works of art.

Olohan took the painting down to his lab in the freight elevator and set it up on a metal easel. He was in his mid-thirties and had worked for the gallery for half a dozen years. He had photographed hundreds of paintings. He'd seen others emerge from under clouded layers of equally heavy grime. "It's like looking at a woman through a window that hasn't been washed in a hundred years, all streaked with dirt and dust," he once re-

marked. "You can tell it's a woman, but you can't tell much else. Then you wash the window and you see her shape and form, and you see that she is young and lovely."

Brian Kennedy had already alerted Olohan to the arrival of the Jesuits' picture, although he had not mentioned that it might be a Caravaggio. He had told the photographer only that he wanted a particularly thorough documentation of the painting. Olohan assumed that this was because the picture belonged to the Jesuits and not to the gallery. Olohan took photographs of both the front and back of the painting, and then several close-ups of the most important parts, the faces and hands. He made notes of the camera settings and the lighting, so that each successive series of photographs would be taken under the same conditions.

He did not recognize the painting as a composition by Caravaggio, but he did think, as he later put it, that it was "a remarkably fine work." He looked forward to watching the colors and shapes come back to life as Benedetti cleaned it.

❧

IN THE RESTORATION STUDIO, BENEDETTI EXAMINED THE FRAME. It appeared to be late eighteenth century or early nineteenth century, gilded and well made. Along the sight edges, that part of the frame closest to the picture, ran a finely carved beading, like a string of pearls, although several of them had broken off. The frame, Benedetti thought, could prove valuable in tracing the provenance of the painting.

But it was the attribution to Honthorst that interested

Benedetti most. He had read long ago, in his student days, Bellori's account of Caravaggio's life, and he'd recognized this painting the moment he saw it as the one described by Bellori. He'd also read Longhi's essay about *The Taking of Christ* and its many copies, although the details were not fresh in his mind. But the name Honthorst—he could not quite put his finger on it, it lurked just outside his memory, yet he knew he had once come across something concerning the Dutch artist and Caravaggio.

The thought no sooner occurred to him than he remembered the context. A short article by Longhi, just a note really, buried inside an issue of *Paragone,* and one paragraph in that note in which Longhi had surmised that a painting attributed to Honthorst was in reality by Caravaggio.

At home, Benedetti had a large collection of books and art journals, including a complete set of *Paragone* issues dating back to his student days. His memory told him that the painting Longhi had written about was *The Taking of Christ,* and that it had been sold to an Englishman as a painting by Honthorst. If that was true, if his memory had not betrayed him, then Benedetti knew he had his first real lead in tracing the painting's provenance.

It took him only a few minutes that evening to find the correct issue of *Paragone,* with Longhi's acerbic three-page note about the German scholar Gerda Panofsky-Soergel and her research in the Mattei archive. The reference to *The Taking of Christ* was brief—a single long sentence on the third page, a mere digression. But Benedetti saw that he had remembered correctly. All of a sudden, it did not seem so preposterous that this particular painting should end up in Dublin, just a short journey across the Irish Sea from Scotland. Benedetti resolved to make

that journey himself as soon as possible, his first stop in piecing together the painting's history.

✦

AT THE GALLERY THE NEXT MORNING, BENEDETTI SHOWED RAYmond Keaveney and Brian Kennedy the article by Longhi. He could see in the director's eyes the skepticism of yesterday begin to waver.

The obvious step was for Kennedy to ask the Jesuits how they had gotten the painting. But the mere act of posing such a question might raise in Father Barber's mind questions of his own. Keaveney didn't want Kennedy to be in the position of having to answer those questions yet. It was too early, he argued.

Benedetti would proceed with restoring the painting and, at the same time, conduct an investigation into its provenance. Father Barber didn't expect to have it back for at least six months, and they could probably delay even longer, if necessary. Until they had proof—documentation of the painting's voyage through time—they would continue to keep the matter a secret even from other gallery employees.

✄ 5 ✄

ANDREW O'CONNOR WAS THE GALLERY'S SENIOR RESTORER AND, in name at least, Benedetti's boss, although in practice he had always treated Benedetti as his equal. They shared the penthouse studio, often working side by side on different paintings, and occasionally even on the same painting. O'Connor was one of the few gallery employees who knew from the beginning that Benedetti suspected this *Taking of Christ* might be the lost original by Caravaggio.

O'Connor and Benedetti had first met more than twenty years ago at Mario's trattoria in Rome, when O'Connor was studying at the Istituto Centrale per il Restauro. Benedetti had by then graduated and gone into business for himself, and from time to time he'd hired O'Connor to help him out. Back then, O'Connor was poor, barely able to make ends meet. Benedetti had always paid him generously, often more than the sum they had agreed upon. When O'Connor took sick and lay abed in his attic room for a week, unable to negotiate the five flights of stairs, Benedetti took care of him, bringing him soup and medi-

cine, mopping his feverish brow, and arranging for a doctor to come and see him. At a St. Patrick's Day party at the Irish embassy in Rome, O'Connor introduced Benedetti to the woman who would become his wife, and then he served as Benedetti's best man.

They had stayed in touch after O'Connor left Rome and returned to Ireland. One day, years later, O'Connor received a letter from Benedetti saying that he'd reached the end of his string, he couldn't tolerate the bureaucracy in Italy, and he didn't know where to turn. O'Connor told him to come to Ireland. As it happened, the other restorer at the gallery had just quit and gone off to Australia. The job didn't pay much, but at least it paid steadily, and they could find outside work. "It's my last chance," Benedetti wrote back.

O'Connor had arranged an interview for Benedetti with James White, then the director of the gallery. White spoke no Italian, and Benedetti spoke no English. O'Connor offered to sit in on the interview and translate. White replied that O'Connor's presence would be inappropriate. O'Connor often wondered how Benedetti managed to get through that interview.

Up in the penthouse studio, O'Connor studied *The Taking of Christ*. From what he could see, beneath the dirt and varnish, the quality of this painting appeared quite good. But O'Connor had cleaned hundreds, perhaps thousands of paintings. Every now and then he'd get excited about one of them. He'd see the qualities rather than the faults. And then one day he'd come in and stare at the painting and say to himself, It doesn't look as good as it did yesterday. What was I thinking, anyhow?

For the time being, O'Connor preferred to remain skeptical.

But the painting interested him. He wanted to work on it, to get a feel for the artist.

O'Connor recalls that within a few days of the painting's arrival, Benedetti began cleaning one or two small areas, only a couple of inches square, on the periphery of the picture. This test cleaning determines which combination of solvents will work best to remove the dirt, grease, and varnish, and how the paint surface will react. In the language of restorers, the process is called "opening a window" on the painting.

Since it was Benedetti's project, O'Connor felt compelled to ask if he might work on it. Benedetti assented. O'Connor selected a dark area at the bottom, near the robe of Christ. He used cotton swabs and began with distilled water, barely dampening the swab, to remove the superficial dirt. Occasionally he wet a swab in his mouth. Saliva contains enzymes and is often effective at removing dirt and some oils. In Italy he'd seen restorers clean paintings with small pellets of fresh bread. The process of cleaning old paintings has a long history, not all of it illustrious. In previous eras, paintings had been variously scrubbed with soap and water, caustic soda, wood ash, and lye; many had been damaged irreparably. An older restorer once described paintings to O'Connor as breathing, half-organic entities. "It's a good thing they can't cry," this restorer said, "otherwise you would go to museums and have to put your fingers in your ears."

Looking at the Jesuits' painting, O'Connor judged that it had survived earlier cleanings rather well. The paint surface was largely intact. O'Connor had seen all types of cracks in the brittle surfaces of paintings—spoke cracks, spiral cracks, garland

cracks, flame cracks, net cracks, grid cracks. They were all signs of damage of one sort or another. But this one had only the characteristic and inevitable craquelure of old age, something no restorer could remedy even if he wanted to.

After half a dozen swabs, O'Connor had cleared away the initial layer of dirt. The window, a few inches square, was still just barely opened. He had reached a more resistant layer of microscopic particles bound by oils, grease, perhaps even some tars from tobacco smoke, a common contaminant in privately owned paintings. In the case of this one, which had hung in the Jesuit dining room, coal dust and smoke from the fireplace had probably been bound into the mixture.

From experience, O'Connor knew which solvents worked best at removing this layer. He preferred acetone because it evaporated so quickly that it remained only briefly on the paint surface. He also used white spirits and alcohol. Often he would mix several solvents. At the Istituto Centrale, he had learned a dozen different recipes. One of the most common was called 3A—acetone, alcohol, and acqua (water), in equal parts.

He began with a dilute solution of acetone, increasing the strength as he went on. The film of dirt and oil came away, and then the yellowed varnish. Within the confines of the small window, he began to glimpse the depth and intensity of the colors in the original paint. Under the microscope at low power, he could see the clear contours of the brushstrokes. If this picture was in fact by Caravaggio, O'Connor knew that he had come as close to the hand of the master as anyone could.

DURING THE NEXT FEW WEEKS, O'CONNOR WATCHED AS MORE OF the painting began to emerge in ever larger windows made by Benedetti. He began to notice that Benedetti was coming in to work at odd hours, times when O'Connor wasn't around. To O'Connor, it seemed that Benedetti was avoiding him, that he wanted to work alone; he had the distinct sensation that Benedetti had become strangely possessive about the painting. In Benedetti's absence, it sat on its easel, covered by a green felt cloth.

One day, about three weeks after the painting's arrival, O'Connor and Benedetti crossed paths in the studio. Benedetti was staring at the painting. He stood with his arms crossed, his eyes narrowed in concentration, his mouth compressed into a frown.

"Look at the arm of Judas," Benedetti said to O'Connor. "What do you think?"

O'Connor studied the painting. "What are you getting at?" he asked.

"It seems too short, doesn't it?" said Benedetti.

It did. A subtle error of proportion, not immediately evident in the context of the entire painting.

"It looks like he painted the shoulder and then didn't have enough room for the arm," said Benedetti.

O'Connor understood that Benedetti was wrestling with his doubts.

"Well," said Benedetti finally, "he wasn't a perfect anatomist. He made other errors like this. In *The Supper at Emmaus,* the apostle's hand is too large."

BENEDETTI DID EXPERIENCE A FLEETING MOMENT OF DOUBT AFTER he'd had the painting for about a month. Looking back on it, he couldn't recall with precision why he'd felt that way. It had not been the arm of Judas, or any specific aspect of the painting itself. In fact, just the opposite. If anything, that spasm of doubt had afflicted him because everything seemed to be going too perfectly. He simply couldn't credit his own good fortune.

As he opened larger windows and stripped away layers of dirt and varnish, he became more and more certain that the painting really could only be by Caravaggio's hand. Apart from the quality of the brushwork, the speed and assurance with which Caravaggio had painted, Benedetti had come across several telltale pentimenti, errors of the sort that a copyist would not likely make. The most significant, visible to the naked eye, was on the head of Judas. Benedetti had found it only because the painting had been cleaned too harshly in the past. Two centimeters above Judas' ear, Benedetti saw the ghostly image of another ear. Caravaggio had painted from live models directly onto the canvas, without making preliminary drawings. He'd probably started his compositions with the face, perhaps the ear, of a central figure. This pentimento supported just such a hypothesis. Clearly Caravaggio had second thoughts and painted over the first ear, but an earlier cleaning had abraded that layer of pigment.

Benedetti discovered other small pentimenti, also visible to the naked eye, such as the belt on the soldier at the center of the

picture, which Caravaggio had enlarged to fit the brass buckle that he'd already painted. And the restorer had found one of Caravaggio's characteristic touches, scoring marks that the painter had made with the butt end of his brush in the wet ground to define the lances that the soldiers carried.

6

BENEDETTI HAD A SMALL OFFICE, NO BIGGER THAN A CLOSET, ON the third floor of the gallery. The furniture consisted of a wooden desk that faced a single round window with a view of Merrion Square, a chair, a bookcase, and a four-drawer filing cabinet. He cleared out one of those drawers and began assembling a dossier on *The Taking of Christ.* In one file, he kept detailed notes on the restoration process and his observations on the state of the painting. He also started several other files—on Hamilton Nisbet, on the Mattei family, on Caravaggio. He gathered together all of his books and articles on Caravaggio and arranged them in the bookcase. When he was not working upstairs in the studio, he came to his office and started filling his files with notes.

He knew that Caravaggio had made at least three, and perhaps four, paintings for the Mattei family. One of those, he believed, was upstairs in the restoration studio. The second one, *The Supper at Emmaus,* was at the British National Gallery in London. Benedetti had seen that picture several times, the painting with the apostle's hand that was too big. On his next trip to

London he would study it again, this time with an eye to detecting stylistic and technical similarities between it and *The Taking of Christ*.

He'd also seen the third painting—the young *St. John* at the Capitoline Gallery in Rome. On his last trip to Italy, only six months before, he'd bought a copy of the *St. John* symposium catalogue published by Correale. Now he went back to that catalogue and studied it with new interest, scrutinizing the photographs in the technical section. There were several close-ups of the canvas that Caravaggio had used to paint the *St. John*. To Benedetti's eye, that canvas, made of heavy hemp, eight to nine threads per centimeter, seemed identical to the canvas of *The Taking of Christ*. The painter had probably cut both canvases from the same long roll. The catalogue also contained a detailed chemical and spectrographic analysis of the pigments that Caravaggio had used. It would be useful, thought Benedetti, to compare those pigments with those in *The Taking of Christ*, but the gallery didn't have the scientific instruments to make such analyses.

He turned to the essay by Francesca Cappelletti and Laura Testa on the history of the *St. John* and the Mattei archive. He began reading it closely, taking notes. He knew the names of many art historians who had written about Caravaggio, but he did not recognize either of these writers. They had somehow managed to get into the Mattei archive in Recanati, which Longhi had complained, twenty years earlier, was closed to Italian scholars. The essay contained only two paragraphs about *The Taking of Christ*, most importantly the date and sum of Ciriaco's payment to Caravaggio. Benedetti wanted to see those docu-

ments for himself, and to see what else the archive might tell him about *The Taking of Christ*. He would have to make a trip to Recanati.

Benedetti knew that Caravaggio had lived in Ciriaco Mattei's palazzo for around two years. He had probably left, going out to live on his own, shortly after January 2, 1603, the date of Ciriaco's last payment, which had been for *The Taking of Christ*. He had managed to stay out of trouble with the law for most of those two years. And he had been very productive, painting more than half a dozen works in addition to those for Ciriaco.

※

ONE OF CARAVAGGIO'S REGULAR MODELS HAD BEEN A YOUNG woman named Fillide Melandroni. He posed her as St. Catherine of Alexandria for a painting that Cardinal Del Monte had owned. She was seventeen, perhaps eighteen years old when Caravaggio first painted her. She had full lips, a milky complexion, and abundant blond hair, which she wore up, with ringlets cascading down the side of her face and neck. In her eyes—dark, lively, slightly mocking—one could see intelligence, wit, and also a fiery temperament. She made her living as a high-class prostitute, a courtesan. Her official lover was a Florentine man of letters named Giulio Strozzi, middle-aged, rich, with connections to the Church. He bought her jewels, and gowns of silk embroidered with gold thread. She had Caravaggio paint her portrait for Strozzi, although Strozzi allowed her to keep the painting in her own house.

Her unofficial lovers were many, and perhaps Caravaggio

was among them. Another was a young man in his early twenties named Ranuccio Tomassoni, whom Caravaggio knew and disliked. Ranuccio was the youngest of six brothers, several of them former soldiers who had fought in Flanders and Croatia during the French Wars. They ruled their neighborhood in Campo Marzio with violence and impunity; even the police would back away from a confrontation with them.

Fillide's relationship with Ranuccio was tempestuous. Early one morning in December 1600, she went to his house in the Piazza della Rotunda, facing the Pantheon. A man named Antonio stood by the fire, warming himself. He later recounted the events of that morning to a magistrate. Fillide ran past him, according to Antonio, up the stairs to the bedroom of Ranuccio. Antonio followed. Ranuccio was still in bed, and beside him was a prostitute named Prudenza. Fillide started screaming at Prudenza, "You filthy whore, here you are!" She ran to a table and picked up a knife, and then rushed at Prudenza, shrieking, "I am going to cut you from here to there, you slut!" Antonio quickly wrested the knife from her, but Fillide went at Prudenza with her fists and grabbed her by the hair. "She pulled a lot of hair out," Antonio testified. Ranuccio managed to separate them, and Fillide, still yelling oaths and threats at Prudenza, finally departed.

Fillide had not finished with Prudenza. Later that day, she and a friend, another prostitute called Tella, came to the house where Prudenza lived with her mother. They forced their way in, pushing aside Prudenza's mother. Fillide, knife in hand, again came at Prudenza, trying to cut her in the face. Prudenza put her arm up in defense and received a gash on her wrist. Fillide man-

aged to inflict a small cut just above Prudenza's mouth, and then she left, screaming that she would be back to cut up her face properly.

Scholars have not yet found Fillide's testimony concerning the dispute, nor the ultimate disposition of the case. In the years that followed, however, Fillide maintained her connections with Ranuccio Tomassoni and his family. She acquired a house on Via Borgognona, next door to Ranuccio's older brother Giovan Francesco. She never married, but she grew wealthy as a courtesan and continued her relationship with Giulio Strozzi, who persisted in trying to wed her. She died in 1618, at age thirty-seven. In her will, written three years before her death, she stipulated that Caravaggio's portrait of her be returned to Strozzi. But by then, Strozzi had also died.

Caravaggio had stopped using Fillide as a model by the time he moved out of Ciriaco Mattei's palazzo, in 1603. He soon took up with a new woman from the Piazza Navona, elegant and dark-haired, whose name was Lena. She first appeared as the Madonna of Loreto in a large altarpiece for the church of San Agostino, near the Piazza Navona. Less than a year later, he used her again for the *Madonna with St. Anne*. In the middle of that year, a young notary named Mariano Pasqualone began courting Lena. Caravaggio encountered Pasqualone one night in July on the Via del Corso, and they had a heated exchange about Lena. Two days later, shortly after dusk, Caravaggio came up behind Pasqualone, who was strolling with another man in the Piazza Navona. With his sword, he hit Pasqualone on the back of the head, knocking him to the ground, and then he fled into the dark. Still bleeding from the gash in the head, Pasqualone gave a statement to the

clerk of the criminal court. "I didn't see who wounded me, but I never had a problem with anyone except the said Michelangelo. A few nights ago he and I had words on the Corso on account of a girl called Lena. . . . She is Michelangelo's girl."

Caravaggio immediately left Rome to avoid arrest. He had been living at the time in a small house in the Campo Marzio, in a narrow street called the Vicolo San Biagio. In spite of his fame, he lived a spare and disorderly existence. He wore his clothes, by one account, until they "had fallen into rags," and was "very negligent of personal cleanliness." He fell six months behind on his rent, even though a single painting by him commanded a sum large enough to pay for two full years. The details of his domestic life are known because his landlady, Prudenza Bruna, went to court seeking the unpaid rent after Caravaggio suddenly disappeared. In addition, she stated that Caravaggio had put a large hole in the ceiling on the second floor, where he had his studio. As compensation, the court gave her a mandate to seize his belongings. A clerk made an inventory of those—a sorry list of dilapidated furniture, a few utensils and plates, some torn clothes, a dozen unnamed books, two large unpainted canvases, a wooden easel, and an assortment of props that he used in his paintings, among them mirrors, vases, swords and daggers, and some cheap jewelry.

He was absent from Rome for almost a month; some said he'd gone to Genoa. He returned at the end of August after working out an agreement with Pasqualone to drop the criminal complaint in exchange for a formal—and rather abject—statement of apology. On his return, he learned that his landlady had seized his belongings. He was furious. He came at midnight to

the landlady's house and hurled stones at her windows, breaking the wooden shutters. She lodged another complaint.

His work was in great demand and yet his behavior was growing increasingly erratic. One report from a Flemish painter who was in Rome in 1604 described his comportment this way: "After a fortnight's work, he will swagger about for a month or two with his sword at his side and a servant following him, from one ball court to the next, ever ready to engage in a fight or argument, with the result that it is most difficult to get along with him."

Three months after his attack on Pasqualone, Caravaggio was himself assaulted and seriously wounded. A clerk of the criminal court came to interview him while he was recuperating at the house of a friend named Andrea Rufetti near the Piazza Colonna. The clerk noted that Caravaggio was in bed and had wounds on his throat and left ear, which were covered with dressings. The clerk asked who had attacked him. Caravaggio replied, "I wounded myself with my sword when I fell on the stairs."

The clerk, obviously skeptical, asked for details. Caravaggio said, "I don't know where it happened, and no one else was present."

The clerk pressed him. Caravaggio responded: "I can say no more."

During his recovery, Caravaggio began with his second Lena painting, the *Madonna with St. Anne*. It was a prestigious commission, intended for display in a chapel at St. Peter's, and especially important to Caravaggio because, in spite of his popularity, he had suffered several professional setbacks. Two months before

his attack on Pasqualone, he had delivered a painting of the death of the Virgin, a huge altarpiece measuring twelve feet by eight, to the church of Santa Maria della Scala in Trastevere. The church rejected it outright, although it was later bought by the Duke of Mantua and ultimately would end up in the Louvre. Caravaggio had depicted Mary stretched out on a table, head canted to the side, arm flung out, face and body swollen in death. He had depicted "the corpse of an ordinary woman," said one of his critics. And that woman, the model for Mary, was a known prostitute, also known to be Caravaggio's lover. "Some filthy whore from the slums," wrote the physician Giulio Mancini, who had once treated the painter for an illness.

Caravaggio finished the second Lena painting in March 1606, while still at the house of his friend Rufetti. It went on display at the chapel in St. Peter's in April. Within the month, it was taken down. The Church never offered an official reason for its removal, but Caravaggio's critics maintained that the cardinals had found it offensive. Lena looked too voluptuous to be the Madonna, her breasts swelling from the top of her low-cut gown. And her son, Jesus, depicted as a four-year-old boy, was too overtly naked, his genitals in full view.

It was his second rejection within the span of a year. Caravaggio took to the streets with his friends, his mood foul. For two months, he didn't work. He drank and spent time at the ball courts, an open dusty expanse near the Via della Pallacorda, playing and wagering on a racquet game similar to tennis. In late May, he encountered Ranuccio Tomassoni, Fillide's onetime lover, in the Piazza San Lorenzo in Lucina. The details of that encounter were not recorded, but it is known that the words ex-

changed were heated. The two men had known each other for six or seven years, since the time they had both been involved with Fillide. Some historians have suggested that she might have been at the center of their enmity. The contemporary reports all stated that Caravaggio owed Tomassoni ten scudi for a wager over a ball game. Perhaps that was true, but their mutual hostility had origins—women, slights, and insults—that went back much further.

Two days after their argument, on the afternoon of May 28, a Sunday, Caravaggio and three of his friends came through the Piazza San Lorenzo on their way to the ball courts at Via della Pallacorda. All were armed with swords. The piazza was the Tomassoni clan's territory, the site of the house where their patriarch had lived for many years and where the brothers had all grown up. Caravaggio's passage through the piazza, armed and with friends, was a deliberate provocation. And Ranuccio Tomassoni reacted by arming himself and following Caravaggio to the ball courts in the company of his older brother, Giovan Francesco, and the two brothers of Ranuccio's wife, both with reputations for violence.

On that afternoon at Via della Pallacorda, the confrontation was not with racquets and balls, but taunts and epithets. It ended with swords. Some accounts suggest that Caravaggio and Ranuccio Tomassoni faced off against each other, with their friends looking on from the sidelines. Others describe a general mêlée. The fight, according to one description, went on for a long time, but in the case of two men going at each other with swords, muscle fatigue and exhaustion would have set in within several minutes. Tomassoni, then twenty-seven and the younger

man by almost a decade, fell to the ground—perhaps in retreat, as one account reported, or perhaps from a misstep. Caravaggio stood over him and aimed a thrust at his genitals, intending not to kill but to humiliate, possibly even to emasculate. His sword caught Tomassoni in the upper thigh, severing the femoral artery.

As Tomassoni lay on the ground, blood jetting from his wound, his brother attacked Caravaggio, cutting him deeply with his sword in the head and neck. And by now the fighting was general. Caravaggio's friend Petronio Troppa, a soldier from Bologna known as the Captain, came to his aid. Tomassoni's two brothers-in-law joined in. The Captain was wounded in the left arm, the thigh, and the foot. Caravaggio, bleeding copiously from his head wound, fled to safety. The Tomassoni clan carried Ranuccio back to the house in the Piazza San Lorenzo.

Ranuccio Tomassoni died there, supposedly after making a last confession, although a severed artery wouldn't have permitted time for confession. He was buried the next morning in the Pantheon. His brother and his two brothers-in-law fled Rome to avoid arrest. The authorities began searching that evening for Caravaggio, but his immediate whereabouts were unknown. He might have sought refuge with Del Monte, whose residence was nearby. Two of his friends also left the city. Only the Captain from Bologna, owing to the serious wounds in his left leg and foot, was unable to escape arrest. He was apprehended and jailed in the Tor di Nona, where the barber who operated on him reported removing seven pieces of bone from the wound in his arm and judged his survival unlikely.

Caravaggio escaped from Rome sometime within the following two days. He went by horseback, or possibly by carriage,

assisted by friends. His injuries prevented him from traveling alone. He was a hunted man. Within the Papal State, his crime carried a bando capitale, a death sentence that anyone could enforce without fear of prosecution. And he also knew, to a certainty, that the Tomassoni brothers would be seeking their own revenge.

His destination was first reported to be Florence, some thought perhaps Modena. Both were wrong. He went to the south, to the Alban Hills. He would never again see the city of Rome.

❧ 7 ❧

RELINING A PAINTING IS NOT A DECISION THAT A RESTORER MAKES lightly. It is the equivalent of cardiac surgery, a delicate and invasive procedure that subjects a painting already weakened by age to great stresses.

All restorers who have been around for any length of time have seen relining disasters and have heard about others. Michael Olohan, the gallery photographer, once watched another restorer glue on a relining canvas with an iron that turned out to be too hot. The restorer lifted the picture off the table and discovered that most of the paint surface had become detached from the canvas and fused to the top of the table.

Benedetti, however, was a skilled restorer and had performed this operation many times without mishap. This painting had become the most important of his career, and he approached the procedure with great care. Relining would occupy him for several days.

His first task was to protect the picture's surface by facing it with tissue paper. On the electric hotplate in the restoration

studio, he mixed up a pot of glue, following a basic recipe he had learned years ago at the Istituto Centrale per il Restauro—a quantity of pellets of colla forte made with rabbit-skin glue, an equal quantity of water, a tablespoon of white vinegar, a pungent drop of purified ox bile, and a dollop of molasses to give the mixture elasticity. There were many such recipes, some consisting of fish glue instead of rabbit, some calling for an ox skull, which contained large amounts of collagen. And there were, of course, modern mixtures containing synthetic resin adhesives that one could buy prepackaged. Benedetti had tried some of them, but he preferred making his own glue according to the old recipes.

To the basic mixture, Benedetti stirred in more water until the glue became very dilute and ran off his whisk like a thin syrup. He left it to cool, using the time to cut up large squares of tissue paper. When the glue was just tepid, he dipped a wide brush into the pot and spread a thin layer on top of the painting, and then applied one of the sheets of tissue paper, brushing more glue over the tissue. The paper functioned as a temporary protective layer and prevented the loss of any paint flakes during the stress of relining. Benedetti repeated this process until he had covered the entire surface of the painting, and left it overnight to dry.

The next morning he took the painting off its wooden stretcher by removing the old, rusty broad-headed nails around the tacking edge of the canvas. When the picture was free of the stretcher, he turned it facedown, with its tissue covering, onto the soft cloth that covered the table. The painting was particularly vulnerable in this state, just a loose piece of canvas without

the rigid support of the stretcher. He began detaching the old lining. It was brittle and tore easily into long strips, two to three inches wide, which Benedetti pulled away with relative ease, as if skinning a carcass. The paste glue used by the previous restorer more than a hundred years earlier turned to a grainy powder as he separated the two canvases. Only occasionally did he have to resort to using a scalpel.

Once he had removed the old lining, he brushed away the powdery residue of its glue and then used a flat wooden scraper to detach any particles that still adhered. It was vitally important to have a smooth and flat surface on which to attach the lining. Any small lumps between the lining and the original canvas would distort the painted surface.

The back of the original canvas had turned dark brown with age. Like the canvas used in the *St. John* of the Capitoline, it was made of a single sheet of good-quality hemp, without any seams or tears or knots in the weave.

On the following day, Benedetti would begin the last and most arduous stage of the procedure—attaching a fresh lining to the back of the old canvas.

THERE IS MUCH DISPUTE ABOUT WHAT HAPPENED NEXT. FOR Benedetti, restoring *The Taking of Christ* was the greatest moment in his professional career, and to this day he adamantly denies that he had any problem relining the painting. O'Connor and others at the gallery, however, tell a very different story. According to them, he came close to ruining the painting.

O'Connor recalls that the gallery had run out of the loose-weave canvas common to Italian paintings. Ordering another roll from Italy and having it shipped to Dublin would take several weeks. But there was, standing in a corner of the restoration studio, a tall roll of Irish linen canvas. The usual practice called for using a lining similar to the original canvas. The Irish linen, however, was of high quality, densely woven and durable. O'Connor remembers that Benedetti elected to use the Irish canvas rather than wait for the Italian to arrive.

In O'Connor's account of events, Benedetti cut a large sheet from the roll, several inches longer and wider than the original canvas, so that he'd have ample room for the tacking edges. He fixed the borders of the Irish canvas securely in an expandable metal frame called a Rigamonte stretcher, developed by an Italian especially for use in relining. In a large pot, he cooked up some more glue from his basic recipe. This time he thickened it with quantities of flour, adding water until it had a gruel-like consistency. He added more molasses for greater elasticity. When the glue had cooled, he brought the pot to the table and spread it on the back of *The Taking of Christ,* using a wooden spatula with shallow notches in it.

As there are modern adhesives, so there are also modern methods of relining. These require large and expensive instruments such as heat tables and low-pressure tables, which create partial vacuums to seal one canvas to another. The gallery had a rudimentary heat table, but Benedetti again preferred the old way, which had been tested over the centuries. He felt he had more control when he was touching the painting directly.

Benedetti placed the new lining, taut in the Rigamonte

stretcher, on the back of the old painting. Then, with a wooden squeegee, and occasionally with the palms of his hands, he pressed the lining firmly into the glue, beginning in the center and working his way out to the edges, forcing the excess glue out from between the two canvases.

When Benedetti had removed as much glue as possible, he took the painting off the table and set the Rigamonte stretcher on end so that air could circulate around it and the water in the glue would begin to evaporate. This stage could take anywhere from a few hours to a day, depending on the temperature and humidity. In Italy, at the Istituto Centrale, they taught students to test the rate of evaporation by putting the palms of their hands on the back of the relining canvas. When it felt just barely damp to the touch, that was the time to apply heat and pressure to create a strong bond between the canvases. Knowing the right moment was a matter of experience and judgment.

Ironing is the final act in relining. It bonds the two canvases together and serves to flatten and secure particles of paint that have cupped and lifted from the picture surface. The process horrifies those uninitiated in the secrets of restoration. In the hands of someone unskilled, it can ruin a painting, as Olohan had seen with his own eyes. Too much heat, too heavy a hand, and the paint surface under the tissue paper can scorch or even melt.

The studio had several heavy irons made especially for relining. The newer ones had temperature controls. Both Benedetti and O'Connor believed their readings were unreliable. They preferred using the oldest of the irons, shaped like a tailor's iron, heated by electricity and weighing around twelve pounds. It had

a cracked wooden handle and a rusted, paint-splotched base, but a clean, smooth ironing surface, and it generated a constant temperature.

<center>❧</center>

THE DAY AFTER BENEDETTI RELINED THE PAINTING, MICHAEL Olohan came up to the studio from his basement lab. Having taken detailed, close-up photographs of the painting at each stage of the restoration process, he had gotten to know it intimately— every square inch of it, he liked to say. And by now he'd also heard the rumor that it might be a Caravaggio. He was hoping that it was, for Benedetti's sake as much as the gallery's. "For an Italian restorer to discover a Caravaggio, that's like having your number come up at the biggest lotto drawing of the century," Olohan said.

In the restoration studio, Olohan saw the painting sitting on the easel. He recalled that Benedetti had taken off the tissue facing. Olohan could not believe his eyes. In his words, "There were areas that had hairline cracks, like a sheet of ice that has started to melt, a flash of cracks all over it. I was shocked. I couldn't believe it."

Benedetti was not in the studio. Olohan went looking for Andrew O'Connor. When he found O'Connor, he said, "Andrew! What the hell has happened to the picture?"

O'Connor had already spoken to Benedetti, who had been terse. The problem, O'Connor said, had been caused by the Irish canvas. Because it was densely woven, it did not absorb the glue at the same rate as the old Italian canvas. It had not dried

properly and had contracted, pulling with it the Italian canvas and raising ridges, small corrugations, in the paint surface. Along those corrugations, the paint layer had cracked and lifted.

O'Connor had the impression that Benedetti wanted no advice and no help in solving the problem. He thought Benedetti had looked concerned, but not alarmed, and certainly not panicked.

Olohan saw Benedetti the next day. The dark look on the restorer's face kept Olohan from saying anything about the painting. It wasn't his place, thought the photographer, and besides, there was nothing to say. Olohan felt bad for Benedetti. He had seen Benedetti successfully reline paintings much more difficult than *The Taking of Christ,* on one occasion a painting so large it took up the entire floor of the restoration studio.

O'Connor knew how much this painting meant to Benedetti. Their relationship, once so close, had changed in recent years. The distance between them had grown even wider around the time *The Taking of Christ* had arrived at the gallery. Yet O'Connor thought he understood what Benedetti must be going through. He had damaged the very thing that he had come to care most about. "I could imagine his unhappiness inside," O'Connor said.

⚜

THE FEW PEOPLE AT THE GALLERY WHO KNEW WHAT HAD HAPpened did not discuss it in Benedetti's presence, and he never brought up the issue himself. O'Connor, in the studio every day, left Benedetti to his own devices. They did not speak much anymore.

The painting sat on an easel, covered by the baize blanket. O'Connor assumed that Benedetti was taking his time to consider possible remedies. In fact, there was no reason to hurry, since the damage had been done and it wouldn't grow any worse.

One possibility was to remove the Irish canvas and line the painting with an Italian canvas. But this would once again subject the picture to the stresses of relining. O'Connor remembered that Benedetti tried to solve the problem by ironing out the Irish canvas, and to some extent, that worked, reducing the dimensions of the cracks in the painting. But it didn't work well enough. The painting would have to be relined again.

Some years later, in an exhibition catalogue titled *Caravaggio: The Master Revealed,* Benedetti would write that an earlier relining, carried out in the nineteenth century by an unknown restorer, had "caused shrinkage of the surface in some limited areas." His relining, he asserts, was not the cause of this damage. He dismisses the accounts of Andrew O'Connor, Michael Olohan, and others at the National Gallery. "They don't know anything about this," he said. "Obviously they are people who are very jealous of me and my success."

8

Awaiting arrival of the Italian canvas, Benedetti took a trip to Edinburgh. He retraced the steps that Francesca had taken only a few months earlier, although he was unaware of this. If the clerks at the Scottish Record Office, the archivist at the National Portrait Gallery, or the middle-aged bespectacled woman at the old Dowell's auction house thought it peculiar that yet another Italian was asking for information on William Hamilton Nisbet, none of them told Benedetti so.

At the National Portrait Gallery, he found the 1921 auction catalogue that Francesca had seen, with the handwritten annotation of eight guineas next to *The Taking of Christ*. To Benedetti's eye, it looked as if the auctioneer had jotted down in the margin of the catalogue the reserve prices for each of the paintings, the minimum prices at which Dowell's would sell the paintings. The sums looked too uniform to be sale prices. He couldn't be certain of this, of course, but he thought it possible that the painting had failed to sell, even at eight guineas, and the auction house had retained it.

At the Scottish Record Office, he pored through the box of files containing the assorted papers of the Hamilton Nisbet family. He came up with two valuable documents in Italian, receipts that Duke Giuseppe Mattei had signed acknowledging payment for six paintings, among them *The Taking of Christ* by Honthorst.

Benedetti began assembling a portrait of Hamilton Nisbet, although it was a vague and indistinct portrait. He had studied at Eton, served in the 3rd Dragoon Guards, and had briefly been a member of Parliament. He had twice taken the Grand Tour to Italy, but he had left no diaries or journals that Benedetti could find, no personal commentary that would give flesh to the man.

Benedetti's most important discovery happened at the National Gallery of Scotland. There, he saw the two Mattei paintings—one by the studio of Francesco Bassano, the other by Serodine—that the gallery had acquired in 1921, after the death of Hamilton Nisbet's last direct descendant. Both paintings had carved, gilded frames like the one on *The Taking of Christ*. The frames were identical, down to the pearl sight moldings.

Benedetti had not doubted that the painting in Dublin had come from Hamilton Nisbet's collection. The mistaken attribution to Honthorst, perpetuated over two hundred years, had been sufficient for him. But now, he had something more. The frames provided physical proof of a direct link to Hamilton Nisbet, and the documentary trail linked Hamilton Nisbet to the Mattei family.

RAYMOND KEAVENEY HAD BECOME A BELIEVER. THE DIRECTOR was by now convinced that Benedetti had found the lost painting by Caravaggio. The documentary evidence and Benedetti's discoveries in Scotland all fit together as neatly as the pieces of a jigsaw puzzle.

Keaveney now began worrying about the future. He doubted the Jesuits could afford to keep the painting. It would cost a huge sum to insure, and the Jesuit residence, with people coming in and out all the time, lacked the security to keep an object of such value. They would probably have to sell it. And that was Keaveney's greatest fear. He knew there would be no lack of ready buyers. Once the Jesuits knew the truth about the painting's origins, his task would be to persuade them to keep it in Ireland as part of the country's national patrimony. He hoped he could persuade them to leave it at the National Gallery of Ireland on a permanent loan: where it would be safe, where others could see it, and where it would add luster to the gallery's reputation.

All of this presumed, of course, that the Jesuits actually owned the painting. That was Keaveney's other worry. He did not yet know how they had happened to acquire it, whether they had purchased it or someone had given it to them. If it had been a gift, it was always possible that the owner, or some heir of the owner, might emerge to claim it, once its true value was known. Given the amount of money at stake—tens of millions, certainly— the issue of ownership could turn into a legal nightmare, one that might take years to resolve.

Keaveney and Brian Kennedy had decided that Kennedy would keep in touch with Father Barber. He would stop by the

Jesuit residence every so often and let the priest know how the restoration was proceeding. Kennedy had no desire to lie to Father Barber. But he would tell him only what they knew for certain.

In his first report, a few months after Benedetti had taken the painting, Kennedy informed Father Barber that the restoration was proceeding more slowly than they had anticipated, but that the painting was "a fairly good" Italian work.

Father Barber looked concerned. "Italian?" he said. "Does that mean that it is not a genuine Honthorst after all?"

"Oh, no, no," replied Kennedy. "Honthorst worked in Rome, and if it is by him, it was almost certainly painted while he was there. We're looking into that aspect."

Father Barber appeared relieved.

On Kennedy's next visit, some months later, he informed Father Barber that the painting was a *very* good Italian painting. "In the manner of Caravaggio," Kennedy added.

Father Barber was pleased to hear this. He asked how the restoration was coming along.

"Oh, it's coming along quite well now," replied Kennedy. "There was a problem at the beginning because Sergio didn't have the right type of canvas for relining it."

"I see," said Father Barber.

"It is going to take longer than we thought," explained Kennedy. "Sergio has a lot of work to do for the gallery. We have an exhibition of fifty-four paintings that are traveling to America this summer, and he must put those works in order."

"Ah," said Father Barber.

Back at the gallery, Kennedy met with Keaveney and

Benedetti. Father Barber was a reasonable and patient man, Kennedy said, but perhaps it was time they invited him over to see his painting. After all, they'd had possession of it for almost a year now.

Keaveney saw no harm in this.

⋇

BENEDETTI HAD RELINED THE PAINTING WITH A FRESH ITALIAN-woven canvas. The process had gone without incident, and the cracks caused by the earlier relining were barely detectable to the uninformed eye. O'Connor, of course, could see them, but even another restorer, one with no knowledge of what had happened, would likely attribute them to age. And the average viewer, looking at the painting in the gallery, would never notice them.

By the time Father Barber visited the studio, Benedetti had also finished cleaning away the brown haze of dust and grime. The colors and details had emerged with a vivid luminosity.

Father Barber stared at the painting as if seeing it for the first time. "I hadn't realized," he murmured, "just how different it would look. It really is quite beautiful, isn't it?"

Everyone nodded assent.

The painting, Benedetti explained to Father Barber, was ready for in-fill and retouching, the final and most time-consuming stages of restoration. He had removed all the work of the previous restorer, revealing many small lacunae, spots of missing paint fragments that showed starkly here and there, down to the original ground on the picture. Most were no larger than the size of a

thumbtack, and some were much smaller. The majority were scattered on the right side of the picture, where the damage had been most severe. Benedetti explained that he would have to fill all those lacunae with thin layers of a putty-like substance to bring the gaps level with the paint surface. And then he could begin retouching, mixing paints made in Italy especially for restoration. They were varnish-based, which meant that they dried quickly and were easy to remove.

Father Barber followed all of this with intense interest. He had many questions, about the use of solvents and why they hadn't also dissolved the paint, about the substance Benedetti would use to fill the lacunae, about matching the colors for retouching. Benedetti answered patiently.

Father Barber had understood from the beginning that the process would be long and meticulous, but now he had a new appreciation of just how long and meticulous. He also understood that Benedetti could work on the painting only part-time, and that the traveling exhibition to America would occupy him for some months to come.

❧ 9 ❧

THE NATIONAL GALLERY OF IRELAND POSSESSED A SINGLE PAINTING by Rembrandt, done in 1647, called *The Rest on the Flight to Egypt*. It was a small and dark painting, a landscape at night, which the gallery had always promoted as one of its main attractions. "Our grandest prize," Raymond Keaveney called it.

Keaveney had gotten a telephone call some months earlier from Neil MacGregor, the director of the National Gallery in London. MacGregor wanted to borrow the little Rembrandt for an exhibition. Could Keaveney make it available?

Requests of this sort are routine between gallery directors, although they often involve considerable bargaining. To Keaveney, it was important to maintain good relations with the British gallery, which was much larger and far richer than its Irish sister. London, for example, owned twenty Rembrandts. Keaveney told MacGregor that they could work something out, although as MacGregor surely knew, the painting was the Irish Gallery's most important work. How long would London want to keep it?

Nine months, replied MacGregor.

Nine months? repeated Keaveney.

A big and important exhibition, explained MacGregor, paintings, etchings, and drawings that would travel to Berlin and Amsterdam.

Keaveney was in a quandary. He wanted to accommodate London, but to have the Rembrandt gone for so long would be painful. On the other hand, he knew he could ask MacGregor for something in return, for reciprocity, but what?

Keaveney made a trip to London, where he wandered around the National Gallery, gazing at its many masterpieces, considering what he might like to have in place of the Rembrandt.

He paused in the vast gallery of Italian Baroque paintings. Denis Mahon owned half a dozen pictures in this gallery, all by Guercino and Guido Reni. All were on long-term loan, although Sir Denis had made it clear that someday the National Gallery would own them outright. The room also contained three paintings by Caravaggio. One, *Boy Bitten by a Lizard,* was a small work, done in the early days when Caravaggio was selling his paintings on the street. The second, dark and melancholic, was *Salome Receives the Head of John the Baptist.* Caravaggio had painted it in 1607 in Naples, where he'd fled after the death of Ranuccio Tomassoni. And the third was *The Supper at Emmaus.*

Keaveney stood in front of the Caravaggio pictures. Of course! he thought suddenly. The answer was staring him directly in the face. *The Supper at Emmaus*! Caravaggio had painted it for Ciriaco Mattei one year before *The Taking of Christ*. The two paintings were similar in size and format, both horizontal with half-length figures. If London would agree to lend it, Benedetti could compare them side by side.

Back in Dublin, Keaveney told Benedetti and Brian Kennedy about his idea. They would use the *Supper* as the centerpiece of a small exhibition of their own, the followers of Caravaggio, the Caravaggisti, as they were known. From their own holdings they could select fifteen or so Caravaggisti paintings to display— a Gentileschi, a Ribera, one by Mattia Preti, and some other minor artists.

The idea for a Caravaggisti show was, as Brian Kennedy observed, something of "a ruse," but it also had obvious appeal, given the growing fame of Caravaggio. Benedetti suggested they might even try to get the *St. John* from the Capitoline Gallery. Then they would have all three of the Mattei paintings together, in one place, to compare. The results of such a comparison might prove quite valuable. Apart from the brushwork, Benedetti could examine the original canvases and compare the weave and the threads. It was possible that Caravaggio had cut the canvases for all the Mattei paintings from the same long roll.

It would, of course, create a sensation in the art world if they also unveiled *The Taking of Christ* at the same time. But that was much too risky. Even if Benedetti didn't doubt the painting's authenticity, they still had to assemble a complete dossier, irrefutable proof, and solicit confirmation from renowned experts like Denis Mahon.

Keaveney called Neil MacGregor to propose the trade. He could hear the hesitation in MacGregor's voice. "Uh, let me look into that," MacGregor said. And then: "Have you considered anything else?"

The Supper at Emmaus was much more famous, and much bigger, than the little Rembrandt. London had lent it out only once

before, to the Metropolitan Museum in New York for a huge and carefully planned exhibition. Keaveney was asking for one of the great prizes of the British National Gallery.

In the weeks that followed, Keaveney had several discussions with London. They tried to persuade him to choose something else. He persisted. London, always polite, never directly told him no, and Keaveney took this as a positive sign.

Benedetti had meanwhile called Rome. He described the Caravaggisti show and asked if they would consider lending the *St. John*. Rome was more direct than London. They said no.

✕ 10 ✕

It was October 1991. More than a year had passed since Benedetti had taken the painting from the Jesuit residence. He had accompanied the gallery's paintings to America, and then he took a short vacation in Italy, to see relatives in Florence. While there, he decided to attend an exhibition of Guercino's paintings in Bologna. He'd heard that Denis Mahon had written the exhibition catalogue and had lent several of his own Guercinos to show.

The train ride from Florence to Bologna took only an hour and a half. At the Museo Nazionale, Benedetti wandered around among the tourists looking at the paintings. The show had opened some days earlier, and on this weekday afternoon it was not particularly crowded.

Benedetti came into a large room and saw, sitting alone on a wooden bench, his back to him, the figure of Denis Mahon. The Englishman wore his habitual dark blue suit, and Benedetti could tell, even from behind, that he was tired, his shoulders slumped.

Benedetti had not expected to see Mahon at the exhibition, this many days after the opening. He went over to the bench and sat down beside Mahon, who was resting with his hands atop his wooden cane. Mahon looked up, as if emerging from a reverie. "Ah, Sergio!" he said softly. "What a surprise to see you."

They spoke in Italian. Benedetti asked after Mahon's health—he calculated that the Englishman was now around eighty-two years old. They hadn't seen each other in six or seven years. Sir Denis replied that he was in fine form, just a bit tired after the inauguration of the exhibit, several speeches, and an endless round of dinners.

Benedetti complimented him on the exhibit and the catalogue.

"Yes, it's all come out rather well, I think," said Mahon.

They chatted for a few minutes, Benedetti all the while debating internally whether this was the right time to tell Sir Denis about *The Taking of Christ*. He had planned to tell him at some point. He knew that the Englishman's opinion of the painting would be essential to establishing its authenticity in the world of Caravaggio scholars. He wanted Sir Denis to give his blessing to the picture, but he had not anticipated seeing him in Bologna. He had imagined a meeting with Mahon for which he would come well prepared, with photographs, detailed close-ups, a file of documentation.

But he couldn't resist. The chance meeting was simply too propitious. He looked around to make sure they were alone in the room, and said to Mahon, in a low voice, "I think I might have found *The Taking of Christ*."

"Caravaggio?" Sir Denis exclaimed, looking up with sharp eyes.

Benedetti nodded.

"You're not really serious, are you?" said Mahon, with a slight smile.

"I am serious," said Benedetti. "I'm certain it is the original."

Mahon grinned broadly and banged his cane three times on the ground, the sound reverberating in the empty gallery. "Where the devil did you find it?"

"You won't believe it," replied Benedetti. "In a religious house in Dublin."

He explained how he had come across the picture in the Jesuit residence, the attribution to Honthorst, and his efforts to trace the provenance.

"I'll send you photos as soon as I get back to Dublin," Benedetti said. "I'm hoping you'll come up to see it when you have the chance."

"Oh, yes, I must, I must!" exclaimed Mahon. "You ought to speak to Francesca Cappelletti," he added. "She has been working in the Mattei archive. I'll give you her number."

Yes, said Benedetti, he knew her name from the *St. John* publication and the article in *Storia dell'Arte*. He would like to speak to her, and he also hoped to go to Recanati himself.

Sir Denis seemed rejuvenated by Benedetti's news. He raised himself from the bench and said, "Let's look at some pictures."

As they walked around the gallery, Benedetti told Sir Denis about Raymond Keaveney's efforts to persuade the British National Gallery to ship *The Supper at Emmaus* to Dublin. "We want

to put the pictures side by side to compare them. We're having some problems with London."

Sir Denis looked thoughtful. He sat on the board of trustees of the National Gallery, and every loan request had to be approved by the board. He said to Benedetti, "Send me the photos and let me take a look at them. I'll see what I can do about London."

⚜ II ⚜

A YEAR AND A HALF HAD PASSED SINCE THE SUMMER WHEN Francesca had gone to Edinburgh with Luciano. In that time, both she and Laura had been awarded their master's degrees, with high honors. Calvesi had asked them to teach a seminar to second-year students at the university on the collections of Mattei, Del Monte, and Giustiniani. They both took the exams, oral and written, for admission to the doctoral program at the University of Rome. Of the several hundred applicants each year, only three were admitted. Francesca, on her first try, was among those; Laura was not. She resigned herself to trying again next year.

Every now and then Francesca heard from Denis Mahon, who called for long chats. Occasionally he asked her to look up documents for him in the Archivio di Stato or the Vatican library. She did so willingly.

The Bibliotheca Hertziana granted her a long-term admittance pass. She spent most afternoons there, studying at her favorite spot, the long wooden table on the third floor with the view over the rooftops of Rome.

When friends asked her what she had found on the trip to Edinburgh, Francesca told them she had run into a dead end. She'd say that she believed the painting was there, somewhere in Scotland. She did not want to believe it had been destroyed.

It seemed that everyone she encountered, even the most casual acquaintances at the university, knew about her search for the lost Caravaggio. At first, she answered seriously, but then she grew bored explaining the details. Still looking for the Caravaggio? someone she barely knew would ask in a jesting way, and she would roll her eyes. She grew weary of it all. She kept saying she hadn't really expected to find it, and this was, in its way, true. Looking back on that time, she realized that finding the picture would have been a miracle. Perhaps she had been a little naïve, she thought. But she didn't regret making the effort. It would have bothered her, a pebble in her shoe, if she had not at least tried.

Then one evening, Francesca got a telephone call from a man who asked in English, "May I speak with Francesca Cappelletti?"

Francesca replied in English. "This is Francesca."

The man seemed hesitant. "I hope I am not disturbing you, but are you the young woman who was looking for the painting by Caravaggio?"

"Yes," said Francesca. "Why do you ask?"

"The painting that was owned by the Scotsman Hamilton Nisbet?"

Again Francesca said yes, her curiosity growing. The caller had a refined, upper-class English accent, slightly pompous; he sounded as if he was in his thirties or early forties, and his

voice sounded vaguely familiar. "Have we met before?" she asked.

"No, no, we haven't," said the man, "but I've heard about your search for the painting."

"Ah, yes?" said Francesca.

Again the man hesitated. "Well," he said, "I was having tea at the Warburg Institute, you see. And I happened to hear a conversation concerning this painting. It seems, well . . . it seems that there is a good possibility it might turn up shortly."

"Do you mean someone has found it?" said Francesca, voice rising.

"Well," said the man, "I am not at liberty to say much. There are other people involved. It is all very confidential, you see."

"My God!" exclaimed Francesca. "How wonderful! How exciting! Can you at least tell me where it was found?"

"I'm afraid I really am not free to say—"

Francesca heard a strange noise at the other end of the line, like someone muffling a sneeze. She listened, perplexed. And in an instant she understood that it was someone stifling laughter. "Who is this?" she demanded angrily.

The laughter erupted in gales, and she then knew that her caller was Roberto Pesenti, the friend who had put her up in the Sloane Square house in London. "Roberto? Is that you?" she said in Italian.

More laughter. The sort of laughter that causes tears to flow.

"Roberto, sei tu!" Francesca screamed into the telephone. "Bastardo, cretino, idiota!"

Through his laughter, Roberto said, "Francesca, I'm sorry, but it's just so funny! I had you absolutely convinced!"

"It's not funny!" said Francesca, but her anger began to wane, and Roberto's laughter infected her. She kept calling him a bastardo, but by then she was laughing, too.

It wasn't quite so funny when she learned that Roberto had told the story of his call, with embellishments, to some of their mutual friends. She tried to be good-humored about it, but she began to grow exasperated the third or fourth time it came up.

IN THE FALL OF 1991, FRANCESCA RETURNED TO LONDON, AGAIN to the Warburg, but this time for only a two-week visit. She and Luciano kept constant company. He told her he wanted to marry her. She'd heard this before, but she'd always dismissed it with a laugh and teased Luciano about being too involved in his work to find someone better suited to him. But this time he would not be put off. This time he was serious.

Francesca couldn't bring herself to tell him no. She said she was undecided.

"That's okay," said Luciano, "but I won't give up."

While in London, Francesca saw Denis Mahon, who brought up the subject of Caravaggio. "Who knows when the next one will be found?" he remarked with a twinkle in his eye. Francesca looked at him expectantly, but he just smiled. "I have a feeling something will turn up soon," he said.

When Francesca returned to Rome, she reported this con-

versation to Laura. "It was very strange," Francesca said. "I think he knows something."

"Knows what?" asked Laura.

"He wouldn't say, and it didn't feel proper for me to ask. But I had a feeling he was talking about *The Taking of Christ*."

Laura shrugged. "We'll see."

ONE EVENING THAT AUTUMN, FRANCESCA ARRIVED HOME FROM the Biblioteca Hertziana and her mother said she'd had a phone call. Some man—her mother couldn't recall his name—who wanted to speak to Francesca. He hadn't left a telephone number, and her mother remembered only that he said he was from the Scottish Academy. Strangely, though, remarked her mother, he spoke Italian very well, with a slight Florentine accent.

The Scottish Academy? mused Francesca. It had been a year and a half since she'd been to Scotland. And the man spoke Italian well? The thought crossed her mind that it might be another prank by Roberto.

The man called again later that week. This time Francesca was at home. Her mother passed her the telephone.

The first words the man uttered were "I am looking for you because I think you are interested in *The Taking of Christ* by Caravaggio. I am interested in it, too."

Francesca said, "Who am I speaking to, please?"

The man said his name was Sergio Benedetti. He worked as a restorer of paintings at the National Gallery of Ireland, in Dublin.

Francesca was dubious. "You are not from the Scottish Academy?" she asked.

"No," said the man, in a voice that sounded puzzled. "Why do you ask?"

"Never mind," said Francesca, realizing that her mother was perfectly capable of confusing Ireland with Scotland, and a gallery with an academy. "How can I help you?"

"Excuse me," said the man, "but may I ask how old you are? Are you married?"

"What kind of question is that?" asked Francesca, voice rising.

"You sound rather young," said the man. "I thought you would be older. Who was the woman who answered the telephone?"

"Who are you?" demanded Francesca. She was close to hanging up. "What do you want from me? Did Roberto put you up to this?"

"Roberto?" said the man. "No, no, I got your telephone number from Denis Mahon. He suggested that I call you."

"From Denis Mahon?" said Francesca, still wary.

"It concerns your research in the Mattei archive in Recanati," continued the man who called himself Benedetti. He had read Francesca's article about the Mattei Caravaggios in *Storia dell'Arte,* he said, and wanted to speak with her about it, especially the information concerning *The Taking of Christ*. He mentioned several details from the inventories, particularly those documents where the attribution had changed from Caravaggio to Honthorst. "I'm coming to Rome soon," he said. "I hope to go to Recanati to see the archive with my own eyes."

"That won't be possible," Francesca said. "The palazzo in Recanati is closed during the winter."

"Are you certain?" he said. "A pity. In any case, I would like to meet with you and discuss your article at greater length. I assure you it's something you'll find interesting. But I must ask you not to tell anyone about this. It's at a very delicate stage."

Francesca was still not wholly convinced, but her curiosity was growing. She apologized for her angry reaction. "I've gotten other phone calls," she explained.

Benedetti said he would get in touch with her when he got to Rome, in a week or so, and they would arrange a place to meet. He asked her again not to mention his call to anyone.

Francesca's first impulse on hanging up the phone was to dial Denis Mahon's number in London and find out whether Benedetti was indeed who he claimed to be. He had been very secretive and had actually told her nothing at all. And asking her how old she was and if she were married—those were not the sort of questions one would expect from another art historian.

She called Sir Denis, who picked up, as usual, after the first ring. They exchanged pleasantries, and then Francesca said she'd just gotten a strange call from someone named Sergio Benedetti. Did Sir Denis know him?

Oh, yes, said Mahon. He had known Sergio for many years. And yes, he had given Benedetti her telephone number. He didn't think Francesca would mind. "It's possibly quite interesting," he said.

Mahon was obviously being discreet. Francesca understood that he was not telling her all he knew, and Francesca knew not to press further. But by now she was very curious.

At the Hertziana the next afternoon, idling away her time, she looked up Benedetti's name to see if he had published anything about Caravaggio or the seicento. She searched the index, but came up empty-handed. If Benedetti had any expertise beyond restoration, he had kept it to himself.

SEVERAL WEEKS LATER, FRANCESCA HEARD FROM BENEDETTI AGAIN. He called one morning to say that he was in Rome, staying at the apartment of friends near the Piazza del Popolo. He hoped Francesca could stop by that afternoon.

Francesca asked if she should also bring Laura Testa.

"No," said Benedetti. "The fewer people, the better."

Okay, Francesca thought to herself, let's see what happens.

The woman who answered the door greeted Francesca with a warm smile. She was in her thirties and seemed vaguely familiar. "Finally we meet," said the woman. "I always see you in the hallways at the university." Now Francesca placed her: an instructor of Byzantine art at the university. She brought Francesca into the living room, a spacious apartment with a view over the trees of Lungotevere, and introduced her to her husband, an archaeologist at the Vatican, and to Benedetti.

Benedetti rose to shake her hand. He wore a neatly pressed shirt and gray slacks. Francesca estimated that he was in his late forties, stout and heavy in the face, a little taller than she, with thick brown hair that was turning gray at the temples. In his youth he might have been handsome, thought Francesca,

but his eyes had a dark, preoccupied look. With a smile that didn't seem quite genuine, he said, "You are younger than I expected."

Francesca smiled back. She was still just a student, she explained.

On the table before him, Benedetti had photocopies of the *Storia dell'Arte* article and the essay that she and Laura had written for the *St. John* symposium. Francesca could see that both were extensively underlined and had notes scribbled in the margins.

Benedetti, taking the articles in hand, wanted to know if she had more information about the Mattei archive, specifically information concerning *The Taking of Christ* that she and Laura had not yet published.

"Plenty of information about the Mattei collection," replied Francesca, "but nothing more about *The Taking of Christ*." She mentioned that she had gone to Edinburgh in an effort to trace the painting, but she'd run into a dead end with the sale at Dowell's auction house.

Benedetti nodded. He had gone to Dowell's, too, he said.

"So," said Francesca, "have you found the painting?"

"I can't say at this point," he replied, shaking his head slowly. "There's a lot of work to do yet. And I have to ask you again not to say anything about this to anyone."

Francesca understood then that he had a painting. Whether it was the original, or yet another of the many copies, remained to be seen. She had a dozen questions to ask, foremost among them where he'd found this painting. But it was obvi-

ous that Benedetti had come not to answer questions but to ask them.

For the next hour, he went through the *Storia dell'Arte* article line by line, footnote by footnote, asking her for details and clarification. He wanted to know what the archive looked like, how the documents were organized, what Annamaria Antici-Mattei was like as a person.

He laughed coldly at Francesca's description of the old building in Recanati. Did she know, he asked, how they had lost the palazzo in Rome? Gambling, he had heard. Did she know any of the details? These old Roman families, he said, they'd all gone soft. Even the Doria Pamphili, they couldn't even produce children anymore, the descendants were all bastards!

Francesca felt offended. She had grown fond of the old Marchesa. She didn't like to hear him making such comments at her expense.

Francesca couldn't put her finger on a precise comment or any factual error that Benedetti had made, but some of his remarks gave her the impression that he lacked something basic, a broader context, perhaps, of art history. That impression, she realized, might have grown out of his manner to her. He made several remarks—"You, of course, wouldn't know this"; "This is beyond your scope"—that made her bristle, although she merely nodded and smiled diffidently. Perhaps he was just reacting to her youth, she thought. Or perhaps it was a sign of his own insecurity. Denis Mahon, whose knowledge of art history was beyond dispute, had never condescended to her this way.

As Francesca put on her coat to leave, Benedetti said he

would be in touch soon. And he warned her again not to speak to anyone about his inquiries.

He was, thought Francesca, the sort of man who, if you asked him, "How are you today?" would say, "Fine, fine. But don't tell anybody."

⚘ 12 ⚘

RAYMOND KEAVENEY FINALLY HAD GOOD NEWS FROM LONDON. The British National Gallery had relented and agreed to lend *The Supper at Emmaus.* Perhaps it had been Keaveney's persistence, or perhaps Denis Mahon had spoken to Neil MacGregor. No one knew for certain. Whatever had happened, the painting was coming to Dublin for a month. It would arrive in mid-February.

That left only a short time to assemble a show, to write an exhibition catalogue, and to prepare and hang the paintings. Benedetti had already chosen the fifteen Caravaggisti pictures for display. It was a small exhibition of decidedly minor works, except for *The Supper at Emmaus.* Outside of Ireland, the show wouldn't attract the slightest attention, but it still required considerable work in the next three months.

Benedetti had wanted to write the exhibition catalogue, his first professional attempt at curating an entire show, and Keaveney had agreed to let him. "But you won't let me down on restoration, right, Sergio?" Keaveney said.

"Always two jobs instead of one," Benedetti later commented, his voice bitter, outside of Keaveney's hearing.

The catalogue required Benedetti to write fifteen short essays, one on each of the paintings, as well as a longer introductory piece. He was well prepared. He knew the paintings well and had a dossier on each. He worked on weekends and late into the night. Upstairs in the restoration studio, *The Taking of Christ* stood on an easel, covered by the baize blanket. He had no time to work on it.

He'd sent Olohan's photos of the painting to Denis Mahon, who had reacted with measured enthusiasm. Mahon said he would come to Dublin in March, at the end of the Caravaggisti show, to take a close look at the painting.

By mid-February, the paintings were hanging in place, the catalogue printed. Benedetti awaited the arrival of *The Supper at Emmaus*. The British were bringing it to Dublin by truck, with an escort of attendants.

On the day the truck pulled up to the gallery's entrance, Benedetti and Brian Kennedy came down to see the unloading of the painting. The British workers, joined by the gallery's Working Party, wheeled out a large plywood crate on a dolly. The crate seemed unusually heavy. Once inside the gallery, they had to carry it up the long curved flight of stairs to the exhibition room on the second floor. It took ten men, struggling and swearing, to carry the crate up the stairs. Benedetti and Kennedy looked on in consternation. The Working Party began to disassemble the crate, which had been screwed together and sealed with rubber gaskets against moisture. When the plywood

came away, Benedetti and Kennedy saw the painting inside the crate, sitting on foam-cushioned supports. It was encased in glass.

"What is this?" asked Benedetti.

Protective glass, bulletproof, said a British worker.

Benedetti was astonished.

Kennedy felt like laughing. "Incredible!" he said. "Does everybody in London think there are bombs going off up here?"

The chief of the Working Party went off to get brackets strong enough to support the painting on the wall. Lifting and mounting the picture in its thick glass case once again required a team of people. Benedetti and Kennedy looked on, along with Keaveney, who had come to join them.

"It's insulting," said Benedetti. "They don't show it under glass in London."

Benedetti wouldn't be able to examine the painting as he had expected to do. He couldn't move it upstairs to the studio, where he could study it closely, under the same conditions and lighting as the *Taking*. He couldn't look at the tacking edges and see if the canvas matched the one used for the *Taking*. The British, without intending it, had thwarted him.

◦※◦

ON AN AVERAGE WEEKDAY, THE GALLERY RARELY HAD MORE THAN fifty visitors, and often fewer than that. You could wander the spacious rooms in silence and near solitude.

The Caravaggisti exhibition, assembled in a few short months, with little funding and almost no money for advertising, opened

on February 19, 1992. From the beginning, it drew two thousand people a day. The guards, the cloakroom attendants, the clerks in the small bookstore were all overwhelmed. Keaveney came down to the entrance and stood nervously by, watching the throngs march in, holding his breath as the gallery teetered on the edge of chaos. "It was really scary," he said of that time.

The show ran for one month, and its success provided Keaveney with a vivid testament to the power of Caravaggio's name. He could only imagine what might have happened if the painting in the studio upstairs, under the baize blanket—a long-lost Caravaggio—had also been on display.

The most important visitor arrived the day after the exhibition closed. Sir Denis was escorted up to Keaveney's office, where Benedetti had set up *The Taking of Christ* on a sturdy easel.

Sir Denis stood before the painting, leaning on his cane, eyes moving quickly. After a minute or so, he shuffled forward and examined first one area and then another with his nose only a few inches from the canvas. Benedetti moved up with him. He directed Sir Denis's attention to the pentimenti at the ear of Judas and the belt buckle. Sir Denis nodded but said nothing.

A moment later, he turned to Benedetti. He extended his hand and said, "Congratulations, Sergio."

❧ 13 ❧

S IR DENIS RETURNED HOME TO LONDON AND CALLED NEIL MacGregor at the British National Gallery. He told MacGregor that he had just seen with his own eyes the lost *Taking of Christ*. "It looks like the real McCoy," Mahon said.

MacGregor was delighted. He congratulated Sir Denis, and added that he hoped London would have a chance to display it soon.

Sir Denis told MacGregor that he would have the opportunity to see the painting for himself in the near future, provided he would grant a favor. Sir Denis wanted the British gallery's scientific department to examine *The Taking of Christ*—high-quality photos, X rays, infrared, and pigment analysis. "The sort of thing you would do for one of your own paintings," said Sir Denis.

London had one of the most advanced scientific departments in the art world, but London rarely worked on paintings that were not part of its own collection. In this instance, however, MacGregor agreed without hesitation.

AT DAWN ONE MORNING IN MAY, SIX WEEKS AFTER THE Caravaggisti show, Benedetti loaded the *Taking* into a large rental truck with air-cushion suspension and set out with a driver for London. Keaveney had to persuade the Irish government to indemnify the gallery against damage or loss of the painting with a thirty-million-pound insurance policy. He and Kennedy and Benedetti had planned the voyage with the utmost secrecy. Apart from the three of them, no one in Ireland knew the precise date of Benedetti's departure.

The driver had recommended going up to Belfast and taking the ferry from there across the Irish Sea. Benedetti didn't like the idea of carrying the painting through Belfast, but the driver convinced him they would save time because of better roads.

The painting remained in London for only four days, and Benedetti stayed by its side most of that time. The science and restoration departments employed fifteen people full-time and occupied a spacious suite of rooms, along with a huge skylit studio, at the back of the gallery. In the science labs, Benedetti saw a vast array of gleaming machinery and electronic equipment, microscopes, spectroscopes, computer monitors, and beakers of chemicals. He watched as a young woman detached a dozen minuscule fragments from the borders of lacunae in the painting and carried the fragments to a machine that embedded each one in a small block of resin. On a television monitor attached to a microscope, the fragments appeared like landscapes of an alien terrain, jumbled strata of brightly colored boulders and crystals of green, yellow, vermilion, and ocher.

The head of the science department, an organic chemist named Ashok Roy, interpreted the findings. He had taken pigment samples from *The Supper at Emmaus* to compare with *The Taking of Christ*. The chemical composition of the paints in both pictures was similar. Caravaggio had bought his pigments—lead-tin yellow, malachite, red lake, bone black, green earth—at the store of a druggist, perhaps the one near the church of San Luigi dei Francesi. They came either in rough form, in blocks and large granules, or already ground to powder by mortar and pestle. He had mixed the pigments with walnut oil, the most common binding agent of the day. Nothing in the composition of the paints suggested that *The Taking of Christ* had been painted by anyone other than Caravaggio. But that did not prove he had.

One aspect about the *Taking* did strike Ashok Roy as unusual. The priming layer, the ground, had been applied irregularly, thickly in some parts, thinly in others, and it had a gritty texture. That was typical of Caravaggio, but Roy found the composition of this particular ground strange—"bizarre" was the word he used. It contained reds and yellows and large grains of green earth, a pigment composed of iron and magnesium. Grounds usually contained lead-based pigments and calcium, which dry quickly. Green earth dries slowly. This primer looked to Roy like a "palette-scraping" ground—the painter had simply recycled leftover paints from his palette board to make the priming layer.

❧

IN THE ROME OF CARAVAGGIO'S DAY, NEWS TRAVELED LARGELY BY word of mouth, although both printed and handwritten notices,

called avvisi, were also posted from time to time in various piaz-
zas. One such avviso appeared on October 24, 1609. It read:
"From Naples there is news that Caravaggio, the celebrated
painter, has been killed, while others say badly disfigured."

Two weeks later, Giulio Mancini, the doctor who had once
treated Caravaggio, wrote to his brother in Siena with more in-
formation. "It is said that Michelangelo da Caravaggio has been
assaulted by four men in Naples, and they fear that he has been
slashed. If true, it would be a shame and disturbing to all. God
grant that it is not true."

Caravaggio was a regular customer at the Osteria del Cer-
riglio, a large tavern in the Carità district of Naples. The osteria,
three stories tall and built around a courtyard with a fountain,
was renowned for its food and wine, and also for the allure of
the prostitutes in the upstairs rooms overlooking the courtyard.

He was assaulted on the night of October 20, in the steep
and narrow street leading to the osteria's door. The men who at-
tacked him apparently did not intend to kill him, but to cut his
face and disfigure him. Baglione, the biographer who knew Ca-
ravaggio best, wrote that "he was so severely slashed in the face
that he was almost unrecognizable." The identities of his attack-
ers remain unknown, although art historians have speculated at
length on the reason for the assault. Caravaggio did not lack for
enemies.

It had been more than three years since he fled Rome after
the death of Ranuccio Tomassoni. In those years he had wan-
dered southern Italy, from Naples to Malta, then to Syracuse,
Messina, and Palermo in Sicily, before again returning to Naples.
His reputation as an artist had preceded him. He had been wel-

comed wherever he went. He painted prodigiously and swiftly, large public commissions for churches and smaller works for wealthy patrons who knew of his fame and clamored for his works. In Naples, for the church of Pio Monte della Misericordia, he painted a huge canvas depicting the Seven Acts of Mercy, for which he was paid four hundred ducats. In Malta, *The Beheading of John the Baptist,* measuring seventeen by twelve feet. In Syracuse, for the church of Santa Lucia, *The Burial of St. Lucy.* In Messina, two more large works: *The Raising of Lazarus* and, for the Capuchin church, *The Adoration of the Shepherds,* for which he was paid a thousand scudi, the highest fee he'd ever received.

His paintings had changed in mood and tenor, and he had changed his methods, too. He painted sparely and quickly, without the finish of the Roman days, but with greater drama and a stark intensity. He often depicted scenes of violent death in settings that were dark, shadowed, and cavernous. He occasionally used himself as a model, as he had in Rome. One of his last paintings, *David with the Head of Goliath,* shows the boy David gazing in melancholy at the decapitated head of Goliath, which he holds aloft by a fistful of black unruly hair. In death, the opened eyes of Goliath—Caravaggio's self-portrait—seem fixed inwardly in horror, mouth agape, blood dripping from the severed neck. It was as if Caravaggio knew his fate.

He had stayed for a full year in Malta, and had been accepted into the Order of the Knights of Malta, a high tribute that normally required a substantial payment. Caravaggio paid in paintings. For a few short months he enjoyed the rich life of a nobleman and the respect accorded a member of the order. And then he fought with a fellow cavaliere, a grievous crime in that

strict and hierarchical society. He was imprisoned briefly, but managed to escape and flee to Sicily. The documents of the order record that he was expelled "like a foul and diseased limb." And now the Knights of Malta and the cavaliere with whom he'd fought were also seeking justice from him.

He had plenty of money and was famous, but he still lived under the bando capitale, the sentence of death. He was a hunted man with a bounty on his head. He had powerful allies in Rome, among them Cardinal Scipione Borghese, nephew to the Pope, and Cardinal Ferdinand Gonzaga, who were working to get him a pardon. But his mental state was growing more and more unbalanced.

In Sicily he was described by those who met him as "deranged" and "mad." He lived in constant fear, sleeping fully dressed with a dagger always by his side.

He left Sicily for reasons unknown and returned to Naples, perhaps because he'd heard that a papal pardon was in the offing, or maybe because he was just trying to keep ahead of his pursuers. To return to Rome, he needed not just the pardon but also a formal pact of peace with the Tomassoni family. Ranuccio's two cousins and his older brother, Giovan Francesco, had all been allowed to return after a three-year exile. Some art historians speculate that they were the men who had attacked Caravaggio at the Osteria del Cerriglio, exacting their price for the peace by disfiguring the painter's face. Others think it likely that the Knights of Malta and the offended cavaliere had caught up with Caravaggio in Naples. And it was always possible that Caravaggio, in his deranged and paranoid state, had simply offended someone else altogether, someone heretofore uninvolved in his past.

It took him months to recover from the attack. His face was by now badly scarred from three separate woundings. But he did not stop painting. In Naples, in a period of eight months, he produced half a dozen works, some destined as gifts for those in Rome who were pressing for his clemency. Others were commissioned works for churches, such as *The Resurrection of Christ* and *St. Francis Receiving the Stigmata,* both paintings now lost.

Around the beginning of July 1610, Caravaggio boarded a small two-masted transport ship, a felucca, and sailed up the coast. He had heard from his protectors in Rome that Pope Paul V would soon sign a pardon. He carried with him a bundle of belongings and two rolled-up paintings. The felucca's northernmost destination was Porto Ercole, a fortress city on a spit of land sixty miles north of Rome, but it made several stops along the way. Caravaggio intended to debark at a small customs port near the mouth of the Tiber and make his way upriver to Rome.

Two days after leaving Naples, the felucca put in at a coastal fortress in the small village of Palo, just north of the Tiber. The captain of the garrison summoned Caravaggio, who was forced to leave the ship without his belongings. According to one account, the captain had mistaken Caravaggio for someone else, for another cavaliere whom he had been told to detain. It is likely that Caravaggio reacted to the captain as he usually did to those in uniform, with rudeness and insults. Whatever the reason, the captain put Caravaggio in the garrison jail for two days and released him only after he had paid a substantial penalty, a hundred scudi according to one account.

The felucca, with a schedule to keep, had gone on to Porto Ercole, where its cargo had been unloaded. Out of jail, the

painter, in a fury, decided to make for Porto Ercole and his possessions, among which was a painting of St. John promised to Scipione Borghese for his intervention with the Pope. It was a long journey by foot under the summer sun, nearly sixty miles of dunes and coastal marshes, with only a few fishing villages along the way and the ever-present risk of bandits. Rome was closer, but Caravaggio apparently decided he couldn't return to the city without his possessions and without bearing tributes for his benefactors.

Baglione, his rival, wrote: "In desperation, he started out along the beach under the fierce heat of the July sun trying to catch sight of the vessel that carried his belongings. Finally he came to a place where he was put to bed with a raging fever; and so, without the aid of God or man, in a few days he died, just as miserably as he had lived."

He died on July 18, 1610, at the age of thirty-nine, in an infirmary in Porto Ercole. Most scholars assume that he died of malaria contracted in the mosquito-infested marshes. But the incubation period for malaria is at least eight days, and more commonly a month or longer. He more likely died of dysentery and dehydration, his constitution still weak from his wounds.

Word of his death reached Rome ten days after he died, on July 28. By then the Pope had already granted his pardon.

❧ 14 ❧

DENIS MAHON, AGAIN IN BOLOGNA, BOARDED THE TRAIN FOR Rome, en route to yet another Caravaggio conference. It was May 1992. An Italian colleague had mounted an exhibition at the Palazzo Ruspoli, on the Via del Corso, of twenty paintings by Caravaggio, each with detailed technical analyses, X rays, and infrared photographs. The exhibition was entitled "How Masterpieces Are Born."

At Termini, Rome's train station, Sir Denis was met by an acquaintance, a journalist named Fabio Isman from the Roman daily *Il Messaggero*. Isman had known Mahon for ten years, since he had started covering arts and culture for the newspaper. He carried Sir Denis's bags to his car.

On the way to the conference, Sir Denis and Isman discussed one of the paintings in the exhibition, *The Lute Player,* which Mahon had recently played a role in authenticating. Isman said to Mahon, "So, when is the next Caravaggio going to turn up?"

Sir Denis laughed. "Oh, I just saw one a few weeks ago."

Isman was startled. He had just been making conversation. "Seriously?" he said to Mahon. "Where?"

"I really can't say any more," replied Mahon. "It's not my painting."

Isman pressed for more information, but Sir Denis only smiled enigmatically and remained resolutely silent on the matter.

The conference, a one-day affair, bustled with many famous Caravaggio scholars. There was Mina Gregori, who had put together the exhibition, and Maurizio Marini, Luigi Spezzaferro, and Maurizio Calvesi. From America had come Keith Christiansen; from Germany, Christoph Frommel and Erich Schleier.

Fabio Isman circulated among the crowd, going from one expert to the next as they chatted in small groups. "Have you heard about the new Caravaggio?" he would ask. He was rewarded with surprised looks and puzzled queries. "What new Caravaggio?" he heard time and again.

Isman did not doubt that Mahon had told him the truth, that a lost Caravaggio had recently turned up. Mahon was not the type to make such a remark in jest. But no one else seemed to know anything about it. Very strange, thought Isman.

And then, in making his rounds, he encountered Claudio Strinati, the superintendent of arts and culture for Rome. Isman had known Strinati for many years and considered him a friend. They chatted for a moment. Isman said: "I heard from Denis Mahon that a new Caravaggio has turned up. Do you know anything about it?"

Strinati laughed. "There's always a new Caravaggio turning up," he said. "Except that most of them aren't actually Caravaggios."

"Yes," said Isman, "but in this case Denis said he'd seen it himself."

"Well, then," said Strinati with a shrug, "I guess there really must be a new Caravaggio."

Isman saw in Strinati's eyes a look of amusement. His demeanor told Isman that the minister must, in fact, know something about this new painting; otherwise he wouldn't have responded so casually to such news. "You do know about it, don't you?" said Isman.

Strinati smiled, and said: "I really can't tell you anything."

Isman took out one of his calling cards. "Just do me a favor," he said, pressing the card into Strinati's hand. "Give this to the person who has the painting. Tell him I want to speak to him. Tell him to call me anytime."

Strinati took the card. "Okay. But no promises, you understand."

❧

AS IT HAPPENED, SERGIO BENEDETTI WAS ALSO AT THE CONFERENCE. He knew most of the celebrated Caravaggio scholars, and many of them knew him, but only as a restorer and enthusiastic amateur scholar. He had not been invited to speak. He sat in the audience, listening to the presentations. It would never have occurred to anyone that he might have been invited to speak. But the day would soon come when he would enter the ranks of the experts, and his opinions would be sought after, just as theirs were now. He had in his briefcase, by his side, a series of pho-

tographs of *The Taking of Christ*. He comported himself with the serene assurance of a man who possessed a superior knowledge.

Among the hundred or more people at the conference, only two, apart from Denis Mahon and Benedetti himself, knew about the painting. One was Mina Gregori, the organizer of the conference, and the other was Claudio Strinati, whom Benedetti had known since the days of Mario's trattoria.

At the end of the conference, as people stood and gathered their belongings, Strinati came up to Benedetti. He handed the restorer the card that Fabio Isman had given him. "He's a reporter for *Il Messaggero*," Strinati explained. "Apparently Denis let something slip. But he doesn't know anything beyond the rumor that a painting has been found."

Benedetti took the card and put it in his jacket pocket. He had never met Fabio Isman, and he certainly had no intention of calling a journalist.

✺

WHILE HE WAS IN ROME, BENEDETTI GOT IN TOUCH WITH Francesca again. They arranged to meet late one afternoon at the Bibliotheca Hertziana. This time Benedetti had no objection to having Laura present. He had a variety of questions, some concerning the export license for the Mattei paintings that she had found in the Archivio di Stato.

They met in a small, well-lit room on the third floor of the library. The Germans who ran the Hertziana were strict about maintaining silence, a rule that Francesca was often reprimanded

for violating. This third-floor room, with two scuffed brown leather couches and several tattered upholstered chairs, was the only place in the library where conversation was tolerated. But it had the disadvantage of serving as a corridor for people going to the periodical room.

Benedetti greeted Laura in a manner that she found brusque: a perfunctory handshake and no hint of a smile. She thought he carried himself with an air of self-importance that verged on conceit. He spoke in a low voice and would fall silent when someone happened to pass through the room. Laura found it annoying at first, and then amusing. She exchanged a glance with Francesca, who merely lifted her shoulders and smiled.

Benedetti asked Laura for details about the export license. She told him that the license had listed the prices that Hamilton Nisbet had paid for the six paintings—a total of five hundred twenty-five scudi—prices that she had doubted. Benedetti nodded. She'd been right to doubt them. He'd found a document in the Scottish Record Office, a receipt signed by Duke Giuseppe Mattei, with a price of two thousand three hundred scudi. Hamilton Nisbet's agent, Patrick Moir, had grossly understated the cost of the paintings to avoid paying customs duties. Perhaps Moir had been acting on behalf of his employer, or perhaps in his own interests, and had simply pocketed part of the export fee.

From his briefcase, Benedetti took out several photos and color transparencies of *The Taking of Christ*. He showed Francesca and Laura close-ups of parts of the painting, including the ghostly second ear of Judas, visible through the thin layer of overpainting. As they studied the photos, Benedetti glanced around constantly,

making sure that no one else was looking on or could overhear them.

The photos convinced Francesca that Benedetti really did have the original *Taking of Christ* by Caravaggio. Laura was more skeptical. She asked Benedetti where he'd found the painting, and he replied vaguely, mentioning only a "religious house" in Dublin. She asked if he'd discovered what had happened at Dowell's auction house in Edinburgh. Benedetti said, "I can't give you any details now."

Later, after Benedetti put the photos back into his briefcase and departed, Francesca said to Laura, "So, what do you think?"

Laura had been put off by Benedetti's haughty manner. "He didn't tell us much. What's the point in being so mysterious about it all? He acts like he's Roberto Longhi."

"But about the painting?" said Francesca.

"I think it could be the real one," said Laura with a shrug. "Not that it necessarily is."

◈ 15 ◈

FOR WEEKS AFTER THE CONFERENCE, FABIO ISMAN WAITED IN HIS office at *Il Messaggero* for news of the latest Caravaggio discovery. None arrived. He wrote other articles about other exhibitions and other artists, but in his spare time he always returned to the mysterious new Caravaggio.

Finally, he decided to call Denis Mahon in London and try to ferret out additional details. Sir Denis confirmed that a painting existed, but he would divulge nothing more.

Isman called one Caravaggio scholar after another. They all denied knowing about the painting, but Isman wasn't sure they were telling him the truth. He began trying a new tactic. "Congratulations!" he'd exclaim on his next call. "I hear you're the one who's found the new Caravaggio."

"Ah, I wish I had," said Maurizio Marini.

To a person, all denied any knowledge. Isman refined his technique. When he called Mina Gregori, with whom he'd already spoken once and gotten nowhere, he said to her, "I hear

this new painting is an early 'profano,' like *The Lute Player* or the *Bacchus*."

"Oh no," said Mina Gregori, "it's a religious one. A painting we've been waiting for a long time."

She would tell him no more, but he had learned a few important details. A religious painting, one that was apparently well-known. There were only half a dozen Caravaggios that fit such a description.

He put in a call to Keith Christiansen at the Metropolitan Museum in New York. Christiansen and Sir Denis were quite close. The *Lute Player* that Mahon had authenticated in Paris had been acquired by the Metropolitan. Perhaps, thought Isman, the Metropolitan was involved in acquiring this new Caravaggio.

Christiansen confirmed that he had heard about the painting, but the Metropolitan had no stake in it. It had been found, Christiansen said, by someone unknown in the world of Caravaggio studies. "It's nobody you'd expect," he told Isman.

And so Isman made a list of lesser-known Caravaggio experts and began calling them. All to no avail.

He pondered the few facts he had managed to gather. A well-known religious painting, missing for a long time. If it was well-known, there were probably copies of it.

His mind kept circling the problem. He stayed abreast of developments in the art world and subscribed to all the most important journals. He recalled having seen the article in *Storia dell'Arte* about the Caravaggio paintings in the Mattei collection.

And with that recollection, Isman had a sudden inspiration. Could it be that the painting was *The Taking of Christ*? He could

not be certain, of course, but it seemed to fit with the few particulars he had learned.

He quickly located that issue of *Storia dell'Arte*. He saw that the article had been written by two women, Francesca Cappelletti and Laura Testa, whose names he did not recognize. Might they have found the painting? He decided that was improbable. According to their article, *The Taking of Christ* had left Italy for Scotland in 1802, and had gone missing after the auction in Edinburgh in 1921. Most likely it was still somewhere in the British Isles.

He concentrated his efforts on Great Britain, looking through journals and catalogues for some clue. He came across the catalogue of a small and curious exhibition—"Caravaggio and His Followers"—that had taken place in Dublin. Very odd, Isman thought, a Caravaggio show with no Caravaggios except for *The Supper at Emmaus,* which Dublin had somehow managed to get on loan from London. He leafed through the catalogue. The curator, he noticed, had been one Sergio Benedetti, obviously an Italian. Isman looked in the index of Maurizio Marini's compendious volume on Caravaggio. Marini had listed the author of every article written on Caravaggio. Benedetti's name was not among them. Benedetti was unknown in the world of Caravaggio scholarship. That fit with what Keith Christiansen had told him: "It's nobody you would expect."

On the Friday before Easter Sunday—Good Friday—Isman picked up the telephone and called the National Gallery of Ireland. Ten months had passed since he'd first heard from Denis Mahon that a lost Caravaggio had been found. He asked to speak to Sergio Benedetti. When Benedetti picked up the line,

Isman said, as he had said to so many others, "Congratulations! I hear that you've found the lost Caravaggio."

"Cazzo!" exclaimed Benedetti in surprise. "How did you find that out?"

Isman was equally astonished to discover that he had guessed right. "So it's true?" he said to Benedetti. "You've got *The Taking of Christ*?"

"Who told you about it?" asked Benedetti.

Isman could hardly believe his luck. He'd also guessed right about the painting. "No one told me," he said to Benedetti. "It was an educated guess. So where did you find it?"

"I can't tell you that now," said Benedetti. "This is still top secret."

"Not anymore, it isn't," said Isman with a laugh.

Benedetti said, "I'm writing an article for publication in *The Burlington Magazine* in September. We'll have a press conference before the exhibition and I'll tell you everything then. But you can't publish until then."

"Oh, no," said Isman. "I'm publishing this tomorrow. It'll be on the front page. Can you send me a photograph of the painting?"

"Absolutely not!" said Benedetti.

※

FABIO ISMAN DID NOT, IN FACT, PUBLISH THE NEXT DAY. HE LACKED a significant piece of information—where Benedetti had found the painting. That, and a photograph.

But Isman was not about to hold back a story of this impor-

tance on such details. His article appeared on Tuesday morning, four days after he'd contacted Benedetti. It was indeed on the front page of *Il Messaggero*, under the headline "A Lost Caravaggio Returns." The newspaper used a photo of the Odessa painting, duly noted as such, in place of the Dublin original.

16

IMMEDIATELY AFTER HIS CONVERSATION WITH ISMAN, BENEDETTI notified Brian Kennedy that word of the painting had gotten out. The problem was urgent. The Jesuits did not yet know the full truth about the painting, and Kennedy did not want them to learn from the newspapers.

Kennedy tried to get in touch with Father Barber. He discovered that the priest was away for the Easter weekend, on a silent retreat at a monastery, and not expected back until Tuesday. Kennedy left word that he had called, and then he considered driving to the monastery and slipping a note under Father Barber's door. "If he thinks it's important enough, maybe he'll come out," Kennedy said. But in the end, he decided not to interrupt the priest's meditations. "At least we know he's not reading any newspapers," reasoned Kennedy.

On Tuesday morning, Kennedy told Father Barber that he needed to talk to him right away. Ten minutes later, after a fast walk from the gallery, Kennedy appeared at the Jesuits' door. He

said to Father Barber, "You better sit down, Noel. I've got some news that you can't take standing up."

They sat in the front parlor on the old, worn couches. On the wall above them was the large empty space where *The Taking of Christ* had once hung. Kennedy got straight to the point. The painting was almost certainly by Caravaggio. There could be little doubt of it. They had the proof, not just in the painting's quality, but in the documents.

"By Jove!" exclaimed Noel Barber, clapping his hands together. "That's wonderful news!"

Kennedy explained the implications, starting with the value of the painting—perhaps as much as thirty-five million pounds—and the clamor its announcement would cause in the art world. He warned the priest that there would be a media onslaught beginning within the next few days. And of course, the Jesuits would have to decide what to do with the painting. They would have plenty of offers from museums and wealthy collectors. But first the gallery would like to display it for a time, in exchange for the restoration work that Benedetti had performed. After that, the decision was up to Father Barber and the Jesuit community.

At first Father Barber looked a little shocked by this news. And then, once he had absorbed it, he made no effort to conceal his enthusiasm. He expressed his delight freely. "He couldn't contain himself," Kennedy later reported to Raymond Keaveney. "He was nearly floating."

One other matter, Kennedy said to Father Barber. In order to have a full history, a complete provenance of the painting,

they would have to know how the Jesuits had happened to acquire it.

Father Barber reflected on this for a moment. He told Kennedy it had been given to Father Tom Finlay, one of the priests who had lived in the house, by a woman whom Father Finlay had counseled many years ago. At least, that was what Father Barber had heard from an elderly resident of the house. The woman's name was Dr. Marie Lea-Wilson. She had been a pediatrician of some distinction in Dublin. She had died more than twenty years earlier.

Do you know if she has any heirs? asked Kennedy.

Father Barber didn't know.

⌘

IT FELL TO BENEDETTI TO TIE UP THE LOOSE ENDS OF THE PROVE-nance. He came by the Jesuit residence to interview Father Barber and examine whatever records the Jesuits had concerning the painting. By now, Father Barber had made inquiries of his own. He confirmed that the painting had been a gift by Marie Lea-Wilson to Father Finlay, who had been a professor of political economy at University College Dublin. As far as anyone could determine, she had given him the painting sometime in the early 1930s.

That, at least, was the institutional memory as handed down by the elderly Jesuit priests at the residence. Father Barber had searched the files for some declaration of the gift and its precise date, but had come up empty.

Benedetti was amazed. The Society of Jesus, known for its intellectual rigor, didn't keep careful records? "A shameful situation," the restorer later remarked, with some petulance. "Religious archives in Italy, they record everything. Not here in Ireland. They are a peculiar people."

Benedetti began an investigation into the life of Marie Lea-Wilson. He stopped first at the probate court to look at her will. Dr. Lea-Wilson had died in 1971, at the age of eighty-three. She'd never had children. She had lived for fifty years in a large old Georgian house on Upper Fitzwilliam Street, a short walk from the Jesuit residence. In her first will, she had left much of her estate to a longtime housekeeper named Bridget. While hospitalized, however, she'd apparently had a change of heart. She had another will drawn up that cut Bridget out entirely. That will stipulated that her estate be divided among a number of charities, principally the Children's Hospital in Dublin, where she had practiced medicine for more than forty years.

Benedetti tried to track down the housekeeper Bridget. All he found was a death certificate. It was clear to him that Dr. Lea-Wilson had no heirs who could lay claim to the painting. It belonged to the Jesuits.

But how had Marie Lea-Wilson gotten the painting in the first place? It had gone up for auction at Dowell's in Edinburgh in 1921, and the Jesuits had acquired it from her at some point in the early 1930s. That left a gap of ten or more years in the painting's life.

Benedetti set out to learn everything he could about Marie Lea-Wilson. She had been born Marie Monica Eugene Ryan in

1888 to a well-to-do Catholic family in Charleville, County Cork. Her father had been a solicitor, and she too had studied law. At the age of twenty-five, she married an Englishman, a Protestant, named Captain Percival Lea-Wilson, then twenty-seven and a district inspector of the Royal Irish Constabulary in Gorey. At the outbreak of the Easter Rebellion, two years after their wedding, Captain Lea-Wilson was given charge of a group of Irish Republican prisoners. He humiliated them, forcing some to strip naked in the rain and lie facedown in the mud. The IRA vowed vengeance. Captain Lea-Wilson knew that he was a marked man. He took to drink. Four years later, on the morning of June 16, 1920, he was shot and killed on the road in front of his home as he went to get the newspaper.

Marie Lea-Wilson descended into a prolonged period of mourning. Some years after her husband's death, she met Father Thomas Finlay, who offered her spiritual guidance, solace, and practical advice. She began studying medicine at Trinity College and was awarded her degree in 1928. She was then forty years old, and one of the few female doctors in Dublin.

At the National Children's Hospital on Harcourt Street, Benedetti got a fuller picture of Dr. Lea-Wilson from nurses and staff people who had worked with her. She was, according to one nurse who had known her since the 1950s, "a small, shrunken woman," with white hair that had a yellow streak running up the middle. She smoked cigarettes continuously—"Continuously!" the elderly nurse emphasized. She dressed in dark Victorian-like clothes, in skirts that descended to her ankles. On the front of her long black coat she had pinned row upon row of religious

medals, and more medals adorned the front of her blouse. She made annual pilgrimages to the shrine of Fatima in Portugal and had gone several times to the Vatican. In those days, she was the only female doctor in the hospital, devoutly Catholic in a profession dominated by Protestant men. She would arrive at the hospital in a car driven by Bridget the housekeeper who, it seemed, had a compulsion to drive in reverse. "We would all roar laughing at the way Bridget drove," recalled another nurse. Marie Lea-Wilson held clinics three mornings a week and would see children without a referral letter. Her manner was severe and autocratic. She would sit on a chair, smoking and dispensing advice, always with one of her little dogs, of which she had many, in her lap. "She did have a great feeling for the poor," said another woman who had known her. "In a bit of a strange way," she added.

Benedetti scrutinized Dr. Lea-Wilson's university records, hoping he could find some link to Edinburgh, which was a world-renowned center for medical study. But he could find no evidence that she had ever studied there.

He came away knowing a great deal about the life of Marie Lea-Wilson, but he could find no clue in that odd and eccentric life about the thing that mattered to him most. How had she gotten the painting? Had she bought it for eight guineas at Dowell's? Or had she chanced upon it in the shop of some antiques dealer in Edinburgh? Or perhaps even a dealer in Ireland? There was no way to trace its passage across the Irish Sea. In those days, Ireland had been part of the British empire, and no export license had been required to move goods out of Scotland.

It frustrated Benedetti. The painting was almost four cen-

turies old, and he could track its precise whereabouts, down even to the rooms in which it had hung, for all but ten of those years. He could find no way to penetrate the veil of that decade. He would have liked a complete accounting, but the one he had was good enough. Much better, in fact, than for most masterpieces.

❧ 17 ❧

WHILE BENEDETTI INVESTIGATED THE LIFE OF MARIE LEA-
Wilson, the Jesuits of Ireland debated the fate of the painting.
They agreed that an object of such value could no longer be kept
at the Lower Leeson Street residence. A few among them ar-
gued that it should be sold. They could use the money to endow
the order's St. Vincent de Paul Society, the largest charity in Ire-
land. Or to build a new school, for which the order was at that
moment trying to raise money. Unemployment in Ireland was at
19 percent. How, in good conscience, asked some of the fathers,
could they ask for donations from Irish citizens when they had a
painting worth thirty million pounds or more?

This was a compelling argument. At the National Gallery,
Brian Kennedy and Raymond Keaveney understood its logic
and feared its outcome. But others among the Jesuits—Father
Barber foremost among them—insisted that it should stay in
Ireland. "The country would turn on us in anger if we sold it
off," said Father Barber.

And so there arose a suggestion that the Irish government

purchase the painting—at a handsome price, of course, although certainly much less than the J. Paul Getty Museum in Los Angeles might have paid.

That solution also didn't appeal to Father Barber. He mustered new arguments. He maintained that, absent any documents attesting to Marie Lea-Wilson's intentions, the painting should be regarded as a deposit "in trust." By this reasoning, the Jesuits were not in a position to sell it or to give it away. "We received it freely, not to flog it in the marketplace," he said. "We should make it freely available."

Father Barber kept Brian Kennedy informed of the debate, and Kennedy in turn passed on what he heard to Benedetti and Raymond Keaveney. Finally Father Barber called and said the society had arrived at a decision. They asked to have a meeting at the gallery.

Father Barber arrived with the Provincial, the head of the Society of Jesus in Ireland. Benedetti had set up the painting, now fully cleaned and retouched and glowing under a fresh coat of varnish, on an easel in a third-floor conference room. The Provincial, seeing it for the first time, paused to admire it, and Benedetti pointed out to him several interesting aspects, such as the self-portrait of Caravaggio and the pentimento of Judas' ear.

They took their seats around the table, Benedetti next to Kennedy and Keaveney on one side, Father Barber and the Provincial on the other.

The Provincial announced the decision. The Jesuits would retain ownership of the painting. They would, however, make it available to the National Gallery of Ireland, where it would reside, on an "indefinite loan." A Jesuit lawyer would work out the

arrangements and terms, but in practice this meant that the gallery would have full possession of the painting.

There were smiles, handshakes, and expressions of gratitude all around. Kennedy had already gotten a pretty clear idea from Father Barber of this outcome and, short of an outright gift, he and Keaveney could not have hoped for more. In truth, the debate among the Jesuits had never been very heated. Father Barber, as head of the Lower Leeson Street residence, had quickly prevailed.

The Jesuit lawyer later worked out the conditions of the indefinite loan, none of them very stringent. The gallery would consult the Jesuits on all matters concerning the painting, such as loans to other museums, which would require the Jesuits' approval. The society would also derive income from licensing the rights to the painting's reproduction on cards and posters. And finally, the gallery would provide a full-sized, high-quality reproduction, complete with frame, to hang on the empty wall in the parlor of the Lower Leeson Street residence.

PART IV

❦

THE
PARTY

It was November 1993, a day of dull gray skies and inter-mittent rain in London. At Gatwick Airport, Francesca and Luciano sat in plastic chairs at a departure gate, waiting to board a flight to Dublin. The National Gallery of Ireland had planned several days of ceremonies for the public unveiling of *The Taking of Christ*. Benedetti had asked Francesca to give a speech, along with Sir Denis Mahon and eight other Caravaggio scholars. He had extended an invitation to Laura Testa as well, but she had declined to come. She didn't speak English and, even more to the point, she had not liked Benedetti when they'd met at the Hertziana.

Francesca held in her lap the speech she had written, ten typed pages, which Luciano had translated into English. She had never given a speech in English before. She had rehearsed it time and again, but the prospect of addressing an English-speaking audience of several hundred people still made her fingers flut-ter with anxiety. Luciano told her not to worry. "You won't be scared," he said, "you'll be unconscious."

On the plane to Dublin, Francesca heard a voice speaking in Italian. Several rows ahead of her, across the aisle, Francesca saw the freshly coiffed gray hair of a small, elderly woman. It was Mina Gregori, the Caravaggio scholar from Florence. Francesca had met her once, but she didn't expect that Mina Gregori would remember.

When the plane landed in Dublin, Francesca watched Mina Gregori and her companion, also an elderly woman, start out first in one direction and then turn abruptly in another. They clutched their handbags, stared at a sign overhead, conferred, and looked agitated and uncertain. Francesca decided to introduce herself. Mina Gregori's hand fluttered to her chest in relief and gratitude. Yes, of course she remembered Francesca, she said, and introduced the other woman as her sister. Francesca steered them to the baggage claim. When the suitcases came into view, to cries of relief from the sisters, she had Luciano lift them from the conveyor and wheel them out to a taxi.

They were all staying in the same place, a small, elegantly appointed pensione near the National Gallery, where Benedetti had reserved rooms for those speaking at the unveiling. After settling in the room, Francesca went out for a walk to clear her head and see Dublin for the first time. She strolled around Merrion Square in the direction of the National Gallery. It was late afternoon. The ceremonies weren't scheduled to begin until the next day, but Benedetti had told her to come over to see the painting when she arrived.

At the gallery entrance, she asked for Benedetti, and a few moments later he came down to greet her. She hadn't seen him in several months. He had dark circles of fatigue under his eyes

and his face looked heavy and weary. He told Francesca he had been through endless rounds of interviews and television appearances, in addition to the long hours arranging all the details for the conference. He invited her upstairs to the exhibition room, where several other scholars were looking at *The Taking of Christ.*

The room, the biggest in the gallery, was dark as twilight. Among the shadows a few members of the Working Party were setting up the last long rows of folding chairs to accommodate hundreds of visitors. At the far end of the room hung *The Taking of Christ,* dimly lit by one of the lights high in the ceiling. Three or four people had gathered in front of the painting. Francesca recognized the tall, angular silhouette of Claudio Strinati, the superintendent of arts and culture in Rome. Another, shorter and heavier, was the German scholar Herwarth Rottgen.

Francesca knew the painting intimately, first from her imagination, and then from the photographs and slides that Benedetti had shown her at the Hertziana. And yet, seeing it for the first time, she had the eerie, vertiginous sensation of recognizing something familiar in all its details and yet much different than she had imagined. The painting looked bigger than she'd thought, even though she'd known its precise measurements. The reflected light glinting from the soldier's armor was more sharply brilliant, the colors more deeply luminous, than she had expected. The light—it was always the light in Caravaggio's paintings that astonished her.

She came close to see the details, the self-portrait of Caravaggio holding the lantern, the powerful, veined hand of Judas grasping the shoulder of Christ. She looked for the pentimenti

that Benedetti had pointed out to her in the photos, the ear of Judas and the belt of the first soldier. Close up she could see individual brushstrokes and the texture of the canvas, the fragile reality of the painting. In the dark background she noticed things not readily visible in the photos—the bole of a tree and the leaves in the shadows, the eyes of the third soldier behind Caravaggio. She felt herself drawn into the drama of the scene, spellbound the way she'd been as a young girl seeing for the first time *The Calling of St. Matthew* in the church of San Luigi dei Francesi. She forgot, for a moment, that she was looking at a painting.

And then she was brought back to reality by the voices of the others around her. She didn't like looking at paintings in the company of other scholars. She felt the obligation to say something intelligent and profound when all she wanted was to absorb the work. The others were making observations, pointing out details here and there. Except for Benedetti, who stood to the side, leaning against the wall and holding a glass of what looked like whiskey. He seemed uninterested in the painting, but then, she reasoned, he had spent the past three years alone with it.

She heard Claudio Strinati say to Benedetti, "Well, Sergio, I'd say this is a very fine painting by Giovanni di Attili."

Francesca laughed aloud at this reference to the unknown artist who had been paid twelve scudi by Asdrubale Mattei to make a copy of the *Taking*.

Benedetti was not amused. At another time he might have smiled, but he took everything regarding his discovery of this painting with the utmost seriousness. He had refused, for ex-

ample, to invite Maurizio Calvesi to the conference. He had taken offense when the professor had written in a journal that Benedetti had found the painting because of the archival work of Francesca and Laura Testa. He wrote an irate rebuttal to Calvesi asserting that the professor was completely wrong, that the discovery of the painting had occurred solely because of his own extensive knowledge of Caravaggio's work.

<hr />

THAT NIGHT FRANCESCA AND LUCIANO WENT OUT TO A RESTAUrant recommended by Benedetti. Others in the Italian contingent had taken his recommendation, too—they encountered Claudio Strinati and Fabio Isman, as well as the scholar Maurizio Marini and his young wife. It was, Francesca remarked to Luciano, like being in the Piazza Navona on a Saturday night.

Marini had wanted to speak at the conference, but Benedetti wouldn't permit it, for fear of offending Denis Mahon. Marini and Sir Denis had been feuding recently about the authenticity of two nearly identical versions an early Caravaggio painting, *Boy Peeling Fruit*.

Marini had come anyway, if only just to see the painting. His recent book, an enormous volume called *Caravaggio: Michelangelo Merisi da Caravaggio "pictor praestantissimus,"* was the result of a lifelong obsession. He was the only Western scholar who had traveled to Odessa to see the other *Taking of Christ,* the copy probably painted by Giovanni di Attili. Francesca liked Marini, who was fat and ribald and spoke with a thick Roman accent. He was, to her mind, a case study of someone afflicted, unabashedly, with

the Caravaggio disease. She heard that he had mounted a scaffold in the church of Sant'Agostino while restorers were working on Caravaggio's *Madonna of Loreto.* He'd leaned over, trying to kiss the face of the Madonna—Lena, of the Piazza Navona—and had nearly fallen into the painting. The restorers told her that they'd grabbed him by the shirt and pulled him back just in time.

Over wine and dinner, the group of Italians exchanged gossip. Francesca heard Strinati advise Marini to make up with Sir Denis. The Englishman was too powerful in the world of Caravaggio to have as an enemy. But Marini would not hear of it. He merely laughed. He respected Sir Denis; he just thought he was wrong about *Boy Peeling Fruit,* which Mahon had affirmed on behalf of a wealthy Japanese client. And Marini, who had a financial interest of his own in the other version, wasn't about to concede anything.

AT THE GALLERY THE NEXT AFTERNOON, FRANCESCA CAUGHT sight of Sir Denis amid an admiring crowd. She went over to the group. He noticed her and smiled broadly. "Ah, Francesca, che piacere!" he said, shuffling toward her.

She hadn't seen him in half a year, and without thinking, she embraced him warmly, as she would any friend, both arms around his shoulders. She knew instantly that she'd made a mistake. In her delight at seeing him, she'd forgotten how he disliked being embraced. She felt him go rigid and she quickly took herself away. He staggered back a few steps, raising his arms and bringing his cane aloft as he did so. Later, when Francesca told

this story to Luciano, she said that she'd thought for a moment Sir Denis might strike her with his cane. She felt her face flush with embarrassment, but Sir Denis quickly regained his composure and acted as if nothing untoward had happened.

Sir Denis, standing to one side of *The Taking of Christ,* gave the opening address to an overflow crowd that included many citizens of Dublin as well as reporters and television cameras. Looking up at the painting, gleaming under its fresh coat of varnish, Sir Denis said: "*Habent sua fata picturae*—that's a fancy way of saying that pictures have their vicissitudes." He gave an account of those vicissitudes and of Benedetti's serendipitous discovery, mentioning along the way the archival work that Francesca and Laura Testa had done, and noting that the Russian scholar Victoria Markova was also present in Dublin to confirm that the Odessa version was "a careful and accurate copy," but merely a copy.

Afterward Francesca moved among the crowd with Luciano, stopping now and then to chat with someone she knew. She didn't have to give her speech until the next day. She watched Victoria Markova approach Sir Denis with arms opened in greeting, and she knew intuitively what would happen next. The Englishman began to recoil, but Victoria Markova grappled with him anyway. When she finally released him, his face was white and his glasses sat cockeyed. Thereafter, Francesca noticed, Sir Denis thrust his right hand out in peremptory greeting well in advance of every woman who approached him.

Francesca kept telling herself that she was the youngest scholar there—she had just turned twenty-nine—that no one would pay too much attention to her, and that even if they did,

they would forgive her errors. She found Benedetti and confided her anxiety about speaking in English. Benedetti listened sympathetically. "The most important thing is that you are here," he told her. Meanwhile, he had other problems to deal with. Mina Gregori had just decided that she wanted his help in translating her fifty-page speech into English. And Herwarth Rottgen had lost the slides to accompany his speech and appeared on the verge of nervous collapse.

The festivities continued for three days. Luciano had to return to Oxford to teach, so he didn't hear Francesca give her speech about the Mattei collection. She had no real memory of giving it. She was, as Luciano had predicted, all but unconscious with stage fright. Afterward, both Denis Mahon and Claudio Strinati complimented her. She suspected they were just being polite, but she began to enjoy herself at last, at one round of dinner parties after another, always in the company of other scholars, always talking about art.

❧

SEVERAL WEEKS AFTER THE CEREMONIES, BENEDETTI WAS ON HIS way to lunch when a woman stopped him on the sidewalk and asked for his autograph. He gave it with a smile and a flourish. He carried himself in a new way. His name, now forever linked with Caravaggio, would appear alongside those of Roberto Longhi and Denis Mahon in bibliographies and indexes of the artist. He had made his name in the world of art history, he had achieved immortality on a small scale.

He was invited twice to give lectures at the Bibliotheca

Hertziana. The Longhi Foundation in Florence, directed by Mina Gregori, asked him to speak, an honor akin, Benedetti observed, to conducting Mass at St. Peter's Basilica. Irish television made a documentary about his discovery of the painting. The gallery's board of governors agreed to make him curator of Italian art. He no longer worked as a restorer. *The Taking of Christ* traveled to exhibitions in London, Rome, and America. He went with it.

He would like to find another Caravaggio. Many are still lost. Caravaggio's painting of St. Sebastian, apparently owned only briefly by Asdrubale Mattei, was reported by Bellori three hundred years ago to have been taken to somewhere in France. It has never been found.

<hr>

FRANCESCA AND LUCIANO GOT MARRIED THE FOLLOWING YEAR. The ceremony took place in the fifth-century basilica in the Piazza San Lorenzo in Lucina, the same piazza where the Tomassoni clan had once lived, and only a short distance from the Via dei Condotti, where Francesca had spent her earliest years.

Francesca wore a white dress and veil. The wedding, ceremonial and formal, was, Francesca later said, "the mistake of the mistake." Luciano returned to Oxford, Francesca stayed in Rome. They commuted back and forth and talked daily on the telephone. But Francesca did not want to move to England, and Luciano did not want to return to Italy. "I have more bacon and eggs in my blood now than cappuccino and cornetti," he said. After three years of marriage, they separated. In time, Luciano remarried, and so did Francesca, to a lawyer. She has a three-year-old son

named Tommaso. Luciano teaches philosophy and logic at Oxford; Francesca teaches art history at the University of Ferrara.

✺

DENIS MAHON IS NINETY-FIVE YEARS OLD. HE TRAVELS REGULARLY and is often asked to render his opinions on paintings. He still appears at conferences on Caravaggio, although, as Francesca points out, his stories have begun to repeat themselves. The seventy-three paintings that once filled his house in Cadogan Square have taken up residence at the British National Gallery.

✺

FOR A TIME, THE NATIONAL GALLERY OF IRELAND WAS BESIEGED with people carrying in old works of art, hoping they had found a lost masterpiece. Many of the hopeful were priests from small parish churches and religious houses around the country.

The Taking of Christ became the gallery's biggest draw, attracting thousands of visitors a year. One of those visitors, gazing at the painting on a warm day in April 1997, happened to notice a tiny dark brown speck on the inner edge of the gilt frame. It would not have caught the visitor's attention had the speck not started to move in erratic circles, and then suddenly take wing.

The visitor debated whether this was an event worth reporting to the gallery attendant. It seemed trivial. But in the end, she did mention it, offhandedly, to the attendant, who gravely said that he would have the matter looked into.

That evening, after the gallery had closed, Andrew O'Connor

came down to look at the painting. He saw nothing amiss, but he asked the Working Party to bring it up to the restoration studio so that he might take a closer look.

O'Connor removed the metal clips that held the painting in the frame. As he lifted the stretcher, dozens of small dead insects, reddish brown in color, with beetle-like carapaces, dropped onto the table. Along the tacking edges at the top and bottom of the picture, O'Connor saw a dense network of silky white filaments, the cocoons in which the larvae had grown. And the larvae themselves, hundreds of small white grubs, were writhing among the warp and weft of the canvas. They had eaten away patches of the relining along the tacking edges. O'Connor measured one section of the relining, four centimeters by eleven, that had been devoured in its entirety by the bugs. He had never before encountered anything like it.

An entomologist from the Natural History Museum, one block away, came over and examined the dead specimens. He quickly identified it as *Stegobium paniceum,* more commonly known as the biscuit beetle. The entomologist presented his findings, along with an animated disquisition on the beetle's life cycle, in a meeting with Raymond Keaveney and O'Connor. The entomologist seemed quite delighted to have his expertise engaged in a case of such significance. Keaveney, looking grim, didn't share his enthusiasm.

The biscuit beetle, according to the entomologist, thrived on starch—flour, bread, rice, pasta—hence its name. Its life span ranged between three and seven months. The adult beetles, which measured an eighth of an inch long and could fly, lived only three to four weeks. They did not eat, but they were prodi-

gious breeders, generating four broods during warm months. It was the larvae, which fed for many months, that did the damage.

The source of the insects' food was immediately evident to O'Connor. It was the glue—the colla pasta, with its large quantity of flour—that Benedetti had used in relining.

As senior restorer, O'Connor assumed the task of tackling the problem. He had all the paintings in the Italian room of the gallery taken down. He inspected each in turn for sign of infestation, but found none. *The Taking of Christ* was the sole painting afflicted by the biscuit beetle.

O'Connor examined the entire painting carefully. He found, to his great relief, that the seventeenth-century Italian canvas, Caravaggio's original canvas, had not been damaged. The beetles had gotten only as far as the tacking edges of the new canvas.

O'Connor considered relining the entire painting, but decided against it in the end. He opted not to subject the picture to the additional stress of relining. But he had to replace the tacking edges. With a scalpel he cut away the infested parts of the relining and glued on new tacking edges, a process called strip lining. He did not use the old colla pasta method. He used a modern adhesive, a synthetic resin called Beva 371.

As Denis Mahon might have said, *"Habent sua fata picturae."* Pictures have their vicissitudes.

EPILOGUE

The Caravaggio Disease

⚜

IN THE SPRING OF 2003, TEN YEARS AFTER THE UNVEILING OF *The Taking of Christ* in Dublin, a restorer and art dealer in Rome named Mario Bigetti began hearing word that another version of the painting, long regarded as a copy, had come on the market. Bigetti's sources told him that the asking price was sixty thousand euros. A considerable sum for a copy, thought Bigetti, even if the copy did come with an illustrious history. The painting, owned by the Sannini family of Florence, had been discovered by Roberto Longhi sixty years ago, in 1943. While it lacked the brilliance of an authentic Caravaggio, wrote Longhi, it appeared to be a faithful copy of the lost original that Bellori had described in such precise detail. Some years later Longhi arranged to borrow the painting from its owner, Ladis Sannini, a lawyer and amateur collector, for the 1951 Caravaggio exhibition in Milan.

Bigetti was curious about the painting. After the Milan exhibition, it had gone back into the Sannini collection, never to be displayed publicly again. It existed in the world of Caravaggio

scholars only as a few dark, old photos. Bigetti heard rumors through his network of sources that one dealer or another had gone to look at it, but apparently no one had been seriously tempted to buy.

Bigetti's curiosity finally got the better of him. He read what he could find on the painting. There wasn't much, just the few notes by Longhi, and the dark photo in the 1951 catalogue. What intrigued Bigetti most was the size of the painting. It was two feet wider and a foot taller than either the now accepted Dublin painting or the Odessa version. Most of that additional space was simply dark background. The only significant feature, on the left edge of the Sannini painting, was the fleeing disciple's extended arm, depicted as far as the wrist. In both the Dublin and Odessa paintings, the arm stopped at the elbow, leaving the viewer to conjure the rest.

Strange, thought Bigetti: no copyist he'd ever heard of would have painted more than the original. He decided to go see the painting for himself. Even a copy, he reasoned, might be worth buying at the right price. He made a few phone calls and arranged, through an agent of the Sannini family, to view the painting.

❧

MARIO BIGETTI HAD SPENT HIS ENTIRE LIFE DEALING IN OLD OBjects, some of them valuable, some of them little more than junk. He was self-taught and industrious, and he had a particularly good eye for paintings. He was fifty-seven years old, short and stout, with a face as round as the full moon. He dressed like

a laborer, in dungarees and layers of sweaters covered by a denim jacket. Unlike the fancy antiquarians in suits and ties who catered to tourists and decorated their shops with Persian carpets, polished furniture, and artfully placed spotlights, Bigetti's shop, on Via Laurina two blocks from the Piazza del Popolo, was not the sort of place that beckoned to the average passerby. His neighbors were a butcher, a small bar, a punk clothing store, and the Hotel Margutta, on whose sad blue neon sign half the letters had burnt out. Bigetti's shop—it was a bottega, really—was long and narrow, more like a garage than a showroom. There were no windows; the only illumination came from a row of cheap spotlights on the ceiling, angled down on a few prizes that Bigetti had mounted on easels. In the shadow and the gloom, dozens, perhaps hundreds, of other paintings rested on the tiled floor and leaned, one atop another, against the scabrous green walls.

Bigetti's eye and his knack for finding old cast-off paintings at trifling prices had made him the acquaintance of nearly all the most famous scholars of the Baroque. Denis Mahon had visited his shop several times, as had Mina Gregori, Maurizio Marini, Herwarth Rottgen, Frederico Zeri, and others. In his time, Bigetti had come across several important paintings and dozens of lesser works of good quality. One never knew what small gem one might find in his dusty bottega.

On a day in May 2003, Bigetti and his wife left Rome and drove up to Tuscany, to the small, ancient village of Certaldo where Boccaccio had been born. The Sannini country house was a stone castle atop a hill, with gardens, olive groves, and views of the surrounding countryside. One of the family's retainers met Bigetti and his wife at the gated entrance and escorted them in.

Ladis Saninni, dead now for many years, had acquired a picture gallery of around seventy paintings, many of them portraits.

Bigetti spent only a short time examining *The Taking of Christ*. A small spotlight illuminated the painting to provide for careful examination. His eye was drawn to the face of Judas, where the paint surface was intact, with no overpainting or touch-up. The rest of the painting was dark and yellowed with old varnish and heavily retouched by earlier restorers.

After a few minutes, he nodded to the retainer and turned away. He made no comment about the painting. "When you are there for only a few minutes, you are sure about the painting," Bigetti once said. "When you must study it for half an hour, an hour, then you are simply trying to convince yourself. Plus, I want to give them the idea that I am not very interested."

He cast a quick, appraising glance at several other works in the Sannini collection. He thanked the man who had escorted him, and he and his wife departed. They had been there less than fifteen minutes, and few words had been exchanged.

In the car, his wife said to him: "Well, did you like it?"

"Certainly I liked it!" replied Bigetti. "I think it could be the original Caravaggio."

Bigetti resolved to buy the painting, restore it, and study it further. He let a week pass before contacting the Sannini representative. When Bigetti said he was interested in buying the painting, the agent remarked that it was a work of great historical value, highly esteemed by Roberto Longhi.

Yes, replied Bigetti, he knew the history of the painting.

The price, said the agent, was four hundred thousand euros.

And thus began Bigetti's negotiation for the painting. Four

agents and twenty days later, according to Bigetti, the negotiation stalled at 135,000 euros.

The price was more than double what Bigetti had heard from other dealers. But the agent for the Sannini family would go no lower. Perhaps, thought Bigetti, he had made his desire to own the painting too evident, after all.

A few days later he agreed to the price, even though he didn't have that sort of cash on hand. He quickly set about trying to find someone to finance the purchase in exchange for part ownership of the painting. One of his clients, who was to all appearances a man of means, agreed to provide the money. Together they produced a handwritten contract, and the client handed over a check. The only slight problem, said the client, was that the check would have to be postdated until funds arrived in the bank account.

Like Benedetti before him, Bigetti fretted with each passing day that some other dealer or antiquarian would see the painting and snatch it up. He had a Caravaggio, or so he believed, nearly within his grasp. He explained his dilemma to an acquaintance, a lawyer. The lawyer, who had faith in Bigetti's professional judgment, offered to advance Bigetti the money for the purchase.

And so Bigetti returned to Certaldo on June 20, 2003, in the company of the lawyer. He signed a contract and took possession of the painting. He wrapped it and loaded it into the back of his van and returned to Rome. That evening he installed it on a large wooden easel on the second floor of his bottega and spent several hours admiring it. The next morning, with eager anticipation, he sat before the easel with an array of solvents and

opened a small window in the grime and old varnish that covered the surface. The painting had not been cleaned at least since the 1951 exhibition, if then. Bigetti could see many places in which previous restorers, decades and centuries earlier, had retouched the original surface with a heavy hand.

The more Bigetti worked on the painting, the more certain he became that it was an autograph work by Caravaggio. He compared it incessantly with photographs of the Dublin version. He could not deny that his own was more crudely done. The intertwined fingers on the hands of Christ were like sausages, lacking definition, and his face seemed wooden and compressed, as if it had been put in a vise. The sleeve that draped off Judas' arm, and the cloak of the fleeing man, were rather coarse. Most strikingly, the back of the second soldier's head was bizarrely proportioned, as if the painter had depicted a microcephalic deformity.

Bigetti, in his desire to believe that this painting was by Caravaggio, made a virtue of the painting's crudeness. Yes, it was less elegant, less clean than Dublin, he would admit. But it was more *spontaneous*! And, most important, it was more complete.

OVER THE SUMMER, BIGETTI OPENED SEVERAL LARGE WINDOWS ON the painting, but many months of work still lay ahead of him. After cleaning off the dirt and varnish, he would have to remove large areas of overpainting applied by previous restorers. Yet he felt a need to share his belief that he had in his possession a gen-

uine Caravaggio. He called an art historian of his acquaintance, Maria Letizia Paoletti. "I want to show you something extraordinary," Bigetti told her.

Paoletti, then in her mid-fifties, had known Bigetti for many years and had visited his shop several times, always at his urgent behest. "He would call me all the time," Paoletti later recalled. "Come look at this Guido Reni, this Guercino, this Raphael," he would say. It was rarely ever what he thought it was, but sometimes he did make a discovery. He is not an art historian, he wouldn't know how to write a single line, but he does have a particular eye, a sensibility."

Paoletti was not known as a Caravaggio scholar, but she had a particular skill that Bigetti valued. Her expertise lay in the scientific techniques of examining old paintings. She had at her disposal portable X-ray and infrared machines, and access to a laboratory that could analyze pigments.

When she came to Via Laurina to see the painting, Bigetti pointed out aspects that he found convincing. It was bigger than either the Dublin or Odessa versions, and what copyist ever painted more than the original? It simply wasn't done! And look here, said Bigetti, there was clearly a scar on the back of Judas' hand, on the meaty part between the thumb and forefinger, the sort of scar caused by the slip of a knife, a scar just like Bigetti had on his own hand! It didn't exist in the Dublin painting, and a copyist would never invent such a thing!

These observations intrigued Paoletti. She admired certain elements of the painting. "I was pulled into it by the hand holding the lantern," she recalled later. "Caravaggio made hands in a

certain way, and to me this had his signature." She agreed to examine the painting with her machines to see what lay beneath the surface.

Even more important to Bigetti, she said that she would bring Sir Denis Mahon to look at the painting. Sir Denis was coming to Rome to help arrange a Guercino exhibition, and Paoletti had recently begun accompanying the elderly Englishman on his rounds. She saw to his needs and arranged transportation for him. This had previously been the task of the art historian Stephen Pepper, a Guercino expert whom Mahon had taken under his wing thirty years ago. But Pepper had recently died of a massive heart attack on the train from Bologna, and Paoletti had leaped at the chance to take his place.

In truth, it didn't take much to persuade Sir Denis to come to Bigetti's bottega. The lure of the Sannini painting's history, and the fact that he had not seen it since the Milan exhibition fifty years ago, were enough to stir his interest. He was now ninety-three years old. He tired easily and would doze from time to time at conferences, but his critical faculties were very much intact. He still occupied the preeminent position among Caravaggio scholars. His opinion on the authorship of a Baroque painting still counted for more than any other expert's, and it could sway the others.

He and Paoletti arrived at the door of Bigetti's shop on an afternoon in September. Sir Denis rode in a small electric cart that bumped over the cobblestones. On seeing the Englishman,

Bigetti scurried out to greet him with a broad smile. Once or twice, years earlier, Sir Denis had visited Bigetti's shop. This time, however, Bigetti worried that the elderly man might have difficulty climbing the flight of stairs up to the restoration studio. But once inside, at the foot of the stairs, Sir Denis arose from his chair and clambered up with an alacrity that astonished Bigetti, who was himself not fast on his feet.

For more than an hour, Sir Denis studied the painting and listened to Bigetti make his case that it was by Caravaggio. Sir Denis did not dismiss this possibility. He seemed, in fact, disposed to believe that Caravaggio had made more than one version of some of his paintings. "Longhi always maintained that Caravaggio never painted the same painting twice," said Mahon, ever willing to find fault with his old rival. "That's not true, as we've already seen on other occasions. We have to change our ideas." From time to time he rose from the armchair that Bigetti had provided to examine the painting close up.

"Most interesting," said Sir Denis as he prepared to leave. "*The Taking of Christ* has always been a great mystery." He told Bigetti that he would like to see the painting again, after it had been thoroughly cleaned and the overpainting removed, and after Paoletti had taken X rays. Until then he would reserve judgment.

❧

FIVE MONTHS LATER, IN FEBRUARY 2004, SIR DENIS WAS BACK IN Rome for the opening of the Guercino show. By then, Bigetti had stripped the painting down to its original state, and Pao-

letti had completed a full set of X rays and an infrared examination.

Her findings were startling. They showed dramatic alterations beneath the surface of the painting, not just pentimenti, but changes in the way two of the figures had been positioned and in the arm of the fleeing disciple; there was also a ghostly image that looked like the braided hair of a woman. Like Bigetti, Paoletti was fully convinced that this painting was no mere copy, but Caravaggio's original version of *The Taking of Christ.* "Pentimenti," she explained, "are done by artists who are just fixing small errors. These are major corrections, and corrections are by an artist who is rethinking the painting as he works on it." And a copyist, of course, had no need to rethink a painting.

Sir Denis returned to Bigetti's shop on the afternoon of February 12, 2004, in the company of his friend Fabio Isman, the journalist for *Il Messaggero*, and Paoletti. Sir Denis installed himself in the armchair in front of the painting, getting up only now and then to make a close examination with his magnifying glass. He spent two hours in Bigetti's shop that afternoon, speaking mainly with Paoletti, who was after all an art historian. He studied the X rays and the infrared images, he periodically asked Bigetti's shop assistant to move the spotlight around, and his excitement led him to pound on the floor with his cane. Isman looked on and took notes for an article.

"I have no doubt about it," Sir Denis exclaimed. "Now that the painting has been brought back to zero, stripped of all the overpainting, one can see perfectly well that it is genuine. It's full of pentimenti, and they are not banal corrections."

Bigetti was beside himself with delight. What was the value of a Caravaggio? Tens of millions! "And so this is the original and the Dublin one is just a copy!" he said to Mahon.

"Oh, no," replied Sir Denis. "Dublin is certainly by Caravaggio. There is no doubt about that. The Mattei inventories tell us that they had more than one version of the painting."

Paoletti and Bigetti had both made close study of the twenty-four Mattei inventories published a decade earlier by Francesca Cappelletti and Laura Testa. Bigetti's copy of their book was densely underlined and filled with notes in the margins. Many inventories cited two versions of *The Taking of Christ,* one attributed to Caravaggio, the other usually noted as a copy "by a disciple of Caravaggio," no doubt the authorized copy by Giovanni di Attili, who had been paid twelve scudi for his work. But a few of the inventories contained three and, sometimes, even four paintings called *The Taking of Christ.* It seemed highly improbable that all would be copies of Caravaggio's original. More plausibly, they represented different treatments by different artists of the same subject. Bigetti followed as well as he could the path of the paintings through the years, as they were moved from one room to another in the vast Mattei palazzo. He found significance in their travels, in the brief descriptions of the frames, in the changing color of a silk drapery that had adorned the original. In Bigetti's mind, the significance always pointed to his painting as the sole original.

"The one in Dublin has an arm cut off," said Bigetti, "and mine is complete. That means that Dublin is a copy."

"No," said Sir Denis again. "We'd always thought that Ca-

ravaggio never made replicas of his own paintings, but now we can prove that he did so. He also made try-outs—*bozzetti*. But until now we've never found any."

FABIO ISMAN'S ARTICLE ABOUT THE NEWLY REDISCOVERED *TAKING of Christ* came out three days later, on February 15, 2004. "New Caravaggios are sprouting up like mushrooms after the rain," Isman wrote, his tone ironic. He quoted Sir Denis at length on the authenticity of the painting. "An open war," concluded Isman, between Bigetti, who claimed his *Taking of Christ* was the sole original, and Benedetti, who asserted the same about the Dublin painting.

Isman's article was quickly picked up by British and Irish newspapers, which pursued the matter with interviews of their own. Paoletti, who spoke English, announced in the *Daily Telegraph* that she had "cast-iron proof" of the authenticity of the Sannini painting. "At the end of six months of painstaking investigations," she told a reporter, "I can say that it is unquestionably Caravaggio's original work. . . . Every expert who has seen the painting agrees with me." Contrary to Sir Denis, however, she stated that the Dublin painting was most likely a copy by another artist and not a replica by Caravaggio.

Clearly Sir Denis could not repudiate without embarrassment his earlier authentication of the Dublin painting. But he saw no need to. He seemed serenely untroubled at the awkward embrace of both. He even suggested that the Odessa version

might be yet another copy by Caravaggio himself, although he admitted that he had not yet personally examined that work.

Despite Sir Denis's affirmation, the Dublin painting's status was in jeopardy. Where once it had held undisputed preeminence, now it was merely second in a series. Bigetti's painting now laid claim to being the original manifestation of Caravaggio's genius.

At the Irish National Gallery, Raymond Keaveney was caught completely by surprise. He had known nothing about the events in Rome before he read the newspapers. There was little he could do beyond issuing a simple statement in defense of the Dublin painting. "All the homework has been done," Keaveney said, "and this [painting] has been in the public domain for fifteen years. It is universally accepted that ours is a Caravaggio."

<center>⚜</center>

AND THEN, IN ROME, CAME THE LAWSUITS, BOTH CIVIL AND CRIMinal, an Italian opera of claims and counterclaims, allegations of fraud, deceit, misrepresentation, falsification, counterfeit, and calumny of every sort.

They began with the client of Bigetti's who had agreed to help him finance the purchase of the painting with a postdated check. From there they grew into a tangle of bewildering complexity involving the other financier, the Italian state, Maria Letizia Paoletti, and even, according to word on the street, the Sannini heirs. Rumors abounded. One antiquarian heard that the Banca Nazionale del Lavoro had offered to buy the painting

for thirty million euros. This was not true, but on April 1, six weeks after Isman's story appeared, the court ordered the painting impounded in Bigetti's bottega until the ownership claims had been decided. Within weeks, matters grew even worse for Bigetti. An art-crimes prosecutor launched a criminal investigation; the possible charges ranged from falsely advancing a copy or reproduction as an original to illegally altering an original work of art, with many permutations in between. Bigetti looked on in woe and disbelief as the special art squad of the Carabinieri, the Italian national police, marched into his bottega and carried the painting off to their depository.

As if all this were not enough, Maria Letizia Paoletti, Bigetti's ally in advancing the painting as an authentic Caravaggio, also sued Bigetti. She claimed, in the first instance, that he had not paid her for her work. (Her bill, according to Bigetti, was for 200,000 euros, a "preposterous" sum.) And in the second instance, which was even more important to Paoletti, she said that Bigetti was defrauding her by claiming *he* had discovered the painting.

"He is playing a dirty game," said Paoletti, in her studio on the Aventine. "I am the one who discovered it, not him. He had an intuition, but it was confirmed by me and my investigation. Thus I discovered the painting!"

At stake for Paoletti was her right to publish the painting in an academic journal and thus enter the ranks of certified Caravaggio scholars, just as Benedetti had done years earlier. Bigetti was just a simple restorer, said Paoletti, who was incapable of writing a coherent line. "He cannot publish it, but he doesn't want me to publish it," she said in a voice full of outrage. "He

wants Maurizio Marini to do it. Why? Because I am not famous and Marini is! Marini has the name! Whoever publishes it is the one who discovered it. I will publish it, thus I discovered it! If Bigetti lets another person publish it, that is fraud!"

Paoletti shook her head bitterly. "It is like flies to honey when there is Caravaggio."

❧

FRANCESCA CAPPELLETTI HAD ALWAYS BEEN WARY OF WHAT SHE called "the Caravaggio disease." In the case of the Sannini painting, it seemed to have taken full possession of everyone who came near.

She kept her distance, watching from afar as developments unfolded. She had not seen the painting before it was seized by the Carabinieri, but she had looked at photographs. She found it hard to believe that Caravaggio had painted it, Denis Mahon's attribution notwithstanding. And she suspected that Paoletti's proof was anything but "cast-iron," as Paoletti had often asserted. For one thing, Paoletti had claimed to find an important document in the Recanati archive that Francesca and Laura had transcribed incorrectly. Francesca knew this was impossible. The Mattei palazzo in Recanati had been under lock and key by court order since the late 1990s, when the heirs began fighting over the estate. Apprised of this, Paoletti amended her story and said that she had found the document in the Archivio di Stato in Rome. But she would not reveal its contents or its significance to proving the authenticity of the Sannini painting until she was allowed to publish the painting herself.

Whatever Paoletti had found, or not found, the fact remained that the history of the painting before the lawyer Ladis Sannini acquired it was completely unknown. The Sannini family had no documents concerning the acquisition. Bigetti and Paoletti theorized that Ladis Sannini, who had practiced law in Rome before moving to Florence, might have purchased it in the 1930s, just after Duke Giuseppe Mattei had lost his palazzo and its contents in a card game. But the last full inventory of the Mattei collection, taken in 1854 and listing 218 paintings, contained no work called *The Taking of Christ*. There was, it appeared, no way to trace the painting back to the Mattei family.

The Dublin painting, on the other hand, had an excellent pedigree. It indisputably came from the Mattei collection. Even the mistaken change in attribution from Caravaggio to Honthorst worked in its favor. When the German scholar Von Ramdohr saw the painting in 1787, he dismissed the attribution to Honthorst and deemed it the work of Caravaggio. He made no mention of the only other painting of the same subject, which was unattributed in the inventory and described only as "large."

The size of the Sannini painting was in itself puzzling. Among the many versions of Caravaggio's original—there are as many as twelve—it was by far the largest. This constituted proof, according to Bigetti's reasoning, that it must be the original. But if that were so, why would the many copyists all paint uniformly smaller versions, ones the size of the Dublin painting? If the Sannini painting was the original, why wouldn't they have replicated *that*?

Last, and most important, there was the fact of Dublin's su-

perior quality, a fact acknowledged by everyone involved in the affair. Bigetti had a ready explanation: a copyist, without the burden of creation, had time to improve on the original, to smooth the rough edges and make a painting uniformly harmonious.

Bigetti's explanation was not without a sort of logic. But to accept such logic as an operative principle would turn the study of Caravaggio on its head. Ever since scholars began, some fifty years earlier, to identify Caravaggio's paintings, they have judged by the quality of the work, the swiftness, elegance, and cleanness of execution. In this instance, Bigetti would have the process inverted. Instead of being a Caravaggio because of its excellence, it was now a Caravaggio for precisely the opposite reason—that it was cruder and full of errors.

The sole aspect of the Sannini painting that gave any credibility to its claim as an original by Caravaggio was the profusion of gross pentimenti beneath the surface. Copyists, as a rule, rarely made so many errors, because they often had the original before them. But they were not immune to error, nor were they all equally talented. One could, for example, imagine a circumstance in which a young painter, trying to develop his skills, briefly saw the original in the Mattei palazzo. Returning to his atelier, he painted from memory. And then he went back to look again, realized his mistakes, and corrected many of them. Such a scenario is, of course, pure speculation, but it is no less plausible than Bigetti's explanation of the pentimenti as a result of Caravaggio's creative ferment.

IT WAS APRIL 2006. TWO YEARS HAD PASSED SINCE THE CARA-
binieri had seized the Sannini painting from Bigetti's bottega.
Bigetti sat at his desk in the gloom at the back of his bottega,
smoking a cigar under a sign that read "Smoking Prohibited."
He awaited the resolution of the lawsuits and the return of his
painting. "The wheels of justice turn slowly in Italy," he re-
marked in a disconsolate voice. He paused, and then added
darkly, "If this were Sicily, legs would have been broken
already."

He tried to comprehend the fate that had befallen him: how
could things have gone so badly wrong just at the moment when
his biggest triumph was at hand? He could find no flaw, no mis-
step, in his own actions. He believed everything would turn out
right in the end, that he would become wealthy and famous after
surmounting the formidable obstacles on the path to good for-
tune. His painting, after all, had the benediction of Sir Denis as
the original *Taking of Christ* by Caravaggio. That was the most im-
portant thing. He would just have to wait and endure.

As he waited, the criminal case proceeded with an investi-
gation into the nature of the painting. The aim of the two
prosecutors overseeing the case, Paolo Ferri and Fabio San-
toni, was to determine, to the extent scientifically possible,
whether the painting was a genuine work by Caravaggio. To
that end, the prosecutors contacted an expert named Maurizio
Seracini, the founder of a private company in Florence that
specialized in art and architecture diagnostics. Seracini had a
degree in electronic engineering from the University of Cali-

fornia at San Diego, and then had studied medicine at the University of Padua. He had turned his learning to the scientific analysis of artworks. He was, by any measure, one of the world's foremost authorities in the field, having examined more than two thousand paintings, frescoes, and statues, among them works by (or attributed to) Cimabue, Giotto, Botticelli, Raphael, and Leonardo. And, of course, Caravaggio—twenty-nine paintings at last count, most of them genuine, a few that were merely wishful attributions.

Seracini inspected the Sannini painting front and back and subjected it to his many instruments. He took microscopic samples of pigment from a variety of areas to determine their chemical constituents.

He paid particular attention to samples of yellow, from the bands on the soldier's pantaloons, from the apricot-colored cloak worn by Judas, and from the green cloak of the fleeing disciple. On examination, he found lead and tin, the common components of yellow in Caravaggio's day. And he also found another element, the brittle, toxic metal antimony. Lead and antimony were the constituents of an ancient color known as Naples yellow, then used widely in ceramics because of antimony's heat-resistant qualities.

Neither Seracini nor any other investigator had ever found antimony in a painting by Caravaggio. He had used only lead-tin yellow, as did all the other painters of his era and his predecessors dating back to the late medieval. The sole exception was *The Martyrdom of St. Ursula,* in Naples; in that work, researchers had found trace amounts of antimony, which they speculated

had come from an eighteenth-century restoration that had since been removed. Although Naples yellow had been around since before the time of Christ, the first oil painting in which it appeared was a work by Orazio Gentileschi done in 1615, now at the National Gallery in Washington, D.C. It was not until after 1630 that painters began to adopt Naples yellow for use on the canvas, a use that continued until the mid-nineteenth century.

Seracini sent a detailed report—some dozen pages long, according to several sources—to the two prosecutors in Rome. His conclusion: the Sannini painting was not by Caravaggio. It had been painted sometime after 1630, more than twenty years after Caravaggio's death.

⁂

Bigetti had no knowledge of Seracini's conclusion, no knowledge even that tests had been ordered by the prosecutors. In Italy, such matters remain secret until either the case comes to trial or the prosecutors close the file and it is archived. But even if he had known, the report would not have shaken his faith in the painting. Nor that of Maria Letizia Paoletti, who had conducted her own tests and was convinced of her "cast-iron" proof.

As for Sir Denis Mahon, one can imagine his old rival Roberto Longhi, who had always believed the Sannini painting to be a copy, enjoying a mirthless laugh. Some of Sir Denis's acquaintances suspect that in his old age, with death not far off, he

has felt the desire to embark on a last campaign of discoveries. Not to enhance his reputation, which needs no added luster, but for the pure pleasure of chasing the greatest painter of the Baroque, the one painter whose work he has never succeeded in owning.

ACKNOWLEDGMENTS

I owe a debt of gratitude to many people in Italy who helped me in ways large and small. Among them are Teresa Notegen, owner of the Bar Notegen on Via del Babuino; Gianni Amodeo, my first teacher in Italian; Jessica Young, the kindest landlady I've ever met; the poet and raconteur Vito Riviello and his talented daughter Lidia Riviello; the painter Ettore de Conciliis, for his friendship and introduction to Maurizio Marini; the art historian Stephen Pepper, whose sudden death two years ago affected many people; the painter Tiziana Monti, who helped to arrange an interview with Mario Masè, former owner of Mario's trattoria; my friend Arnulf Herbst; the beautiful Esther Baird; at *Il Messaggero,* the journalist Riccardo De Palo, who arranged for me to meet Fabio Isman; Emanuela Noci, a friend and journalist who read an early draft of the book, and her husband, the artist Steven Meek; the restorer Maurizio Cruciani; my friend Mayo Purnell; Francesca's husband, Gottardo Pallastrelli di Celleri; and Katya Leonovich, who read this in many versions and endured me at my worst. My thanks also to those at the Ameri-

can Academy, particularly the former director Lester Little, and to the Bibliotheca Hertziana.

I could not have written this book without the consent of those people whose names appear in the narrative. I am deeply appreciative for the time they sacrificed in repeated interviews. This is especially true in the case of Francesca Cappelletti, who tolerated with wonderful good humor my endless requests for details. It applies as well to Denis Mahon, Laura Testa, Giampaolo Correale, Luciano Floridi, Paola Sannucci, Maurizio Calvesi, Stefano Aluffi, Fabio Isman, Caterina Volpi, and Roberto Pesenti. In Dublin, my thanks to Raymond Keaveney, Brian Kennedy, Sergio Benedetti, Andrew O'Connor, Father Noel Barber, and Michael Olohan. In London, thanks to Hugh Brigstocke, Ashok Roy, and Larry Keith. My gratitude as well to Gerda Panofsky-Soergel, with whom I spent a delightful afternoon at the Neue Galerie in New York.

My friend Tracy Kidder read many versions of the manuscript and took pen in hand occasionally when I got too tangled up. I turned to several other trusted friends for advice, among them Richard Todd, Craig Nova, and Bill Newman, and I'm grateful for their comments. Andrew Wylie was always encouraging when I felt dispirited. At Random House, I was saved countless embarrassments by marvelous copy editors Jolanta Benal and Vincent La Scala.

To Bob Loomis, my editor and friend, the wisest person I know—I don't know how to thank you properly, except to say that I am proud of your confidence and friendship.

And of course, to Diane, who sustained me sweetly throughout, as always.

A NOTE ON SOURCES

This book grew out of a visit of several months to the American Academy in Rome in early 2000. Six years earlier, I had written an article for *The New York Times Magazine* about the discovery of *The Taking of Christ*. I'd thought back then that I might expand the article into a book, but I let the idea lie fallow while I pursued other projects. When Lester Little, then the director of the American Academy, extended an invitation to come to Rome, I was required (if only for the sake of formality) to have a project in mind. I decided to resurrect the idea of the lost painting and see if I could turn it into a book.

The project has taken longer than I anticipated. My first task was to learn to speak Italian with some degree of fluency, since many of the people I wanted to interview in Rome spoke little or no English, and I did not want to use interpreters. Francesca Cappelletti was the notable exception; her English is good, although she much prefers to speak in Italian, and I tried to oblige her.

I have not changed any of the names of the people I've written about. This account is based on interviews with the partici-

pants that I conducted in Rome, Dublin, and London. My focus
in writing this book was deliberately narrow. Readers who are
interested in knowing more about Caravaggio's life and works,
and the history of the early Baroque, can avail themselves of sev-
eral biographies of the artist. Three were published in 1998. I
found *Caravaggio: A Life,* by Helen Langdon (Farrar, Straus &
Giroux), to be particularly helpful. The other two, *M,* by Peter
Robb (Henry Holt and Company), and *Caravaggio,* by Catherine
Puglisi (Phaidon Press in London), are each meritorious in their
own very different ways.

The books that I made most use of, however, are landmarks in
their own rights. The first of those is Walter Friedlander's seminal
work *Caravaggio Studies,* published in 1955 by the Princeton Univer-
sity Press. It is now unfortunately out of print, but the clarity of
Friedlander's writing, the depth of his observations on the artist's
work, and the large appendix of documents concerning Caravag-
gio's life and work, in both original language and translation, make
the book invaluable. Howard Hibbard's biography, *Caravaggio*
(Harper & Row, 1983), has many of the same merits.

But the most remarkable, exhaustively detailed, and fully
thumbed volumes in my possession are the second and third
editions of Maurizio Marini's *Caravaggio: Michelangelo Merisi da
Caravaggio, "pictor praestantissimus,"* published in Rome in 1989 and
2001, respectively. I thank Maurizio also for his friendship, hos-
pitality, and discussions about Caravaggio.

The following books, articles, and monographs were all use-
ful to me. This list does not represent a complete bibliography of
works on Caravaggio, nor all the works that I consulted. For a
complete bibliography, one should turn to Marini's third edition.

Askew, Pamela. *Caravaggio's Death of the Virgin*. Princeton, N.J.: Princeton University Press, 1990.

Benedetti, Sergio. *Caravaggio and His Followers at the National Gallery of Ireland*. Exhibition catalogue. Dublin: National Gallery of Ireland, 1992.

———. "Caravaggio's 'Taking of Christ': A Masterpiece Rediscovered," in *The Burlington Magazine*, CXXV, November 1993.

———. *Caravaggio: The Master Revealed*. Exhibition catalogue. Dublin: National Gallery of Ireland, 1993.

———. "Gli Acquisiti Romani di William Hamilton Nisbet," in *Paragone*, September 1995.

Bernardini, Marie, Silvia Danesi Squazina, and Claudio Strinati, eds. *Studi di storia dell'arte in onore di Denis Mahon*. Milan: Electa, 2000.

Black, Jeremy. *The Grand Tour in the 18th Century*. London: Sandpiper Books, 1992.

Blunt, Anthony. *Artistic Theory in Italy 1450–1600*. London: Oxford University Press, 1973 edition.

Brigstocke, Hugh. *William Buchanan and the 19th Century Art Trade*. Privately published by the Paul Mellon Centre for Studies in British Art, London, 1982.

Calvesi, Maurizio. *Le Realtà del Caravaggio*. Turin: Einaudi, 1990.

Cappelletti, Francesca. "The Documentary Evidence of the Early History of Caravaggio's 'Taking of Christ,'" in *The Burlington Magazine*, CXXV, November 1993.

Cappelletti, Francesca, and Laura Testa. "Caravaggio: Nuovi dati per i dipinti Mattei," in *Art e Dossier*, February 1990.

———. *Il Trattenimento di Virtuosi: Le collezione secentsche di quadri nei Palazzi Mattei di Roma*. Rome: Argos Edizioni, 1994.

———. "I quadri di Caravaggio nella collezione Mattei. I nouvi documenti e i riscontri con le fonti," in *Storia dell'Arte*, May–August 1990.

Cinotti, Mia. *Michelangelo Merisi detto il Caravaggio: Tutte le Opere.* Bergamo: Poligrafiche Bolis, 1983.

Cohen, Elizabeth S. "Honor and Gender in the Streets of Early Modern Rome," in *Journal of Interdisciplinary History,* XXII, Spring 1992.

Correale, Giampaolo, ed. *Identificazione di un Caravaggio.* Venice: Marsilio Editori, 1990.

Corridini, Sandro. *Caravaggio: Materiali per un processo.* Rome: Monografie Romane, 1993.

Corridini, Sandro, and Maurizio Marini. "The Earliest Account of Caravaggio in Rome," in *The Burlington Magazine,* vol. 140, 1998.

De Courcy, Catherine. *The Foundation of the National Gallery of Ireland.* Dublin: National Gallery of Ireland, 1985.

Finaldi, Gabriele, and Michael Kitson. *Discovering the Italian Baroque: The Denis Mahon Collection.* London: National Gallery Publications, 1997.

Floridi, Luciano. In *Cervelli in Fuga.* Rome: Avverbi, 2001.

Frommel, Christoph L. "Caravaggios Fruwerk und der Kardinal Francesco Maria Del Monte," in *Storia dell'Arte,* vol. 9–10, 1971.

Gash, John. *Caravaggio.* London: Bloomsbury Books, 1988.

Gilbert, Creighton E. *Caravaggio and His Two Cardinals.* University Park, Penn.: Pennsylvania State University Press, 1995.

Gregori, Mina, ed. *Come dipingeva il Caravaggio.* Milan: Electa, 1996.

Judson, J. Richard, and Rudolph E. O. Ekkart. *Honthorst.* Doornspijk, Netherlands: Davaco Publishers, 1999.

Keith, Larry. "Three Paintings by Caravaggio," in *National Gallery Technical Bulletin,* vol. 19. London: National Gallery Publications, 1998.

Kirwin, W. Chandler. "Addendum to Cardinal Francesco Maria Del Monte's Inventory," in *Storia dell'Arte,* vol. 9–10, 1971.

Kitson, Michael. *The Complete Paintings of Caravaggio.* London: Wiedenfeld & Nicholson, 1969.

Longhi, Roberto. "Appunti: 'Giovanni della Voltolina' a Palazzo Mattei," in *Paragone*, 1969.

———. "Ultimi studi sul Caravaggio e la sua cerchia," in *Propozione I*, 1943.

———. "Un originale del Caravaggio a Rouen e il problema delle copie Caravaggesche," in *Paragone*, 1961.

Macioce, Stefania, ed. *Caravaggio: La Vita e le Opere Attraverso i Documenti*. Rome: Logart Press, 1995.

Macrae, Desmond. "Observations of the Sword in Caravaggio," in *The Burlington Magazine*, CVI, 1964.

Magnuson, Torgil. *Rome in the Age of Bernini, Vol. I*. Uppsala, Sweden: Almqvist & Wiksell, 1992.

Mahon, Denis. "A Late Caravaggio Rediscovered," in *The Burlington Magazine*, XCVIII, 1956.

———. "Addenda to Caravaggio," in *The Burlington Magazine*, XCIV, 1952.

———. "Caravaggio's Chronology Again," in *The Burlington Magazine*, XCIII, 1951b.

———. "Caravaggio, Michelangelo Merisi: 'Nude Youth with a Ram,' " in *Artists in 17th Century Rome*. Exhibition catalogue. London: Wildenstein & Co., 1955.

———. "Contrasts in Art-historical Method: Two Recent Approaches," in *The Burlington Magazine*, XCV, 1953a.

———. "Egregius in Urbe Pictor: Caravaggio Revised," in *The Burlington Magazine*, XCIII, 1951a.

———. "Fresh Light on Caravaggio's Earliest Period: His 'Cardsharps' Recovered," in *The Burlington Magazine*, CXXXII, 1990.

———. *Studies in Seicento Art*. London: Warburg Institute, 1947.

Martin, John Rupert. *Baroque*. New York: Harper & Row, 1977.

Moir, Alfred. *Caravaggio and His Copyists*. New York: New York University Press for the College Art Association of America, 1976.

———. "Did Caravaggio Draw?" in *The Art Quarterly*, XXXII, 1969.

———. *The Italian Followers of Caravaggio.* Cambridge, Mass.: Harvard University Press, 1967.

Mormando, Franco, ed. *Saints and Sinners: Caravaggio and the Baroque Image.* Exhibition catalogue. Boston: McMullen Museum of Art, Boston College, 2000.

Nicolaus, Knut. *The Restoration of Paintings.* Cologne: Koneman, 1999.

O'Neil, Maryvelma Smith. *Giovanni Baglione: Artistic Reputation in Rome.* Cambridge: Cambridge University Press, 2002.

Pacelli, Vincenzo. "New Documents Concerning Caravaggio in Naples," in *The Burlington Magazine,* vol. 119, 1977.

Panofsky, Erwin. *Idea: A Concept in Art Theory,* 1968 edition. New York: Harper & Row.

———. *Meaning in the Visual Arts.* Chicago: University of Chicago Press, 1955.

Panofsky-Soergel, Gerda. "Zur Geschichte Des Palazzo Mattei Di Giove," in *Romisches Jahrbuch fur Kunstgeschichte.* Vienna-Munich: Anton Schroll & Co., 1967–68.

Podro, Michael. *The Critical Historians of Art.* New Haven: Yale University Press, 1982.

Roskill, Mark. *What Is Art History?* 2nd edition. Amherst, Mass.: University of Massachusetts Press, 1989.

Sherman, John. *Mannerism.* London: Penguin Books, Ltd., 1967.

Spear, Richard E. *Caravaggio and His Followers.* New York: Harper & Row, 1975.

Strinati, Claudio, and Rossella Vodret, eds. *Caravaggio e il Genio di Roma.* Exhibition catalogue. Milan: RCS Libri, 2001.

Thompson, Colin, Hugh Brigstocke, and Duncan Thomson. *Pictures for Scotland: The National Gallery of Scotland and Its Collection.* Edinburgh: Trustees of the National Gallery of Scotland, 1972.

Various authors. *Caravaggio e la collezione Mattei*. Milan: Electa, 1995.

Wittkower, Rudolf. *Art & Architecture in Italy, 1600–1750,* 1982 edition. New Haven: Yale University Press.

Wolfflin, Heinrich. *Principles of Art History,* 1950 edition. New York: Dover Publications, Inc.

THE
LOST
PAINTING

JONATHAN HARR

A Reader's Guide

READING GROUP GUIDE

1. Caravaggio is widely regarded by art historians as a revolutionary painter. Discuss how his work differed from his contemporaries, and how his work was received by the Church.

2. Caravaggio's reputation went into eclipse for almost three hundred years, and yet today, along with Michelangelo, Raphael, and Leonardo, he has become one of the best known of the Italian Old Masters. What is it about his work that speaks to modern tastes?

3. Discuss how and why tastes in art can change so dramatically from one era to the next.

4. One of the recurring problems among Caravaggio scholars is identifying the painter's original works from among many copies. Do you believe that a high-quality copy can create for a viewer the same aesthetic and emotional experience as the original? If so, what is it about the original that makes it so important?

5. At the suggestion of their professor, Francesca and Laura published what they had discovered in the Recanati archive without informing their boss, Giampaolo Correale. How does this affect your view of the two young women? Was Correale justified in his anger?

6. This is a work of nonfiction in which the author depicts the lives and actions of real people without changing their names or concealing their identities. Discuss how you feel about their treatment. Did you feel the author was objective and fair in his depictions?

7. The world of art scholars, as described in this book, was riven with jealousies and feuds. Discuss why this was so, and whether you think other disciplines are afflicted with the same sort of atmosphere.

8. The opinion of Sir Denis Mahon was highly esteemed in the art world. Why do you think this was so? Is it reasonable to place such weight on the judgments of one man?

9. Francesca refers several times to the "Caravaggio disease," and fears at one point that she might get infected by it. What does she mean by it?

10. Benedetti left Rome and went to work in Ireland. What was it about Italy that made it so difficult for him to work there?

11. Even though Benedetti managed to repair the damage that he'd caused during the restoration of the painting, he denied that anything had gone amiss. Do you think he was justified in doing so?

12. Francesca and Laura traced *The Taking of Christ*'s journey from Rome to Scotland. What does this tell us about the rise and fall of family fortunes and historical events in Italy and Great Britain?

JONATHAN HARR lives in Northampton, Massachusetts, and Rome. He is the author of *A Civil Action,* which was awarded the 1995 National Book Critics Circle Award.

ABOUT THE TYPE

This book was set in Requiem, a typeface designed by the Hoefler Type Foundry. It is a modern typeface inspired by inscriptional capitals in Ludovico Vicentino degli Arrighi's 1523 writing manual, *Il modo de temperare le penne*. An original lowercase, a set of figures, and an italic in the "chancery" style that Arrighi helped popularize were created to make this adaptation of a classical design into a complete font family.